Fantasy Film Post 9/11

FANTASY FILM POST 9/11

FRANCES PHEASANT-KELLY

FANTASY FILM POST 9/11
Copyright © Frances Pheasant-Kelly, 2013.

First published in 2013 by
PALGRAVE MACMILLAN®
in the United States—a division of St. Martin's Press LLC,
175 Fifth Avenue, New York, NY 10010.

Where this book is distributed in the UK, Europe and the rest of the world,
this is by Palgrave Macmillan, a division of Macmillan Publishers Limited,
registered in England, company number 785998, of Houndmills,
Basingstoke, Hampshire RG21 6XS.

Palgrave Macmillan is the global academic imprint of the above companies
and has companies and representatives throughout the world.

Palgrave® and Macmillan® are registered trademarks in the United
States, the United Kingdom, Europe and other countries.

ISBN: 978–0–230–39212–0

Library of Congress Cataloging-in-Publication Data

Pheasant-Kelly, Frances, 1960–
 Fantasy film post 9/11 / by Frances Pheasant-Kelly.
 pages cm
 Includes bibliographical references and index.
 ISBN 978–0–230–39212–0 (alk. paper)
 1. Fantasy films—History and criticism. 2. September 11 Terrorist
Attacks, 2001—Influence. I. Title.

PN1995.9.F36P53 2013
791.43′61509051—dc23 2012037261

A catalogue record of the book is available from the British Library.

Design by Newgen Imaging Systems (P) Ltd., Chennai, India.

First edition: March 2013

10 9 8 7 6 5 4 3 2 1

For my parents

CONTENTS

LIST OF ILLUSTRATIONS

ACKNOWLEDGMENTS

MY SINCERE THANKS GO TO FRIEND AND COLLEAGUE STELLA HOCKENHULL, who has been a constant source of support and intellectual inspiration, and to Steve Badsey for his insightful comments and helpful discussion. Also my thanks to Mark Jones, James Chapman, Isaac Vayo, and Todd Comer, who have all made valuable suggestions, and to Michael Kelly and Denise Pheasant, who have helped me along the way. I would further like to acknowledge the University of Wolverhampton for its unstinting and generous commitment to my research. Final thanks go to the staff at Palgrave, including Samantha Hasey, Desiree Browne, and Robyn Curtis.

INTRODUCTION

THE TERRORIST ACTS OF SEPTEMBER 11, 2001 (9/11) CAUSED PROFOUND destruction in Manhattan and a loss of life to terrorism unprecedented on American soil, the scale of 9/11 prompting some commentators to declare it as a defining historical moment. Frank Rich of *The New York Times* stated in its immediate aftermath, "America is a different country after Tuesday" (2001), and Wheeler Winston Dixon too claimed that "in this bleak landscape of personal loss, paranoia, and political cynicism, American culture has been forever changed" (2004: 3). Several years after the event, Mitchell Gray and Elvin Wyly reported that "everyone from Paul Wolfowitz to Peter Marcuse, Donald Rumsfeld to Norman Mailer, Dick Cheney to Naom Chomsky, agrees that things are different now" (2007: 332). Others, however, located the attacks within a broader spectrum of terrorism, David Holloway arguing that "in many ways the feeling that everything changed on 9/11 was an illusion [...] Catastrophic though they were, the 9/11 attacks were just one incident in a much bigger, transnational Islamist insurgency" (2008: 1). Nevertheless, the date signaled a watershed in US political history as well as marked an escalation in the spectacular possibilities of terrorism. Moreover, the media attention that had been afforded to 9/11 has intensified its persistence in public memory. Indeed, the term "9/11" immediately conjures images of the destruction of the Twin Towers, images that are branded indelibly on the memories of those who witnessed the unfolding of events in 2001, either first-hand or through visual media. Although this witnessing may have occurred vicariously, it caused some viewers to experience symptoms of trauma (Shalev, 2007: 220).

In the immediate aftermath of 9/11, the sense of loss created by the destruction of the World Trade Center (WTC) was replaced with repeated showings of the footage of its collapse, while potentially distressing cinematic releases were postponed or edited, including *The Sum of All Fears* (Robinson, 2002) and *Collateral Damage* (Davis, 2002), both of which centered on terrorism. Holloway further describes the emergence of "allegory-lite" films, explaining these as "pure capitalist utilitarianism, performing the tricky

maneuver of appealing simultaneously to multiple audiences, alienating as few customers as possible, while transferring responsibility for any 'politicizing' of films to viewers themselves" (2008: 83). There were also longer-term cinematic repercussions. While the defining moment of the twenty-first century for many was, and likely will remain for the near future, the destruction of the Twin Towers, a number of related political and sociocultural changes ensued in the intervening period that further influenced films of the new millennium. George W. Bush's political strategy began to promote unease, while widespread economic downturn and climate change concerns led to a sobering of national mood. In addition, a number of large-scale global disasters occurred, resulting in substantial loss of life, which included the Indonesian Boxing Day tsunami (2004) and Hurricane Katrina in the United States (2005). Cinema, as in previous times of collective anxiety, began to reflect this prevailing tone of pessimism, with allusions to 9/11, environmental catastrophe, and economic recession becoming discernible across a range of genres.

Moreover, the dramatic events of 9/11 elicited comparisons with mainstream disaster films that preceded and, indeed, seemed to anticipate, the Twin Towers' attacks. As Geoff King (2005) notes,

> The spectacle of high-profile American buildings being severely damaged or entirely blown to bits became a familiar one in the 1990s, especially in action-disaster-scifi hybrids such as *Independence Day* (1996) and *Armageddon* (1998), (King, 2005: 47)

King draws specific parallels between the fireballs of the Twin Towers and similar scenes from films such as *Die Hard* (McTiernan, 1988) and *Armageddon* (Bay, 1998). Although he argues that Hollywood's fictionalized scenes of disaster provide pleasure in their "sheer spectacle" (2005: 49), and "the notion of a cleansing destruction of centers of government and urban decadence, against which certain powerful notions of American-ness have often been defined" (2005: 49), he observes that such pleasure is displaced by confrontation with scenes of genuine devastation. These fictionalized versions of destruction that saturated cinema before the real events of 9/11 led postmodern scholar Jean Baudrillard to articulate a number of controversial concepts concerning the attacks. In *The Spirit of Terrorism*, he suggests that the West was inadvertently complicit in the events of 9/11, claiming that "[t]he countless disaster movies bear witness to this fantasy, which they clearly attempt to exorcize with images, drowning out the whole thing with special effects" (2003: 7).

The connection between spectacle, visual effects, and terror in the pre-9/11 disaster film has since rematerialized in the post-9/11 fantasy film,

a genre that has dominated box-office figures from 2001. Wheeler Winston Dixon, writing a year after 9/11, asked: "What effect will the events of 9/11 have on film genres?" (2004: 2). He subsequently went on to respond to that question, listing the production of numerous 9/11 narratives comprising documentaries, fictional films, and docudramas, which, in turn, have prompted various scholarly studies of the relationship between 9/11 and the media. These include analysis of documentary footage of the Twin Towers' destruction (see Baudrillard, 2003; Bruzzi, 2006; King, 2005; Smith, 2005; Virilio, 2002; Žižek, 2002) as well as representations of 9/11 in fictionalized film or docudrama (see Austin and Jong, 2008; Baudrillard, 2003; Birkenstein *et al.*, 2010; Boggs and Pollard, 2007; Butler, 2009; Dixon, 2003; Dixon, 2004; Holloway, 2008; Kaplan, 2005; Kendrick, 2008; Markovitz, 2004; McAlister, 2006; Prince, 2009; Valantin, 2005; Weber, 2006). Often, these accounts comment on the similarities between documentary and fictionalized versions, or their relationship to trauma theory, to explain the effects of their respective visual forms, though none has yet specifically explored the post-9/11 fantasy film.

Despite the developing discourses surrounding 9/11 narratives, however, few films that directly address 9/11 have been commercially successful. Although Michael Moore's documentary *Fahrenheit 9/11* (2004) was the highest grossing documentary of all time, it performed only moderately overall. Generally, the reception of other 9/11 narratives has been uneven. Two films, both released in 2006, that relived the events of September 11, 2001, *United 93* (Greengrass) and *World Trade Center* (Stone) also fared reasonably, whereas, despite often being critically acclaimed, subsequent films that centered on the war on terror were much less lucrative. Significant examples of the latter include Paul Greengrass's *Green Zone* (2010) and Kathryn Bigelow's *The Hurt Locker* (2008), though Martin Barker (2011) has identified a further 23 films released between 2005 and 2008, which centered on the Iraq conflict. However, as Barker explains, "All of them, until the very last one in the cycle, bombed at box-office, if they made it there at all and just about all of them vanished without a trace" (2011: 1). Indeed, the poor commercial performance of these films led Barker to label them a "toxic genre" (2011), with Douglas Kellner suggesting that "the box office failure of many Iraq films shows that the experience is too painful for audiences to confront" (2010: 233). In marked contrast, the fantasy film has proved particularly fertile ground for oblique mediations of 9/11, achieving phenomenal and, indeed, groundbreaking box-office success.

One obvious reason for this is the way that fantasy allows an escape from reality, a point to which I will return. However, gauging a more generalized proclivity for fantasy in his analysis of "The Easternization of the West," Colin Campbell (2010) suggests that its rising prominence has been the

result of a widespread cultural change within the West, emergent over the past 50 years. He argues that this preoccupation with fantasy is congruent with an increasingly pervasive acceptance of Eastern values. Noting a "turn from realistic to fantasy fiction that has been such a marked feature of popular culture over the last 40 years" (2010: 748), Campbell concludes that "it has occurred because historical narratives are no longer seen to be credible" (2010: 748). Ted Friedman, on the other hand, argues that the turn to fantasy is a much more recent phenomenon, its current ubiquity deriving from "two intertwined preoccupations of our era: technology and nature" (2008). Clearly, the popularity of fantasy films that are dependent on developing digital technologies seems to vindicate Friedman's claim. Certainly, the other strong contender in the ranking of highest grossing films since 9/11 is the animated fantasy, with films such as *Toy Story 3* (Unkrich, 2010) and the *Shrek* series (Adamson, Asbury, Hui, Jenson, Miller, Mitchell, and Vernon, 2001–2010) also performing strongly.

In general, however, there is growing recognition that 9/11 has partly motivated the trend for fantasy, with many films of the genre clearly allegorizing 9/11. In her study of Japanese *animé*, Susan Napier (2005) asserts that "in America, at least, the events of September 11 have cast a long shadow over the national psyche. It is little wonder that fantasy worlds offering alternatives to the frightening new reality should become increasingly popular" (2005: xi). Although he acknowledges claims for a much earlier resurgence of the fantasy genre (from the 1970s), David Butler also concludes:

> For Western cinema, the pivotal year [for fantasy] was 2001. Not only did the end of 2001 see the release of the first part of *The Lord of the Rings: The Fellowship of the Ring*, but it also witnessed the first instalment of the other fantasy film series to triumph at the box office throughout the 2000s, *Harry Potter and the Philosopher's Stone*. If they were the most famous, these films were not, however, the only fantasy-themed productions to succeed financially in 2001. (Butler, 2009: 5)

Indeed, fantasy film has since dominated box office figures, with almost all current top-grossing fantasies (as of August 2012) having been released since 9/11. The date therefore not only signaled a major political watershed but also heralded an upturn in the fortunes of the fantasy genre with many films thereafter gaining Academy Award recognition and several premiering at the Cannes Film Festival. This, in turn, has affected fantasy's academic standing since, although there is already an established critical canon in relation to fantasy literature and the fairytale (including Bettelheim, 1991; Todorov, 1975; Warner, 1995), until recently, the fantasy film had received scant scholarly attention. Seminal studies of film genre, including Steve

Neale's *Genre and Hollywood* (2000) and Rick Altman's *Film/Genre* (1999) make only cursory mention of fantasy. However, the past decade has seen an increasing number of academic publications about fantasy film that reflect its ascendancy, with important contributions by scholars such as Joshua Bellin (2005), David Butler (2009), Katherine Fowkes (2010), Jacqueline Furby and Claire Hines (2012), Karen Lury (2010), Leslie Stratyner and James Keller (2007), James Walters (2011), and Jack Zipes (2011). There is also considerable rise in the examination of individual fantasy films, especially *The Lord of the Rings* trilogy (Jackson, 2001–2003) and the *Harry Potter* films (Columbus, Cuarón, Newell, and Yates 2001–2011).

Although 9/11 may be a contributory factor in the current popularity of fantasy, there are also more fundamental aspects to consider. Many top-grossing fantasies feature charismatic, high-profile stars, including Harrison Ford, Johnny Depp, Keira Knightley, Christian Bale, Morgan Freeman, and Heath Ledger, though Jackson's *The Lord of the Rings* and the *Harry Potter* films were responsible for generating stars rather than being vehicles for them. In addition, the most successful film of all time, *Avatar* (Cameron, 2009) is dependent on fabricated, computer-generated characters and sublime, fictionalized landscapes. In this respect, *Avatar* highlights one obvious cause for fantasy's domination, as Friedman suggests—that of technological innovation. Yet, Spielberg's film *Indiana Jones and The Kingdom of the Crystal Skull* (2008), whose claim for a low computer-generated imagery (CGI) content was a distinctive feature of its marketing strategy, is also listed as one of the top box-office performers, suggesting that the attraction of spectacular digital effects may not be solely responsible for fantasy's status. Of course, as with many recent fantasy franchises, it was the latest in the *Indiana Jones* sequels and therefore had an established market as well as a prominent director in Spielberg. Franchises developed from preexisting literary sources with their cross-generational readymade markets are also obvious targets for exploitation by the film industry. In fact, film franchises deriving from multipart novels dominate box-office ratings, which include *Harry Potter* (Rowling, 1997–2007), *The Chronicles of Narnia* (Lewis, 1950–1955), and *The Lord of the Rings* (Tolkien, 1954–1955). Alternative sources for fantasy films comprise those adapted from the *Marvel Comics,* whereas the *Pirates of the Caribbean* series was initially based on a Disney theme park ride, though its most recent incarnation, *On Stranger Tides* (Marshall, 2011), is inspired by a novel of the same name (Powers, 1987). In relation to commercial strategies and technological advances, David Butler draws attention to other marketable aspects of the fantasy film that target family audiences and hence increase revenues (Butler, 2009: 5–6). To this end, many fantasy films have a PG or PG-13 rating. Certainly, Peter Kramer

sees the drive toward family-orientated entertainment as an initiative that is aimed at capturing the baby-boomer generation (2006: 275).

Thus, one must assume that a complex range of interrelated commercial, sociocultural, and technological factors has brought about the recent success of fantasy. In addition to these aspects, this book suggests that the performance of fantasy in box-office ratings since 2001 implicates a further contributory dynamic—its capacity to address or rearticulate collective anxieties and traumatic histories. Douglas Kellner alludes to this when he states:

> Film creators tap into the events, fears, fantasies and hopes of an era and give cinematic expression to social experiences and realities. Sometimes the narratives are contrived to represent political figures and events of the era [...] Sometimes, however, films provide indirect commentary and critique of their social and political contexts. (Kellner, 2010: 4)

In an earlier book, Kellner (together with Michael Ryan) also observes that "detachment from the constraints of realism allows fantasy to be more metaphoric in quality and consequently more potentially ideological (1988: 244), pointing to the reasons why fantasy has succeeded where realism has not. Furthermore, though filmmakers may not consciously reinterpret films' contemporary contexts, they may nonetheless chime with audiences in respect of associations generated between themes, characters, and settings and the circumstances of their release. This may be the case with *Harry Potter and the Philosopher's Stone* (Chris Columbus) and *The Lord of the Rings: Fellowship of the Ring*, which were released immediately after 9/11 (and therefore mostly filmed before 9/11), although Kathy Smith suggests otherwise. Pursuing a claim for fantasy as escapism, she contends that "in the wake of the realization of events previously confined to disaster movies, the global audience looked for a different kind of fantasy into which to escape, a 'guaranteed' fantasy, the reality of which was securely beyond imagination" (2005: 69–70). Fantasy, as Katherine Fowkes (2010) tells us, constitutes a genre that audiences perceive as a substantial deviation from reality.

Accordingly, Smith's comment suggests that there is relief inherent in the fantasy genre. While some of the films discussed here do have lighthearted, romantic, or comic elements, and initially appear to deviate from their twenty-first-century contexts, many are dark and nihilistic and invariably espouse a subtext of death. These images and themes of mortality arguably reflect a somber post-9/11 milieu of terrorism, recession, and impending environmental catastrophe, with many scholars and writers observing a general "darkening" of film and a prevailing mood of pessimism. Such qualities therefore seem incongruous with Smith's remarks. This is not to say

that dark films are a wholly recent phenomenon. Indeed, they have con-
stantly reemerged in film history and have captured the imagination of
audiences experiencing traumatic events before 9/11. For example, Stella
Hockenhull (2008) argues that the wartime films of Michael Powell and
Emeric Pressburger assumed neoromantic tendencies and suggests that these
(mostly dark) aesthetic nuances offered solace to audiences contemporary to
the time of their release. In a similar vein, the noir films of the 1940s and
the 1950s emerged from the political instabilities of the Second World War
and the Cold War (Spicer, 2002). I am not suggesting here that the darkness
of post-9/11 fantasy is analogous to noir but, rather, that it—in association
with the various other reasons already discussed—similarly encapsulates the
contemporary zeitgeist.

Indeed, in line with Kellner's observations, these post-9/11 fantasies
commonly impart mediations of 9/11 and the war on terror, explicitly (as
in *Iron Man* (Favreau, 2008), *Iron Man 2* (Favreau, 2010), and *Avatar*, or
more obliquely (as illustrated by *The Dark Knight* (Nolan, 2008), and *The
Kingdom of the Crystal Skull* (Spielberg, 2008)). In fact, themes of death
and violence dominate *The Dark Knight*, itself the twelfth-highest grossing
film of all time,[1] the film containing unequivocal visual and thematic allu-
sions to 9/11 and terrorist action. Similarly, each of the *Harry Potter* films
commanded high box-office figures, yet their entire underpinning theme is
persistently one of death, with repeated visual resemblances to 9/11. *Avatar*,
currently the highest-grossing film of all time, contains obvious analogies
with the war on terror, particularly in relation to preemptive attack, the
Iraq Wars, and "oil" as a motivating factor. Though its emphasis lies on a
condemnation of the American military, which causes the death of innocent
"civilians" on the fictionalized planet of Pandora, its other dominant mes-
sage is one of environmental catastrophe. A further way in which fantasy
films may be meaningful to audiences is in their inadvertent reflection of
contemporaneous events, which elicit spectator cognition through associa-
tions and intertextuality rather than through overt resemblances. Therefore,
though many of these films illustrate an increasing Easternization of val-
ues in their qualities of magic and spiritualism, while also depending and,
indeed, at times reflecting on technology and nature, their engagement,
conscious or otherwise, with themes and imagery connected to their new
millennial contexts, raises other possibilities concerning their meaningful-
ness and popularity.

Although there is already general recognition that literary fantasy and
fairy tales provide consolation, escapism, and recovery (Zipes, 2002: 163),
Bruno Bettelheim claims that "the fairy tale [. . .] confronts the child squarely
with the basic human predicaments" (1991: 8). In this respect, Bettelheim
observes how "as the story begins, the hero is projected into severe dangers"

(1991: 145), indicating an element of threat to the protagonist. In a similar vein, one might suggest that post-9/11 fantasies also offer viewers "safe" ways to subconsciously reenact, or work through anxieties and traumatic memories for those reluctant to witness more realistic filmic accounts of the actual event of 9/11. David Butler implies this when he notes, "For Freud [...] fantasy was a psychic process and one related to the repression of traumatic memories. Fantasy constructs were a means of negating or soothing the pain of the past" (2009: 13). Fantasy films may also enable viewers to address or acknowledge issues arising from the subsequent war on terror, for example, revelations about abuse of detainees at Guantánamo Bay, Bagram, and Abu Ghraib, and the failure to find weapons of mass destruction (WMD) in Iraq. Movies such as *Pan's Labyrinth* (del Toro, 2006) and *The Chronicles of Narnia: The Lion, the Witch and the Wardrobe* (Adamson, 2005), which are set against a backdrop of war, may function in comparable ways, allowing audiences that are experiencing the current war on terror to find a connection with a fictionalized wartime setting. Roger Luckhurst suggests this when explaining the concept of "multidirectional memory," whereby "we frequently understand one instant of historical trauma through another" (2010: 18). Drawing on Michael Rothberg's (2006) account of multidirectional memory (emerging in relation to the 1954 to 1962 Algerian War and the Holocaust), he contends that "*Pan's Labyrinth* is watched [...] through the filter of Iraqi occupation" (2010: 18), similarly providing an instance of the "overlap and interference of memories [that] help constitute the public sphere" (Rothberg, 2006: 162). Such an overlap is further discernible in *The Kingdom of the Crystal Skull*, its Cold War and atomic bomb scenarios, conveyed in 9/11 analogies, also harnessing historical and contemporary violence, whereas the World-War militarism that characterizes Tolkien's epic *The Lord of The Rings* speaks to contemporary audiences in the post-9/11 contexts of Peter Jackson's cinematic adaptation. It is also possible that those who witnessed traumatic events before 9/11 (such as the Vietnam War or World War Two), may engage with post-9/11 fantasy narratives in a parallel manner, thereby reliving their earlier experiences through contemporary mediations of conflict.

SPECTACLE AND MEMORY

In articulating 9/11 as traumatic event, fantasy film does not always utilize trauma cinema's conventional visual vocabulary, such as the flashback, (though this does arise in several films examined here), nor does it necessarily deploy the typically harrowing narrative. More often, deriving from its quality of being "substantially beyond reality" (Fowkes, 2010), the post-9/11 fantasy film translates terror and anxiety into various forms of spectacle.

Certainly, a large-scale study conducted by Martin Barker and Ernest Mathijs of *The Lord of the Rings* films affirms the significance of spectacle to viewers, with Mikos *et al.* indicating that in viewers' responses to the movie experience and their involvement, the "most often mentioned attributes were 'spectacular', 'emotional', or 'gigantic experience'" (2008: 121). The nature of spectacle offers a way of dealing with responses to terror through the concept of the "arresting image," which, according to film scholar Barbara Klinger (2006), has the capacity to mobilize spectator emotion. Spectacle, channeled though the arresting image, may also serve to fetishize terror, in the way that it simultaneously draws attention to loss while disguising it (Elsaesser, 2001: 200). Cinematography and framing are often vital to the 9/11 connotations of such images. For example, circling helicopter shots of burning edifices might remind viewers of similar views of the smoldering Twin Towers. Low angle perspectives may also heighten the anxiety induced by an image. For Klinger, the "arresting image" (2006: 24) marshals spectator emotion through its associations and is thus an important concept in considering how post-9/11 fantasy narratives may operate. Klinger describes how "arresting images are often generated by juxtaposing incongruous elements" (2006: 30), thereby conferring a surreal quality on them, while the pace of the narrative tends to slow down. The sequence may undergo additional temporal distortion through the deployment of slow-motion editing. The very nature of fantasy lends itself to such surreal juxtapositions, particularly evident in, for example, *Pan's Labyrinth* and *Avatar*—while spatial and temporal distortion is a distinctive feature of many of the films considered here. Through the network of associations that Klinger describes, the singular arresting image or sequence may encapsulate entire events, evoking the emotion of their broader context. Thus, although scenes of falling bodies might specifically remind us of those falling or jumping from the Twin Towers, they do not exist as an isolated memory but summon the greater catastrophe of 9/11.

Moreover, the spectacle engendered by the arresting image may take diverse forms and, in some instances, occur through a manipulation of cinematography, editing, and mise-en-scène to produce, what Geoff King determines as an "impact aesthetic." In these cases, "cuts tend to be made on movement, particularly the movement of the fireball, and serve to magnify its impact" (King, 2000: 94). In addition, the "impact aesthetic" involves "pace and motion towards the camera" (2000: 101), while these shots usually "[intercut] with other images in which the dynamic of the impact is more lateral, across the screen rather than towards it" (2000: 101). King identifies further common factors in this type of explosive editing, which he locates predominantly in the action film. These include the use of the fireball, which "has the virtue of being clearly visible. Bullets and other weapons

can be slowed down, but to do so more than fleetingly is to risk losing the vital element of pace" (2000: 102). Although he attributes this type of aesthetic to the action film, he also acknowledges that large-scale spectacular images demand a more lingering, slower-paced cinematographic approach. In these cases, the action spectacle unfolds in long shot, thereby inviting a contemplative gaze (King, 2000: 97). As King suggests of such spectatorship, "the pleasures offered might include a sense of being taken beyond the scale of everyday life to something suggesting a grandeur, an awe, or a sense of the sublime, even if a format such as blockbuster cinema might offer a rather debased and commercialized version of such an experience" (2003: 118). Typically, impressive landscapes engage such contemplation (e.g., the panoramic vistas of *The Lord of the Rings*, or *The Kingdom of the Crystal Skull*), where spectacle may also present as the terrifying sublime, provoking a combination of fear and awe in the spectator (Burke, 1998). In other cases, it may take the form of abject horror (Kristeva, 1982), instilling a sense of disgust and revulsion in the viewer. The abject spectacle too manifests diversely, materializing as the decaying corpse, the monstrous-feminine, and the violated body, each of these being capable of eliciting a sense of fascinated horror. The magical, spiritual, or digital display is also pervasive in the fantasy film, these often being interrelated since magical and spiritual effects are usually created by digital means. On occasion, technology itself is the source of spectacle—therefore, fantasy films not only depend on technological innovation but may also highlight technology as spectacle. This is especially true in the case of *Avatar*, *The Dark Knight*, *Iron Man*, *Iron Man 2*, and the *Potter* series.

Aylish Wood's thesis of "timespaces" is salient here, whereby she discusses the nature of digital spectacle in connection to setting and its impact on narrative progression. In contrast to dominant theoretical perspectives on spectacle (which claim that spectacle arrests narrative flow entirely), Wood contends that certain types of spectacle can introduce a spatially bound progression to the narrative, an effect that digital enhancement may heighten. She points out that "digital effects produce spaces with the ability to transform, or which have a temporal quality, thus adding an extra dimension to the narrative progression" (2002: 371). According to Wood, CGI effects achieve this because they can "lengthen the time that spectacular elements remain convincing before drawing attention to themselves as illusions" (2002: 372). Alternatively, "digital effects [...] when they [...] give extended movement to spatial elements, introduce a temporal component to space" (2002: 372). In short, Wood suggests that digitally enhanced spectacle can produce a temporal effect in certain spatial scenarios, thereby collapsing the space-time distinction and manipulating the temporality upon which narrative coherence is conventionally predicated. Wood designates

these temporally extended special-effects spaces as "timespaces" (2002: 374). She further subdivides "timespaces" into dynamic and nondynamic categories, where "the ability to create dynamic spatial elements with a temporal quality through digital effects is most obvious in images where normally inanimate spaces literally become mobile. This is a device frequently found in fantastical films where portals open into other dimensions" (2002: 375). Examples of "timespaces" thus abound in the films examined here and might include Harry Potter's (Daniel Radcliffe) passage through a seemingly solid brick wall in *The Philosopher's Stone*, the disappearance of the spaceship at the end of *The Kingdom of the Crystal Skull*, and the journey to the afterlife in *Pirates of the Caribbean: At World's End* (Verbinski, 2007). Nondynamic elements, on the other hand, remain in the background and have less of a temporal effect. Thus, certain digital effects may construct "timespaces" that function in similar ways to "arresting imagery," though they are not mutually exclusive (since they both extend narrative time), and the creation of a "timespace" may compound the effects of, or be integral to, the arresting image. For example, the Ringwraiths' attack on Frodo (Elijah Wood) in *The Fellowship of the Ring* involves digital effects to construct a surreal sequence and slow motion to create a dreamlike dimension that is distinct from the rest of the narrative. Spectacular spaces may also gain agency in their intertextual references that further invite vicarious traumatic associations corresponding with Luckhurst's premise of multidirectional memory (2010).

Characterization too is relevant in provoking memory of and associations with 9/11 and the war on terror. Fantasy characterization has an intrinsic capacity to articulate concerns about terrorism through the "other," reconfiguring the terrorist figure as technological, abject, genetic, cybernetic, or action spectacle (*The Dark Knight's* Joker, the *Harry Potter* series' Voldemort, and *Iron Man 2's* drones being obvious examples). In the films examined here, the terrorist also takes the more stereotypical form of Eastern European or Middle-Eastern character. Alternatively, threat is marshalled by the monstrous or deformed "other" (as in the *Pirates of the Caribbean* series). In fact, fantasy film has a particular propensity for representing difference as terrifying, alien, or fantastic, for, as Rosemarie Garland-Thomson observes, "The presence of the anomalous human body, at once familiar and alien, has unfolded [...] within the collective cultural consciousness into fanciful hybrids such as centaurs, griffins, satyrs, minotaurs, sphinxes, mermaids and cyclopses" (1996: 1). Sometimes, the "other" is unstable and refuses to take a coherent form (e.g., Voldemort in the *Harry Potter* films and Sauron in Jackson's *The Lord of the Rings*), resonating with perceptions of the terrorist as intangible and unknown. In this respect, fantasy films unconsciously enable audiences a visualization of the otherwise anonymous terrorist "other."

FANTASY NARRATIVE AND 9/11

Films in general have potential for emotional impact and catharsis in their narrative forms. As Carl Plantinga (2009: 83) explains, their narratives deploy stock emotional paradigms, fantasy's inclination toward "good overcoming evil," offering an ideal template on which to map contemporaneous anxieties about terrorism. Plantinga also notes that the conventional narrative structure of "order, disorder and order restored" facilitates feelings of emotion through disturbance of the initial stable dynamic, followed by resolution of the disturbance, which affords closure and thereby offers some relief (2009: 93). In this way, the realm of fantasy, in contrast to real life, usually enables a sense of resolution, if not necessarily a "happy ending." Moreover, anxieties connected to wartime scenarios unfold through the protagonist's negotiation of certain spaces and threatening territories within the fantasy film. Such negotiation usually takes the form of a quest (*The Lord of the Rings* is a typical example) or a morality test, which is often borne out through resolving identity crises and the constitution of coherent subjectivities. In relation to parallels with 9/11, this may translate into a mission to overcome an evil figure, reflecting the search for Osama bin Laden (e.g., Voldemort in the *Harry Potter* series or the White Witch in *The Chronicles of Narnia: The Lion, the Witch and the Wardrobe*). Alternatively, the quest may reestablish (or even reject) American unity and identity (as in Jake Sully's (Sam Worthington) transformation in *Avatar*), whereas the passage through fantastic spaces may align territories with specific groups and their accompanying threats (thereby chiming with audiences in relation to boundary security). The visual and narrative capacities of fantasy films are therefore intrinsically amenable to mirroring twenty-first-century insecurities.

TRAUMA AND MEMORY

In considering the relationship between visual media, 9/11, and trauma, the fact that worldwide audiences witnessed events as they actually unfolded, undeniably sustained an immediate collective emotional response, mediated by traumatic imagery, as well as widespread traumatic effects.[2] I do not suggest, however, that the visual content of the post-9/11 fantasy film reevokes trauma in its audiences (although it may do so in predisposed, already traumatized individuals), or even conscious emotional response. Rather, it may stir unconscious emotional or traumatic memory[3] because isolated fragments of 9/11 footage are ingrained in the minds of older viewers who witnessed them the "first time round." As Plantinga claims, "It may be in certain cases, film-elicited emotions are caused by memory traces,

learned associations, emotional contagion [...] More often, however, such stimuli serve as intensifiers or enablers of emotion, rather than objects of emotions" (2009: 76). Drawing on the work of Roger Brown and James Kulik, Richard McNally refers to a similar scenario of traumatic narratives that remain fixed in the viewer's memory, describing this as "flashbulb memory" (in McNally, 2003: 54). McNally notes how images that provoke strong affective responses persist vividly in memory and that those who experience such memory can remember exactly what they were doing at the time of the initial traumatic event through a "quasi-photographic neurophysiologic mechanism that imprints the sensory details of the reception context in memory" (2003: 54). He continues by claiming that flashbulb memories have strong connections to mediated forms of memory. In the case of constantly replayed 9/11 footage, arguably, an element of "learned association" and "emotional contagion" is at play (Plantinga, 2009: 76). As Baudrillard similarly notes of 9/11 footage, "What stays with us, above all else, is the sight of the images. This impact of the images, and their fascination, are necessarily what we retain, since images are, whether we like it or not, our primal scene" (2003: 26). The very nature of fantasy film means that it is impossible to integrate such potent flashbulb images fully—they remain visually discrete, essentially inassimilable, belonging instead to historic and traumatic reality. In addition to its portrayal as spectacle, 9/11 imagery in fantasy film thus operates in two ways. First, its fragmented nature simulates the way that traumatic memory revisits the mind. Second, the punctuated nature of these fictionalized images causes them to stay with us for longer. Like McNally, Susan Sontag notes, "Nonstop imagery [...] is our surround but when it comes to remembering, the photograph has the deeper bite. Memory freeze-frames; its basic unit is the single image" (2004: 19).

Thus, on one level, images may conjure clear recollections of 9/11 for the spectator through the concept of flashbulb memory (though these may diminish with time). For such audiences, flashbulb memory, which has been induced by these films, may merely prompt contemplation or otherwise resurrect a range of feelings, including those of grief, shame, incredulity, and still, over a decade since, a feeling of disbelief and horror. In more extreme cases, there may be a painful reliving of traumatic experience.

At other times, less specific imagery may cause a more diffuse emotional response, generating associations and pervasive memories through Klinger's notion of the arresting image and Luckhurst's model of multidirectional memory. For some of those individuals who either directly witnessed the collapse of the Towers at close proximity or undertook military duty, and for others who may have endured vicarious emotional disturbance or trauma through mediated images (though there is debate concerning the possibility

of this),[4] the ameliorated form of fantasy representation may provide a means to safely access such trauma.

The often-detached and spectacular nature of 9/11-associated visuals in fantasy film, isolated as singular striking moments or as more protracted arresting imagery, has a direct bearing on its role in remembering trauma and traumatic memory. Although some scholars discuss traumatic memory as suffering terror (Kaplan, 2005), others center on its more profound effects of long-term incapacitation. Central to the latter is the unassimilated nature of the original event. As trauma theorist Cathy Caruth explains, "Trauma is not locatable in the simple violent or original event in an individual's past, but rather in the way that its very unassimilated nature—the way it was precisely *not known* in the first instance returns to haunt the survivor later on" (1996: 4). This inability to assimilate traumatic events causes the traumatic memory to replay repeatedly as flashbacks and hallucinations. In other cases, there may be complete avoidance of thoughts concerning the original trauma or, alternatively, trauma may manifest as hypervigilance (Luckhurst, 2008: 1). This collection of symptoms forms the basis for diagnosis of posttraumatic stress disorder (PTSD), a term coined in 1980 by the American Psychological Association.

Since then, work on trauma has intensified, often looking back to Freud's explanation of reactions to stress, but also, as in the case of Caruth (1995, 1996), discussing narrative's engagement with trauma (both filmic and literary) and the function of literature in testimony (Shoshana Felman and Dori Laub, 1992). Subsequently, the trauma debate has broadened to consider more specifically the relation between visual media and trauma, with *Screen* Journal (2001) including a special issue debating the subject. While certain aspects of this debate are outside the remit of this book, it illuminates several points relevant to fantasy film. First, Thomas Elsaesser (2001: 196) identifies the value of narrative as a means of witnessing trauma, and the importance of media in that role. Second, Elsaesser's (2001: 197) observation that traumatic events link several temporalities pertains to the way that imagery from 9/11 materializes within a different time, context, and place in film. Third, Elsaesser aligns trauma with fetish through its relationship to absence. This is relevant in the way that spectacle in fantasy film serves a similar fetishistic function. By this, I refer to the way that spectacle draws attention to real traumatic events (often by the death of characters and the destruction of buildings) but simultaneously disavows them, partly because of fantasy's implausibility, but also through the pleasurable experience of its aesthetic display. In his discussion of spectacular narratives, Geoff King implies an analogous concept when he describes how "the fireball appears to be a burst of pure energy and intensity" (2000: 103), attributing the "abundance [...] of objects [...] consumed in flames" to be a "substitute for the scarcity that

dominates real life for many people" (2000: 103). In a similar way, it is pos-
sible that spectacle, whether abject, sublime, or action-orientated, simulta-
neously highlights and disavows loss associated with 9/11.

Maureen Turim's contribution to the *Screen* debate also focuses on the
flashback. Whereas fantasy narratives are not prone to flashbacks (though
they do occur), the short sequences of 9/11-related imagery that emerge in
post-9/11 films effectively function as flashbacks for some spectators. Since
the *Screen* debate, Roger Luckhurst (2008) has further elaborated on the
flashback, describing how the "brutal splicing of temporally dis-adjusted
images is the cinema's rendition of the frozen moment of the traumatic
impact: it flashes back insistently in the present because this image can-
not yet or perhaps ever be narrativized as past" (2008: 180). Work by
E. Ann Kaplan (2005) is relevant here too because she centers on the role of
visual media in vicarious memory, suggesting that most people experience
trauma through mediated forms rather than first-hand (2005: 2). Kaplan's
claims are important to this book in several ways: first, she posits that "tell-
ing stories about trauma, even though the story can never actually repeat or
represent what happened, may partly achieve a certain 'working through'
for the victim. It may also permit a kind of empathic 'sharing' that moves
us forward" (2005: 37). Second, she contends that "the reader or viewer
of stories or films about traumatic situations may be constituted through
vicarious trauma" (2005: 39). Although Stephen Prince disputes this latter
possibility, he does accede that "by framing the events according to various
narrative and emotional templates, films offer a means of explaining and
understanding them and a form of closure on them" (2009: 13).

EMOTION, TRAUMA THERAPY, AND CINEMA

Although I suggest that fantasy film addresses distressing or traumatic
memory through spectacle, it may function or have the potential to func-
tion in other ways that concern the recall or alleviation of trauma. Several
interventions for the treatment of PTSD[5] rely on reintegrating the traumatic
event, often through reexposure and renarrativization. Francine Shapiro
(1995) also describes a technique known as eye movement desensitization
and reprocessing (EMDR). Here, a patient tracks the lateral movement of
a rapidly moving finger while recalling traumatic memory. The effect is to
reprocess the isolated traumatic memory. Arguably, the tendency for fantasy
film to involve fast-paced cinematography in its action sequences (evident in
most of the films examined here), specifically encourages lateral tracking eye
movements. This type of cinematography often occurs in filmic narratives
at times when threat is imminent, such scenes therefore closely relating to
terror and associated traumatic memory.

The renarrativization of imagery related to 9/11 and the war on terror has potential to address traumatic memory in relation to the concept of "working through" that Kaplan (2005) suggests. This is the basis for regression analysis where patients undergoing hypnotherapy recall unpleasant memories. Alternatively, cognitive behavior therapy, which involves fear reversal, "exposes the [trauma victim] to the feared stimulus" (Bouton and Waddell, 2007: 42), albeit in a reduced form. Conversely, narrative exposure therapy aims to resituate the traumatic event in the past by the construction of narratives that redefine the traumatic occurrence in relation to other life experiences (Kirmayer *et al.*, 2007: 15). Whereas filmic narratives are clearly unable to replicate psychotherapeutic strategies, arguably, the isolation offered by the darkened cinema, and the rewatching of past events in a safe environment (and ameliorated form) may have some potential to address prior traumatic events. Screen theory of the 1970s and the 1980s described the hypnotic effect of watching film during which the spectator assumes a trancelike state and was indebted to theories of psychoanalysis, upon which scholars, including Christian Metz, Laura Mulvey, and Jean-Louis Baudry drew (see Braudy and Cohen, 2009). Although spectator studies have since dismissed the concept of an entirely passive viewer, this model still provides an avenue through which to postulate film's emotional effects. In various ways, the cinematic experience may thus afford opportunities for the emotional energy surrounding these traumas to be released. Indeed, eliciting emotional affect is an overriding intention of narrative film generally.

As Carl Plantinga (2009) claims, "If films approximate conscious experience like no other medium, they do so also in their ability to elicit emotional responses to that experience" (2009: 49). He goes on to say that such emotions often result from "memories and associations that the viewer brings to the film" (2009: 75), which may intensify the emotional impact of the narrative itself. Certainly, there is scientific evidence that empathic emotion, which is generated by watching another person undergo suffering, may trigger emotion in the viewer. As Jody Osborn and Stuart Derbyshire note, "Observing another person in pain, or knowing that a loved one is in pain, activates brain areas known to process the emotional qualities of pain" (2009: 268). Although fantasy film does not always engender overt emotional response (as compared to the melodrama for example), Plantinga's analysis of narrative structure (as discussed earlier) describes how each segment elicits different kinds of emotion. Thus, the restoration of order in the fantasy film narrative may offer closure, especially when it culminates in the capture of the terrorist other—the final film of the *Harry Potter* franchise is meaningful in this respect, its release, involving the killing of Voldemort, occurring shortly after the death of bin Laden. Extending Plantinga's argument, arguably, the tendency toward sequelization accentuates the effects of

narrative segmentation. In other words, the prolonged identification with characters over the course of the franchise may enhance emotional affect. The *Harry Potter* series is a useful example, since the films extended over ten years, literally allowing younger audiences to grow up with the characters. The finale then, whereby good overcomes evil, and for older audiences, which reiterates the death of bin Laden, inevitably carries an accumulated weight of emotional identification. This cumulative "franchise" effect is evident in Barker and Mathijs's study of *The Lord of the Rings* (2008) whereby emotional register was an important component of fans' responses to the final film, *The Return of the King*. For example, in light of viewer comments, Sue Turnbull suggests that the affective experience of *The Lord of the Rings* films "might derive from [...] the actual duration" (2008: 187). This affective aspect may be a potentiating factor in the success of franchises more generally. The responses to the survey that indicated emotion as a significant part of the trilogy also raise significant points regarding the claims of this book, namely, that fantasy provides a means to address anxiety and trauma. As Turnbull further notes, "As many of the participants in this study revealed, feeling terror and sadness, supposedly negative emotions, were part of the very real enjoyment of *RotK*" (2008: 185).

Plantinga considers the cathartic potential of negative emotions that have been generated by films, arguing that the reframing of these emotions to produce pleasure also enables a "working through" (2009: 179). This notion of "working through" relates to my observations concerning renarrativization where spectacle reframes the emotions generated by 9/11 and the war on terror. Indeed, as King contends, "The pleasures of spectacle do not exist in isolation. They gain their resonance from a location within cultural formations and discourses that often take a narrative form" (2000: 162). However, my argument varies from that of Plantinga because the fantasy film inherently lessens the rawness of the initial traumatic event (whereas, for example, the reframing of the sinking of *Titanic* as spectacle may not). Arguably, fantasy therefore provides reexposure, akin to some trauma therapies, in a way that mitigates as well as "reframes" trauma. Yet, as Klinger claims, "[While the arresting image] serves as a focal point for emotions, this image does not typically prove sure resolution or catharsis" (2006: 24). What is salient here is Klinger's claim that "arresting images can activate a web of associations in the viewer that indicates the pervasive role of intertextuality [...] [including] those connections forged from the viewer's personal and cultural experiences" (2006: 24), thereby initiating a means to address distressing memory.

Related to this claim are certain psychotherapeutic contentions concerning film, the first by Ryan Niemiec and Stefan Schulenberg, who indicate that watching films about death may have a positive impact on those facing

mortality (2011). They posit that "movies provide a medium for facing death as the viewer identifies with characters and follows a story and, at the same time, can provide an avenue for escaping death because the viewer knows these are just actors on a screen" (Niemiec and Schulenberg, 2011: 388). Schulenberg further outlines the value of films in clinical psychotherapeutic practice and highlights certain elements that are relevant to the claims of this book. He draws attention to several studies involving film, concluding that

> the implication of these contemporary analyses of, and references to, films is that the importance of movies extends beyond their entertainment value.... There is growing literature suggesting that movies have therapeutic value for clients/patients [...] with [their] appeal being universal themes and [their] function as a means for clients to view their problems from a comfortable distance. (Schulenberg, 2003: 36)

Niemiec and Schulenberg's line of reasoning therefore converges with this book's overall premise. Such discussion invites further empirical analysis regarding the potential of fantasy film in alleviating trauma and anxiety in a way that combines psychotherapy and film theory to provide explanations beyond suggestions of mere relief or escapism.

In general, therefore, this book examines post-9/11 fantasy films and considers their commercial success in relation to spectacular and arresting imagery, especially through their projection of 9/11 and other intertextual associations. It also analyzes how themes and narratives contribute to an articulation of post-9/11 anxieties. Alternatively, as in the case of *Pan's Labyrinth*, *The Kingdom of the Crystal Skull*, and *The Chronicles of Narnia*, it suggests that films that are set in periods of war or political turmoil resonate with current audiences. Each chapter features a discussion of individual fantasy films, selected because of their post-9/11 release and their commercial success and/or critical acclaim. This book engages with a range of theoretical and critical works relevant to a discussion of fantasy, war, and trauma, while also drawing upon the work of other studies germane to the topic. Rather than contesting the boundaries of the genre, as Katherine Fowkes (2010) has already done, or providing a historical overview of the genre, it takes its limits of fantasy to include fantastic films that are, as Fowkes asserts, "substantially beyond reality." Thus, my main focus is fantasy films released since 2001 and the influence of their post-9/11 context on their themes, visual style, and narrative structure.

Beginning with *The Lord of the Rings* trilogy, I chronologically chart fantasy films produced in the post-9/11 period, firstly illustrating how Jackson's adaptation of Tolkien's epic is analogous with the Bush Administration

through its persistent militarist tendencies. For, although Tolkien wrote the novel in the 1950s, inflecting it with his wartime experiences, these readily translate to the films' contemporary milieu. Indeed, Jackson's trilogy often visually exaggerates scenes of conflict, death, and bloodshed. In addition, this chapter examines the films' distinct visual emphasis on spectacles of death, decay, and abjection. It further argues that the trilogy's focus on the notion of the Shire and the traversing of other landscapes reflects twenty-first-century anxieties of infiltration into home and national territory, transforming familiar and sublime spaces into sites of anxiety.

The year 2001 was also important for the first *Harry Potter* film. The second chapter explores how the subsequent *Potter* films, often noted for their increasing darkness, become more politically inflected and cognizant of 9/11 imagery. Analyzing scenes that demonstrate how the films repeatedly replicate the destruction of the Twin Towers, this chapter further points to the allusions to terrorism, torture, and PTSD, which become increasingly pervasive throughout the series.

In a different vein, the *Pirates of the Caribbean* series (2003–2011), perhaps more so than any other film or franchise discussed here, provides humor and has the least recognizable 9/11 imagery. Narratively, it is set in a time removed from the new millennium and, while lacking scenes of US militarism and terrorism, conveys analogous aspects through an interpretation of pirates as terrorists. Relying on dramatic CGI effects as well as the spectacular characterization of Jack Sparrow (Johnny Depp), the franchise's essentially lighthearted and comic narrative does have a supernatural, dark undertone. Similar to *The Lord of the Rings* and *The Kingdom of the Crystal Skull*, it also features submerged or subterranean spaces with persistently abject connotations of death and decay, and there are isolated instances where its imagery distinctly resembles the Twin Towers' collapse.

In chapters four and five, I refer to Karen Lury's (2010) analysis of the child in film to examine *The Chronicles of Narnia* (2005–2010) and *Pan's Labyrinth*. Referring to *Pan's Labyrinth*, among other films, Lury examines the way that the child influences how war narratives unfold. She argues that the child's presence allows filmmakers to produce a different perspective on war and to articulate the trauma and experience of conflict through disjointed, atemporal encounters that do not necessarily reflect the chronologically accurate unfolding of events. In part, Lury's argument rests on the "child's apparent inadequacy in relation to language," which leads to a "stuttering temporality" (2010: 7). Lury's points are salient to *Pan's Labyrinth*, which deploys fairytale iconographies and temporal discontinuities. Such fracturing of temporalities may also reflect the chronological disruption caused by warfare, where instances of bombing, evacuation, and violence lead to disjointed realities as well as to traumatic psychological ellipses.

Inevitably, therefore, chronological rupture correlates closely with spatial disruption. Indeed, such parallel worlds insistently pervade *Pan's Labyrinth*. Moreover, anxieties connected to such scenarios unfold through the negotiation of these spaces, which invariably appear dark and abject. Their surreal quality and atemporality has intertextual associations that may provoke meaning for a post-9/11 audience in the context of "multidimensional memory" (Luckhurst, 2010).

Indiana Jones and the Kingdom of the Crystal Skull was the fourth installment of the *Indiana Jones* franchise, and while seeming unrelated to twenty-first-century terrorism, like *The Lord of the Rings* trilogy, its themes, imagery, and narrative may resonate with post-9/11 audiences in several ways. Primarily, the film resurrects the threat of nuclear holocaust and the Cold War, locating the "other" in Soviet Russia and reconfiguring evil in the character of Irina Spalko (Cate Blanchett). In contrast to films such as *Avatar*, it is consciously antitechnological, yet there are sublime sequences that profoundly echo 9/11 imagery. In addition, its two central visual tropes include underground abject spaces that contain dead, decaying corpses, and extended chase sequences that veer precipitously on or over the edges of high cliffs, and culminate in spectacles of destruction. Like *Pan's Labyrinth* and *The Lion, The Witch and The Wardrobe*, which are also set in wartime, this film, in expounding a Cold-War scenario, may chime with audiences experiencing a parallel threat. Engaging with concepts of nostalgia and the sublime, this chapter thus draws parallels between 9/11 and the film's vision of the Cold War, identifying specific sequences that might be meaningful to post-9/11 audiences.

In chapter seven, I examine *The Dark Knight* (2008), arguing that it establishes 9/11 and the war on terror at its core. Its nightmarish vision of the Joker (Heath Ledger) and his displays of unpredictable and destructive behavior suggest his capacity as an agent of chaos. In addition, both cinematography and mise-en-scène continually operate to signify aspects of 9/11. This chapter therefore interrogates *The Dark Knight's* mediation of traumatic memory through its themes of terrorism and chaos. Engaging theoretically with Jean Baudrillard's *The Spirit of Terrorism* (2003), I argue that the film exemplifies his arguments in relation to terrorism and 9/11, chiefly through the characterization of the Joker, but also in its visual iconography and narrative trajectory.

The final two chapters explore aspects of 9/11 and the war on terror that manifest in the *Iron Man* series and *Avatar* either through expressions of the technological sublime or through the "impact aesthetic." With its affinity for the latter, as well as its setting in Bagram, a site of one of the controversial detention camps for suspected terrorists in the immediate post-9/11 period, *Iron Man* also comments on collateral damage, corrupt politics, and the

supply of weapons to terrorist groups by the United States. Conversely, the sublime mise-en-scène of *Avatar* persistently mediates an aesthetic of terror and awe in its surreal imaginary landscapes, technological aspects, and military scenarios, thereby locating terror in its visual forms as well as in its narrative themes. Although it acknowledges colonial and gendered tropes, which form conscious narrative chords, discussion explores the 9/11 allusions that structure *Avatar*'s imagery and themes. Drawing upon studies of the relationship between America, oil, and war (Elden, 2009; Hurst, 2009), this study aligns *Avatar*'s search for "unobtainium" with that of oil and its implications for environmental disaster.

This volume therefore centers on the textual inflections of 9/11 and the war on terror in post-9/11 fantasy films, either through obvious resemblances or through oblique mediations. It identifies aspects of theme, visual style, and narrative structure that may be significant for contemporary audiences in a post-9/11 climate, and that might serve as a way of addressing issues arising from 9/11 and the war on terror, and also deals with traumatic memory and collective anxiety in relation to broader millennial circumstance. Although the study of such films also merits a detailed consideration of their marketing strategies as well as their commercial aspirations, I chiefly focus here on their textual inferences and their post-9/11 contexts, currently relevant because of fantasy's prominence at the box office and its ongoing discursive and scholarly development.

SETTINGS, SPECTACLE, AND THE OTHER: PICTURING DISGUST IN JACKSON'S *THE LORD OF THE RINGS* TRILOGY

THE THREE FILMS COMPRISING PETER JACKSON'S (2001–2003) ADAPTATION of J. R. R. Tolkien's *The Lord of the Rings* (1954) each achieved critical acclaim and commercial success on their release and currently remain in the Internet Movie Database's top 26 of all-time top-grossing films.[1] In total, the 3 films also gained nominations for 30 Academy Awards, winning 17 of them.[2] *The Return of the King* (2003) won all 11 Academy awards for which it was nominated, included Best Picture. The first of the trilogy, *The Fellowship of the Ring,* was released in December 2001 and, together with its contemporary, *Harry Potter and the Philosopher's Stone*, signaled the onset of fantasy's rise to dominance. Undoubtedly, Peter Jackson's cinematic accomplishments derived considerably from the films' source material, thereby accessing ready-made audiences to whom the films were actively marketed (Wasko, 2008), though this also directed inevitable critical attention to the films' differences from their literary origins (Fuller, 2002; Rateliff, 2011). (While some of these deviations from the novel revolved around omissions and alteration of events, another involved the amplification of female roles, which was designed to widen appeal). Indeed, in his claim for an Easternization of the West, Campbell declares that Tolkien was instrumental in "pioneering the turn from realistic to fantasy fiction that has been such a marked feature of popular culture over the last 40 years" (2010: 748). Martin Barker elucidates the extension of the spiritual appeal of Tolkien's novel to the films,

noting that "where Tolkien's books have been long known and have attained a determinate cultural presence, the films attract a distinct following who love them as a form of nonreligious spirituality" (2008: 175). Arguably, the knowledge that readers already had of the dark resonances of the novel, together with Jackson's reputation for gothic horror, suggest that film audiences likely anticipated the sombre tone of the films. Certainly, the trailer for *The Fellowship of the Ring* focuses on the film's darkest elements, rather than on its optimistic features, and mostly incorporates those scenes that conjure disturbing arresting imagery.

The trilogy's plot follows the character of Frodo Baggins in his quest to return a ring, which possesses evil powers, to the site of Mount Doom. Initially, a Fellowship of nine embarks on the endeavor, though eventually only Sam (Sean Astin) accompanies Frodo in completing their mission. Frodo's quest requires him to traverse a series of landscapes, each of which present a challenge and involve threats to survival and compromises to morality. At each of these points, Frodo almost succumbs to the Ring's evil influence, potentially signifying a loss of morality and conscience that are associated with a desire for power. As well as exemplifying Campbell's claim for an Easternization of values in its emphasis on spiritual and magical dimensions and also reflecting on "technology and nature" in its environmental messages, the films' engagement with war and conflict provides opportunities for alignment with 9/11 and the war on terror. This chapter attempts to reconcile these aspects of Jackson's *The Lord of the Rings* trilogy with its commercial and critical profile, suggesting that its spectacles of abject, sublime, and surreal horror unconsciously mobilized spectator emotion after 9/11 through initiating a "network of associations" (Klinger, 2006) in ways that are parallel to the reception of Tolkien's original novel. These associations are akin to Luckhurst's concept of multidirectional memory in that audiences may interpret the films' World War inferences through the lens of the recent war on terror. Jack Zipes's commentary proves illuminating here, where he refers to C. N. Manlove:

> The trilogy came just when disillusion among the American young at the Vietnam War and the state of their own country was at a peak. Tolkien's fantasy offered an image of the kind of rural conservationist ideal or escape for which they were looking (it could also be seen as describing, through the overthrow of Sauron, the destruction of the US). (Manlove in Zipes, 2002: 175)

The resonances of the original novel with audiences of the 1960s may thus find parallels in Jackson's films for contemporary audiences. Certainly, a

number of scholars have already commented on this possibility (Gelder, 2006; Kellner, 2006; Leotta, 2011; Phillips, 2007). Unlike some fantasy films that have intentionally incorporated imagery pertaining to 9/11, it is not possible to construe images from *The Lord of the Rings* films as consciously referencing current events. This is partly because Tolkien's triptych was published much earlier. Moreover, Peter Jackson completed most of the filming for the trilogy before September 2001. Nonetheless, several nuances of the film, such as a series of long shots cutting to low-angle camera perspectives of the firework display in the early scenes of *The Fellowship of the Ring*, elicit inevitable recall of 9/11 events. Here, one firework assumes a plane-like form during its flight, while another explodes into missile-like flames, the onlookers running away and looking upward in fear. Viewers may identify with this scene, as footage of 9/11 constantly featured onlookers running away and looking upward in a similar manner. In addition, several commentators have correlated the novel and films' border awareness and militarism with increased national security measures and the military interventions of the war on terror. It is also feasible that the imagery Tolkien conjured for the postwar reader resonates vicariously with audiences of Jackson's trilogy in relation to its original contexts. By this, I refer to, for example, the interpretation of Gollum (Andrew Serkis) as a concentration-camp victim (Kellner, 2006: 28)—contemporary audiences too are familiar with Holocaust imagery, while his emaciated appearance connotes famine, the ubiquity of media, and internet images (that were unavailable at the time of Tolkien's novel), now making these sights familiar. The figure of Gollum thus elicits emotion from multiple perspectives, the reframing of the novel as film arguably provoking spectator engagement through a broader spectrum of shared global histories than recent commentaries reveal. Here I explore other implications for post-9/11 audiences, primarily through the notion of abject spectacle, which, on the one hand, generically relates to Frodo's quest (for subjectivity), and on the other, activates links with mortality, warfare, and infiltration. Referring to Kristeva's concept of abjection (1982), Carl Plantinga's discussion of disgust (2009), and Klinger's notion of the arresting image (2006), this chapter thus connects instances of abject spectacle narratively with Frodo's subjectivity and aligns them with postmillennial anxieties for audiences who, only eight weeks before the first film's release, had witnessed first-hand the effects of terror and violation. It considers these in relation to the films' other aesthetics of surrealism and the sublime, which together operate to signify the visual oppositions between settings and characters as being either good or evil.

ABJECTION AND DISGUST

Kristeva's analysis of abjection pivots around the issue of a coherent identity, largely arising through compromises to a sense of self, and provoking reactions of disgust as part of maintaining psychic integrity. In other words, she deals with the mental conception of disgust as threat. Nonetheless, Kristeva discusses such reactions as intensely physical phenomena, referring to "gagging sensations [...] spasms in the stomach [and] sight-clouding dizziness" (1982: 3). In contrast, Plantinga deals more specifically with physiological reasons for such responses to disgust and further considers its manifestation and effects within cinema. In Plantinga's schema, disgust stems from biological necessity but is subject to modification by social factors. Claiming therefore that "physical disgust soon shades into socio-moral disgust" (2009: 205), Plantinga explains that in cinema "physical disgust is used to create [...] moral or ideological antipathy towards certain characters and their actions and to promote their condemnation" (2009: 212). In Jackson's *The Lord of the Rings*, disgust works in relation to Frodo's constitution of subjectivity in line with the fantasy narrative quest as rite of passage. His negotiation of vile, visceral spaces, which is apparent in the trilogy, has parallels with the exclusion of bodily detritus that is vital to the maintenance and development of subjectivity. In resisting the power of the Ring, he rejects immoral action, which Kristeva further designates as abject. However, the trilogy's expression of disgust also functions in Plantinga's biological/sociomoral mode, not only to conjure the horrors of war but also to elicit negative spectator emotions concerning environmental destruction and boundary infiltration through settings and characterization. Certainly, there is close alliance and overlap between the two forms. For Kristeva, abjection further involves the exclusion of other forms of "difference," which may be racially motivated, and loss of ego through psychological disturbance. Consequently, any violation that "disturbs identity, system, order" is liable to abjection (Kristeva, 1982: 4), especially the decaying corpse, while in relation to abject immoral acts, Kristeva cites the Nazi regime as an example (1982: 4). These aspects provide obvious alignments with *The Lord of the Rings*, in its scenes of disgusting Orc "birth," its racial subtext and its preoccupation with boundary infiltration. Further, there are analogies implied between Saruman's regime and Nazism (with recent film audiences liable to interpret Tolkien's allusions to totalitarianism as terrorism). Frodo's transient episodes of disorientation, akin to PTSD (and therefore significant to certain post-9/11 audiences), signify a loss of identity, consistent with the psychic dimension of abjection but also meaningful as a response to physically and morally repugnant experiences (where disgust may be threatening both to psychic and to biological integrity).

Indeed, the literalness of abjection evident in the films is highly suggestive of the death and decay associated with war, reflective of Tolkien's own experiences of World War but relevant to contemporary viewers too in relation to the war on terror, for example, in relation to regular reports of soldiers killed or maimed in Afghanistan. The allusions to female reproduction and sexuality as monstrous threat, evident both in the novel and in the films, seem incongruous with 9/11 discourse but nonetheless convey scenes of extreme terror and disgust, which target contemporary anxieties by exposing the vulnerabilities of its characters. In particular, the sequences of repulsive reproduction activate associations with genetic engineering and environmental manipulation.

Spatial boundaries too are significant in *The Lord of the Rings* and have sociocultural implications for the development of subjectivity, and relevance to the landscapes of the fantasy quest. Cultural geographer, David Sibley (1995; 1999) extends Kristeva's ideas to geographical margins and borders and suggests a tendency to abjection because they are liable to incursion by marginalized groups that may be contaminating or dangerous. His argument is relevant to *The Lord of the Rings* where attention focuses on geographical perimeters, specifically in their relation to "racially" defined territories, and Frodo's passage through them, and provokes meanings of boundary infiltration for a postmillennial security-conscious audience.

ARRESTING IMAGERY

Examples of disgust in Jackson's trilogy often mobilize spectator anxieties through spectacles that invoke Klinger's concept of the "arresting image" (2006). The way in which "the forward motion of the narrative slows down or temporarily halts, allowing the spectacle to fully capture our attention" (Klinger, 2006: 24) is particularly relevant to Frodo's unstable mental status. When Frodo falls under the influence of the Ring, imagery consistently assumes "an additionally unusual temporal status, often appearing outside of time in a fantasy or dream-like dimension" (Klinger, 2006: 24). Here, the films' sound temporarily distorts and commonly accompanies disturbing or surreal imagery, corresponding closely with Frodo's threatened subjectivity, and is highly suggestive of trauma, reflecting Tolkien's wartime experiences (though is also representative of Sauron's evil power). These distorted visuals dissect such scenes from the film's narrative as arresting images, thereby amplifying their emotional resonances. Moreover, they tend to be constituted through digital technology, producing surreal extended "timespaces" as a mode of constructing the effects of PTSD as spectacle. Digital enhancement further arises in the many battle scenes, multiplying the number of soldiers to appear as vast armies that extend into the distance, thereby

amplifying their spectacular aspects. In short, such scenarios are not only visually spectacular but constantly recruit feelings either of power (when on the winning side) or of helplessness (in the face of the enemy) for audiences. In such cases, an ultimate outcome of survival in the face of adversity inevitably proves cathartic.

The films provide arresting imagery in other characters too, reconfiguring the terrorist as abject (and technological) spectacle in the form of Gollum, Sauron, and the Orcs. Indeed, Susanne Eichner *et al.* reveal critical reception interpreting the Uruk-Hai as al-Qaeda terrorists (2006: 151). Moreover, *The Lord of the Rings* consistently associates threat with the East, perhaps conveying generalized Orientalist attitudes, but also summoning links with al-Qaeda for some audiences. For example, the voiceover at the beginning of *The Fellowship of the Ring* comments on a shadow in the East, while there is a racial element both to the novel and to the films. Alfio Leotta acknowledges this "racial" enterprise, noting that "the conflict that tears apart Middle Earth is based upon a clear opposition between white and black races" (2011: 178), though others contest this (through noting the whiteness of the evil Saruman). Leotta continues that "the reception of the films has incorporated the Western anxieties of the time: terrorist menace, fear of the Other and concerns about the prospects of an impending global catastrophe" (2011: 179). He further proposes that

> Jackson's *LOTR* did not merely provide an escape from the real world. It went as far as replacing it and constituting itself as a heterotopia: on the one hand, articulating political conservative discourses that were popular among the Western audiences of the time, on the other, proposing the immersion in a consistent cultural and geographical space—Middle Earth—in which conflicts between good and evil are clearly structured and successfully resolved. (Leotta, 2011: 181)

This opposition between good and evil materializes in the landscapes and settings, which are often rendered especially striking or memorable through the strategies of the arresting image, serving to mobilize terror, awe, fascination, or disgust through intertextual references that invite associations with anxieties and environmental issues that are contemporary to the films' releases.

SPECTACULAR SETTINGS

This is not to say that the films' visuals are consistently pessimistic or terrifying. Rather, in contrast to scenes of abjection, many of the films' landscapes are rural and verdant and undoubtedly contribute to the trilogy's appeal and

emotional response. In *The Fellowship of the Ring*, the colors of the Shire contrast distinctly with the opening monochrome palette of the battle scenes and provide idyllic images of unspoilt countryside. Otherwise, landscapes are grand and sublime, surveyed through expansive sweeping camera movements that generate feelings of awe, wonderment, and freedom. As Leotta (2011: 172) notes, "The use of dizzying camera movements and spectacular locations are just some of the strategies employed by Jackson to reiterate the importance of space and movement in his films" (2011: 173). A common visual strategy of the films involves an extreme overhead panoramic shot that shows its protagonists miniaturized against a vast landscape, the use of helicopter camera shots providing moments of contemplation in line with King's (2003) analysis of large-scale spectacle, before cutting in to close-ups of the characters. Leotta particularly draws attention to an opposition of left versus right movement within the films, whereby "the positive characters consistently enter the frame from the left side and always move towards the right [while] the villains [...] enter from the right" (2011: 173).

Jonathan Rayner highlights a dichotomy in the filmic settings too, noting the differentiation of nature and culture in the landscape itself, and describing "Mordor [as] a blighted land of volcanoes and ash" (2010: 265). Indeed, a common metaphor for the good/evil binary is the framing of sublime, snow-capped mountains set against the distant, flaming, cloud-laden Mount Doom. The films also observe a further vertically orientated spatial opposition, frequently distinguishing good from evil by aligning the latter with subterranean spaces. Indeed, abject spaces tend to be below ground,[3] and often form a network of tunnels and caverns underlying snow-capped, sublime vistas. Moreover, the films' deep spaces regularly entail a second characteristic cinematographic approach—that of a rapidly edited sequence involving an overhead shot zooming rapidly downward. This often gives the viewer an impression of falling—in fact, this theme is a recurrent visual motif of the films. For example, during the siege of Gondor, in *The Return of the King* (2003), the airborne Ringwraiths drop bodies from a great height, seen first from an extreme high-angle shot, before cutting to ground level to highlight falling debris and crashing sounds. Similarly, in *The Fellowship of the Ring* and *The Two Towers* (2002), Gandalf's (Ian McKellen) fall at the Bridge of Khazad-dûm is prolonged. The additional implications of the collapse of buildings, caverns, and edifices, together with frequent overhead shots on the edges of precipices that reveal acutely sheer drops, provide further visual potential for evoking 9/11 in relation to bodies falling from the Twin Towers. One such scene occurs in the first film as the nine members of The Fellowship of the Ring attempt to navigate the pass of Caradhras. On the one hand, its sublime imagery induces pleasure through grandeur, while on the other, extreme long shots of the mountain, which

visualise the group as tiny specks, emphasize their perilous position on a narrow path that follows the edge of a sheer precipice, and which cuts away below them. Simultaneously, Saruman's conjuring of a blizzard that triggers falling boulders and landslides conveys similarities to the falling debris during the destruction of the Twin Towers. This semblance is also distinct in a later scene when the group come under attack by a fire-breathing monster, the Balrog, at the Bridge of Khazad-dûm. In evading the Balrog, an overhead camera angle reveals Frodo teetering on the edge of an enormous precipice, thereby also placing the spectator in a position of peril. The Fellowship attempts to negotiate the cavern by means of a narrow stone bridge—the use of extreme long shot again accentuates its narrowness and their vulnerability in traversing it while its steepness and vast underlying chasms heighten spectator tension. In addition, the group have to leap across a breach in the bridge, and, just as Frodo and Strider (Viggo Mortensen) are about to jump, the edifice begins to crumble and a huge section behind them collapses. A combination of extreme long shots and overhead camera angles continually accentuates their dangerous position, while the collapse of the section behind them means that they cannot go back, and heightens their desperation. They are thus forced to leap over the chasm, the implications of which are bound to reverberate with post-9/11 audiences, who had recently witnessed a real version of such desperation. The fire-breathing Balrog that pursues them intensifies this analogy. Conjured as digital spectacle, the creature has flaming holes for eyes, breathes fire, and exudes flames and fireballs, causing Gandalf to fall to his death (though he is later resurrected), the ensuing grief of the Fellowship cast as an arresting image. Exiting the caverns, an extreme overhead helicopter shot reveals them emerging as minute flecks dwarfed against a massive grey landscape (the transformation from white, snow-capped scenery to grey metaphorically conveying their somber mood). The camera then cuts to a close-up of each of their faces

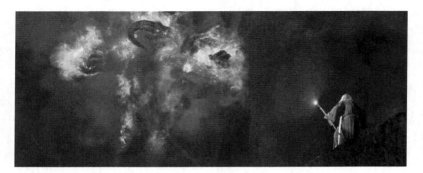

Figure 1 The Balrog in *The Lord of the Rings: The Fellowship of the Ring.*

to countenance their sense of absolute distress. Although they are sobbing, sound is absent and the use of slow-motion editing amplifies the acuity of their grief, perhaps enlisting a similar effect in the viewer. The possibility of this is acknowledged in Barker and Mathijs's study of the films where Kuipers and de Kloet report one respondent as commenting that his favorite part of the trilogy was "Gandalf [...] falling into the fire below and then returning as Gandalf the White in the Two Towers. Simply because I found it moving—the former upset me and the latter cheered me" (2008: 144).

The Two Towers opens with Gandalf's continuing battle with the Balrog as they plummet into the depths, their descent remaining on screen for approximately 30 seconds (though it seems to be part of Frodo's dream initially) and rendered as a continuous spectacle of blazing fireballs set against the blurred sides of the crevasse. Later, in *The Two Towers*, as in many of the films examined in this book, we learn that "it was not the end," and Gandalf is resurrected, thereby observing a tendency in fantasy film for heroic characters to survive falls.

Martin Phillips suggests that the darkness and danger of these filmic spaces follows the pattern established by other films set in New Zealand (which he refers to as the "New Zealand Gothic"), in which "danger and horror lurk around every corner, in any person, and likely to make an appearance at the most unlikely of occasions" (2007: 158). He attributes this Gothic aspect to Jackson's directorial influence, further noting that although Tolkien's novel is "replete with images of wilderness as places of beauty [...] in the films themselves there is a general movement from romantic spectacular wilderness into more classical, gothic images of wilderness as a place of danger and horror" (2007: 159). This transformation of Tolkien's novel thus corresponds with the general darkening of film since 9/11. In fact, Phillips further notes that "the imaginative geographies of space and nature in *LOTR* have parallels, and perhaps even some diffuse connections, with the spaces, and natures, in which these films are produced, circulated and consumed" (2007: 162). In particular, he aligns the retaliatory destruction of Isengard and Saruman by the forest trees with "notions of the 'revenge of nature' espoused within many contemporary 'deep green' eco-centric perspectives" (2007: 162).

The franchise's scenes of battle have also attracted attention regarding their significance for contemporary spectatorship, with scholarly studies identifying general analogies between Jackson's films and the war on terror. For example, Douglas Kellner notes that

> the two Hobbits' [Pippin and Merry] choice of war, and that of other more obviously militarist characters in the film, is not for a clear cause against a determinate enemy. They go to make war against the abstract Forces of

Evil themselves. Indeterminate crusaders against Evil now reflect Bush's war against terrorism. (Kellner, 2006: 31)

Kellner's discussion of *The Lord of the Rings* goes on to highlight the films' parallels with the Bush Administration through their persistent militarist tendencies. Indeed, Jackson's trilogy often visually exaggerates scenes of conflict and bloodshed, and although Susanne Eichner *et al.* acknowledge the horror dimensions of the trilogy, they contend that *The Two Towers* has a hidden generic identity as a war film (2006: 150). The battle sequences in the opening scenes illustrate specific types of perspective that are commonly deployed to augment the films' militarism (and therefore their spectacular nature), namely, a medium close-up that looks down a battle line toward its diminishing perspective, thereby emphasising numbers. A second approach assumes an extreme-long overhead perspective that causes the (digitally multiplied) armies to appear to extend infinitely into the distance. A third technique utilizes rapid editing, multiple camera angles, and the use of whip pans to accentuate battle as spectacle. Such visual strategies render these armies infinitely huge, reflecting the magnitude of the World Wars in Tolkien's world. Arguably, Jackson's escalation of the battle scenes, which essentially externalize Frodo's internal battles, works in a related way for the spectator, enabling the visualization of the war on terror (itself often described as an abject entity[4]). In addition, the opening scenes adopt a muted gray-toned palette and, at the point where Isildur amputates Sauron's hand (thereby removing the Ring of Power), a wind gusts across, followed by a blazing flash of light. Cutting to an extreme overhead perspective, the spectator observes a central blast and shockwave moving toward the screen. The camera position then pulls back rapidly toward the spectator as a secondary shock wave follows. This sequence is thus highly suggestive of an atomic blast and indicates one of the Ring's potential meanings. Further, the Ring's signification as nuclear weapon may have become meaningful to audiences by the time of the release of the third film in December 2003, when Iraq's invasion had been earlier justified on the grounds of alleged possession of WMD. Thus, as Ken Gelder states, "This epic fantasy text from the 1950s gains its power because it now accommodates, and speaks on behalf of, a contemporary war scenario" (2006: 107). Inevitably, the second film's title also resonates with contemporary audiences in its reference to the "Two Towers."

Besides its sublime spectacular effects, the trilogy's settings regularly carry connotations of decay and death and, while not rendered so explicit in Tolkien's account, still convey an element of disgust. One example occurs in *The Fellowship of the Ring*, when Frodo and his companions hide beneath some tree roots to evade a Ringwraith. Pippin's perspective reveals the

ground begin to swell beneath them before it erupts, visibly writhing with various larvae. Here, we see Frodo almost submit to the Ring's lure, his eyes rolling back and his face seen in close-up to convey his mental isolation as he tries to resist the Ring. Associated with this sequence is a pronounced temporal, aural, and spatial distortion. Firstly, the approach of the Ringwraith is made evident by a digitally manipulated distortion of the path down which it travels (thus creating a "timespace" spectacle). Secondly, the camera zooms in rapidly to a close-up of Frodo's face, before there is a moment of silence and arrested movement. As they hide beneath the tree roots, a close-up of a horse's hoof—from Frodo's point of view, through a break in the roots—sees it paw the ground in slow motion. The narrative thus slows down to heighten tension, thereby dissecting it from the film's narrative, while low angle shots from the Hobbits' perspective of the Ringwraith render it an overpowering force. The sequence is thus executed as arresting imagery through its spatial and temporal distortion, abject imagery, and Frodo's psychic lapse, all of which are associated with terror.

Frodo further experiences the influence of the Ring when the Ringwraiths (Nazgûl) first attack him at Bree. These creatures are abject entities, neither living nor dead, ostensibly existing in a borderline state. They are also invisible and faceless, again signifying for some audiences the anonymous face of terrorism. Here, the scene again occurs in slow motion with distorted, screaming sound effects, and the use of edge and rim lighting to evoke their unnaturalness (Gray, 2001: 38). The sequence involves surreal monochromatic imagery, the figures of both the Ringwraiths and of Frodo becoming diffuse and amorphous through digital effects, as if they occupy another dimension. Though Tolkien describes the Ringwraiths as "becoming terribly clear" (Tolkien, 1991: 191), the novel lacks the distortion indicated in the film. Moreover, whereas Tolkien describes "Strider leaping out of the darkness with a flaming brand of wood in either hand" (1991: 191), Jackson's version sees Strider set the Ringwraiths alight, and though they may be interpreted as terrorists, their blazing forms may engender connections with those trapped in the Twin Towers.

The Fellowship's traverse through the Mines of Moria reveals further examples of abject spectacle. "This is no mine, it's a tomb!" remarks Boromir as a series of rapid edits discloses numerous corpses, their mouths wide open as if they died screaming, further escalating their abject qualities and mobilizing associations between Tolkien's experience of warfare and the experiences of those who died in the Twin Towers. In addition, the entombment associated with the films' enclosed spaces not only exemplifies the gothic tropes that Williams defines in Jackson's work (and that are considered to permeate Tolkien's story: see Zlosnik, 2005) but could also generate generalized feelings of claustrophobia and loss for viewers concerning the burial

of 9/11 victims under fallen rubble. A desaturated color palette and minimal lighting (derived from Strider's torch and Gandalf's staff) add to the sequence's melancholic ambience (Gray, 2001: 39).

While the group (and the viewer) contemplate the horrific spectacle, a gigantic tentacle emerges from the lake, adjacent to the mine, as they come under attack from a monstrous octopus. Rapid editing and erratic camera movement emphasize its menace, while cuts between long shot, close-up, and extreme close-up—first of its tentacles and then of its toothed open mouth—fill the frame. This image of monstrosity arguably conveys a voracious female sexuality that permeates the trilogy, articulating such a presence as abject spectacle. As the group becomes trapped in the mines, they are forced to further negotiate piles of decaying corpses in their quest, while the scenes in Moria alternate between close-ups of the corpses and sublime imagery of the group as minute figures set against vast, seemingly bottomless caverns.

The Two Towers' Dead Marshes perhaps convey most vividly Tolkien's experience of war, Gimli (John Rhys-Davies) describing them as "festering, stinking marshlands, as far as the eye can see." As Sam, Frodo, and Gollum traverse the marshes, a mise-en-scène of burning fires and swirling mists conjures the site as a desolate war zone, while a panning shot across the water's surface reveals corpses floating beneath it. "All dead, all rotten. Elves, and men and orcses," Gollum tells Sam and Frodo, and warns, "Careful now or Hobbits go down to join the dead ones and light little candles of their own." This latter remark resonates for all commemorations of death, but the film, released in 2002, likely resurrects associations with media images that emerged immediately after September 11, which included those of candle-lit vigils. A zoom to Frodo's face suggests that he seems hypnotized by the sight of the dead, before a cut to a side-on shot observes him falling into the water. Slow motion cinematography, highly distorted sound effects, and surreal horrific imagery of eyeless, animated corpses from Frodo's perspective beneath the water mediate the scene as an abject arresting spectacle. This latter sequence, though not resembling 9/11 footage, conveys the horror and pessimism of warfare by mobilizing fear and disgust.

Frodo's quest therefore involves passage through a series of clearly demarcated zones, the trilogy's various landscapes and places being differentiated by color tones and lighting. In general, magical, mystical places, such as Lothlorien and Rivendell, are associated with the use of warm colors and high-key lighting, whereas threatening spaces have a limited color spectrum, often with blue tones. Abject spaces in particular correlate with abject beings (Orcs and Ringwraiths being obvious examples), thereby closely aligning setting with "race," as Furby and Hines have noted (2012: 132). Indeed, attention focuses on the borders between different regions and topographies,

indicated by visual replication of Tolkien's map of Middle Earth. Discussion between characters pertains to the protection of borders, suggesting them as sites of conflict and exclusion, in line with Sibley's concept of peripheral abject spaces. The films verbally draw attention to the crossing of borders, with Sam telling Frodo, as they are about to leave the Shire, "If I take one more step, this is the farthest from home I've ever been." We also hear the words, "These borders are well protected" at Lothlorien (*The Fellowship of the Ring*). Visually, the green verdant Shire, the origin of Frodo's quest, contrasts distinctly with Mount Doom, the image of which recurs throughout as a gloomy, distant mountain, overhung with dark menacing clouds, and flames spewing from its summit. For some viewers the image of Mount Doom may evoke the Twin Towers, whereas its visual contrast with the Shire clearly articulates a distinction between good and evil in the landscape itself.

As Phillips notes of Sean Cubitt's study in his analysis of sociospatial identity, "places such as Rivendell, Lothlorien or Osgiliath are all enclosed with barriers to keep out elements from other, different worlds [suggesting] that these chime with contemporary highly political concerns related to biosecurity and migration" (2007: 162). According to Cubitt, "Respect for boundaries is critical to the stability of Middle Earth" (2005: 10). Although neither Phillips nor Cubitt note this as an abject aspect, clearly, both deal with the notion of contamination. The implied infiltration of Bilbo's home in the early scenes of *The Fellowship of the Ring* may also resonate with audiences, bringing to mind the anthrax attacks in the United States that occurred soon after 9/11, and immediately before the film's release. Here, Jackson exploits the horror iconography of creaking doors, darkness, shadows, and a camera that observes Frodo from a distance to imply threat.

Such boundary consciousness is relevant to contemporary concerns of national security in facing the diffuseness of terrorism, and the depiction of Sauron as a pervasive evil presence rather than a physical embodiment contributes to such an analogy. Bob Rehak suggests that "the films' refusal to personify its primary villain echoes the changing antagonists at the center of the United States' response to 9/11 and Iraq: first Osama bin Laden, then Saddam Hussein" (2012: 93). As Cynthia Weber comments, "Not only is al Qaeda [...] located everywhere; it is located nowhere" (2006: 23). François Debrix too notes the importance of boundaries to the war on terror, asserting that "It is a different war, with no really distinguishable home and away fronts. It is a war in the border regions of the concept of war. It has no beginning and no end; only battles, spurts of violence along the way' (2005: 1159). Clearly, the geographical boundaries discernible in *The Lord of the Rings* marshal post-9/11 anxieties in relation to further "infiltration" as well as those pertaining to genetic contamination.

THE RING AND SAURON'S EYE

The trilogy's focus on terror centers on the Ring and its hypnotic effect on its bearers, which invariably initiates sequences of arresting, surreal imagery. Adam Roberts contends that the Ring may symbolize the wedding band, suggesting that "[it] achieves some of its sinister, uncanny effect in the novel precisely by creating a weirdly intense parody of the love relationship" (2005: 61). Arguably, the Ring may also equate to absent maternal power, though its connections to absolute evil, within an allegory of war, also conflate it with totalitarianism and, as suggested above, the use of nuclear weapons. As a malevolent force, it is itself anthropomorphized in the film. A voiceover at the trilogy's outset tells us that "the Ring of power has a will of its own," supported visually by vignetted framing, which implies the Ring's subjective viewpoint, just as its bearer, Isildur, is attacked. The scene occurs in slow motion, with distorted sound, rapid editing, and the use of blur, and whip-pans, which create an arresting image. Indeed, in *The Fellowship of the Ring*, the Ring gains autonomy, bouncing down steps of its own accord, and the spectator often assuming the Ring's point of view. Its subsequent bearers, firstly Gollum, then Bilbo (Ian Holm) and Frodo, in various ways, belong to its maternal world. The monstrous Gollum, whose mind has been "poisoned" by the Ring, is fetal in appearance and manner, and Bilbo Baggins remains infantilized under its influence. Early in *The Fellowship of the Ring*, framing and cinematography (as well as digital effects) render Bilbo almost miniaturized in comparison to the towering form of Gandalf. Bilbo is also childlike in his clinging to the Ring, becoming malevolent in its presence. In fact, he leaves home to separate himself from it, initiating his journey toward "adulthood" and eventual old age. Frodo too, chosen undoubtedly for his wide-eyed youthful looks, soon falls under the spell of the Ring, his small stature and childlike appearance once more signifying his infantile status. The surreal effects that the Ring evokes for its wearers involve the visualization of Sauron's eye, appearing as a vertically orientated slit, which several scholars suggest connotes female sexuality (Goldberg and Gabbard, 2006; McLarty, 2006). Throughout the trilogy, Sauron's eye is a persistent image, which Frodo increasingly envisions as the influence of the Ring grows stronger. The moments at which the Ring compromises Frodo's psychic integrity are highly stylized and distinct from the narrative. Initially, he appears transfixed by the distant Mount Doom before a hyperaccelerated zoom closes in to Sauron's eye—this image is associated with threat and occurs whenever Frodo appears disorientated perhaps reflecting Tolkien's exposure to the symptoms of PTSD. It is unclear why Tolkien should have conflated the meaning of this image with female sexuality. Arguably, the role of the Ring as an abject maternal entity may be relevant in a film that offers few

maternal influences, while its alignment with the desire for absolute power and its traumatizing effects on its bearers reveals a parallel anxiety about war. Certainly, the films and novel channel terror through feminine forms, fetishizing death and threat in spectacles of monstrous femininity (e.g., in Shelob, the giant spider).

Moreover, the Ring is consistently associated with a mise-en-scène of foreboding underground settings. Its discovery in underground caverns by Gollum establishes its connection with abject space at the beginning of the trilogy, this setting contrasting with the idyllic rurality of the Shire. As the journey toward Mount Doom progresses, Frodo's disorientation becomes increasingly evident in the use of canted angles and a laterally oscillating camera, while the physical challenges to his quest escalate. In *Return of the King,* Gollum leads Sam and Frodo upward through a secret stairway, the two being unaware that it leads to a giant spider's lair. An extreme overhead revolving shot further suggests Sam and Frodo's weariness and apprehension. As they reach the top of the stairway, the camera frames Gollum to one side of the frame and Frodo to the other, as if they are mirror images. Their faces are both mud covered, and lighting heightens the whiteness of their eyes so that they appear to resemble each other, thereby signifying Frodo's deteriorating sense of self and implying the dehumanizing experience of warfare.

As Frodo looks down the tunnel (the entrance to Shelob's lair), a digitally manipulated spatial distortion suggests his altered sense of reality as he further succumbs to the Ring's influence. "What's that smell?" asks Frodo. "Orcs's filth," replies Gollum, attaching notions of disgust to the lair (and thereby to female sexuality). Entering the tunnel, we see close-ups of skeletal remains shrouded in webbing. The camera tracking Frodo becomes increasingly erratic in movement, signaling his escalating confusion and terror and, as he too becomes ensnared in the spider's web, the cinematography becomes progressively more kinetic. Corresponding with the conventions of the horror film, the spectator observes the spider behind Frodo before he becomes aware of its presence. The camera cuts to a full-frame image of the spider, before a low-angle close-up from Frodo's perspective looks up toward it, its form now exceeding the frame. The film thus repeatedly heightens Shelob's monstrosity through scale, Frodo appearing diminished against its colossal underside, which completely fills the frame. A close-up of the spider then zooms in rapidly to focus on its fleshy pink jaws and monstrous teeth. As Frodo attempts to escape from the lair (the spider catches him eventually), extreme canted low-angle and high-angle shots mediate a sense of surreal menace, Shelob intermittently coming into view at the top of the frame before attacking Frodo. She spins a web around his flaccid form, his bound body resembling a shrouded corpse, the

camera cutting from long shot to extreme close-up to emphasize the lethal sharpness of her pincers, while lighting heightens her body's slimy surface. As Sam returns to rescue Frodo, an extreme close-up of the spider's stinging tail centers on its viscous abject nature. In addition, the tunnels of its lair and the steep and treacherous pathway leading to it may suggest parallels with the interior feminine body in reflecting the novel's marginalization of women. Although the fascinating but horrific spectacle of Shelob and its alignments with female sexuality are unconnected to the film's contexts, the positioning of female sexuality as a site of horror provides a means to project fears of the other.

SPECTACULAR CHARACTERIZATION: GOLLUM AND THE ORCS

As well as spectacular settings, Jackson's trilogy features a range of fantastic characters and entities, including the Balrog, Gollum, and the Orcs. Whereas the Balrog instils terror, like Shelob, Gollum and the Orcs' repulsive appearance and behavior, invite fascinated disgust. Gollum is the character most corrupted by the Ring's influence—to the extent that his identity literally changes from that of Smeagol to Gollum—and he assumes a distinctly fetal/animal form. Smeagol's degeneration to Gollum is indicated in the opening blue-toned scenes of *The Fellowship of the Ring* where a long shot frames him centrally, casting him as abject spectacle. A similar scene in *Return of the King* reveals him from an overhead long shot, crouched in isolation in the underground caverns of The Misty Mountains, where "the Ring poisoned his mind." He appears small and centrally framed, surrounded by damp rocks, in a darkened cavern, while his utterance, "we wept precious, we were so alone," invites pity from the spectator. This intermingles with repulsion when we witness a close-up of his opened mouth as he devours a raw fish. Jackson's version intensifies the abject aspects of this—a close-up of Gollum's rotting blackened teeth and putrid flesh cuts to his perspective of the wriggling fish, its gasping mouth indicating that it is still alive. A further close-up sees Gollum biting into the living fish, our disgust heightened by the sound effects of tearing flesh overlaid with Gollum's sibilant voiceover that says, "We even forgets our own name." Gollum's ambiguous identity first becomes apparent in a scene occurring in *The Two Towers* as he accompanies Sam and Frodo. While they sleep, he begins to talk to himself, the camera pulling back so that he appears to the left of the frame in close-up and in profile. He then turns toward the camera, as if addressing the viewer. "They stole it from us," he says, before the camera pulls back to reveal him center frame. Cutting again to close-up, Gollum now addresses the viewer as his "other" self, as if his identity

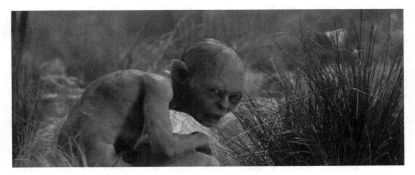

Figure 2 Gollum (Andy Serkis) in *The Lord of the Rings: The Two Towers*.

is literally divided. The camera then follows his "dialogue" by intercutting between him, positioned to the left of the frame and then to the right as though he is two separate entities. There is no doubt that Gollum is a visually compelling, credible character, and one of the main attractions of *The Two Towers*, indicated by the film's Academy Award for Best Visual effects. However, considering the transformation and evil connotations of Smeagol/Gollum, his characterization may also convey associations with the radicalization to terrorism. Gollum's ambiguous identity and questionable morality may also be relevant to contemporary audiences in relation to post-9/11 US identity concerning its vulnerabilities and military intervention in Iraq (which I shall discuss shortly).

In many respects, Gollum epitomizes the abject spectacle, eliciting both pity and revulsion. His figure behavior is unpredictable and excessive, and his vocal intonation is erratic and uncontrollable. Kellner describes him as "appearing like an emaciated barely human survivor of the German concentrations camps" (2006: 28), while Tolkien's text describes a "small black shape [...] with its thin limbs splayed out" (1991: 598), utilizing terms such as "prowling" and "smelling its way," which further imply animalistic qualities. Tolkien himself repeatedly refers to "snuffling" and "smelling," and a constant fear for Frodo is that "they would smell him out sooner or later" (Tolkien, 1991). In Tolkien's version, these preoccupations refer to the smell of decay and filth and translate into abject spectacle in the films. Arguably, the network of associations that Klinger describes might involve viewers' connections between Gollum, Kellner's reference to concentration camp victims, and images of warfare in Afghanistan. Uncannily prescient of Abu Ghraib, and shortly after the final film's release, and certainly, by the time of the final DVD releases, evidence of abuse at Abu Ghraib was in the public domain. These images showed prisoners, mostly adopting, or being

forced to adopt, a similar crouching position to that of Gollum. Moreover, the imagery of Frodo leading Gollum, tied by a rope around his neck, is identical to that of US soldier Linndie England leading a prisoner at Abu Ghraib (see Danner, 2004).

In addition, the films' portrayal of Gollum is itself "abject" in the way that the character transgresses the physical boundaries of the actor, blurring the distinction between human performance and technology, and effectively mirroring Gollum's narrative degeneration. As Tom Gunning explains, "The character that Andrew Serkis performed in the last two films of *The Lord of the Rings* trilogy, and that a variety of CGI and Motion Capture technologies 'bring to life' [...] originated in one of J. R. R. Tolkien's most vivid creations, Gollum" (2006: 323). For Gollum is effectively a synthesis between actor and technology. Indeed, *The Lord of the Rings* is dependent on a high degree of technological input, to the extent that Gunning states that "the directorial voice takes second place to the technology of film" (2006: 320). In part, this may explain its comparative critical and commercial success in relation to earlier attempts at its adaptation, first as an animated television film, and then an animated cinematic version by Ralph Bakshi in 1978 (see Barker and Mathjis, 2008: 23). In its most recent incarnation, the technologies of CGI and motion capture have enabled Jackson to realize fully Tolkien's characters and settings, hence supporting Friedman's claims for technology as crucial to fantasy's domination.

The creation of another source of disgusting "other," the Orcs, has similar abject connotations. Katherine Fowkes alludes to connections between 9/11, abjection, and *The Lord of the Rings* in the Uruk-Hai, locating their monstrosity in their appearance and origins (2010: 136). Isengard's underground tunnels are the site for their creation, which is presented as a grotesque birth. Kellner contends that their breeding "represents fears of eugenics and genetic engineering, such as were visualized by the Nazis and are taking form in the cloning laboratories of the present" (2006: 23). He further suggests that they "represent the fusion of the human and the technological in modern warfare" (2006: 27). Certainly, this alternative interpretation is relevant to the widespread investment in, and deployment of, robotics technology after 9/11 in its various drone manifestations (Singer, 2009: 35). Moreover, the Uruk-Hai are responsible for ecocatastrophe, generating further meaning for twenty-first-century audiences in connection with the destruction of the forests. "The trees are strong, my lord," the Uruk-Hai tell Saruman. "Rip them all down," responds Saruman, the vision of landscape destruction and industrialization creating "multi-directional memory" (Luckhurst, 2010) between

Tolkien's inferences and meanings for contemporary film audiences. The Orcs use the trees to stoke the furnaces of Isengard, manufacturing weapons and engineering the creation of the Uruk-Hai, synthesized by interbreeding Orcs and goblin-men. Jackson renders the creation of the Uruk-Hai in the deep underground caverns of Isengard as an example of Plantinga's claim for "biological disgust shading into socio-moral disgust" (2009: 205). Accessed by an initial typical downward rapid zoom, slow motion and close-up emphasize elements of repulsion, in keeping with Klinger's notion of the arresting image. The amorphous, membranous, mud-covered entities emerge from the ground, mediating connotations of excrement, childbirth, and burial. The use of close-up and viscous sound effects amplify the scene's repugnance, which conveys trench warfare while perhaps also invoking connections with those buried beneath the Towers. The rupture of the membranes (with parallels to birth) reveals the moving forms as Uruk-Hai and further cuts to a close-up display of their open mouths, containing pointed, razor-sharp teeth. The Orcs are additionally repulsive in their "taste for man-flesh," and there are multiple references to cannibalism. In *The Two Towers*, during a scene revealing the capture of the two hobbits Merry (Dominic Monaghan) and Pippin (Billy Boyd), blue-toned lighting and close-ups that reveal their decaying skin and long pointed teeth emphasize their menace. The starving Orcs, having only eaten "maggoty bread," now contemplate eating Merry and Pippin, starvation carrying inferences (of war, famine and the Holocaust) for audiences and readers alike.

This sequence may activate other post-9/11 associations as the Riders of Rohan attack the Orcs, leaving their burnt corpses in a smoldering mound. Subsequently, the camera pulls back as Aragorn, Legolas (Orlando Bloom) and Gimli (John Rhys-Davies) approach, disclosing an Orc's head on a spike to the left of the frame. The camera retreats further to reveal the heap of smoldering corpses, now center frame. The image of burning bodies, presented as abject spectacle, has multiple meanings that further exemplify Luckhurst's (2010) notion of multidirectional memory in its dialogue between the Nazi concentration camps and 9/11. Indeed, as the trio search through the remains, looking for evidence of Merry and Pippin, Gimli pulls out a charred body part, evoking memories of rescuers' efforts at Ground Zero when a paramedic commented, "There's no rescue [...] it's just body parts" (Faludi, 2007: 53). The burning pyre may have specific associations for UK audiences, prompting flashbulb memory of news footage—for 2001 also marked a different kind of catastrophe in the UK, that of bovine "foot and mouth disease," the scenes of burning animal carcasses ubiquitous throughout the countryside as well as in media reports.

For several scholars (Furby and Hines, 2012; Leotta, 2011; McLarty, 2006), the Orcs embody both racism and references to Nazism. The scene of Saruman's address to the Orcs from the Tower of Isengard in *The Two Towers*, and their subsequent assembly in the final battle scenes of *Return of the King* render them much like news images of ranks of Nazi recruits in Hitler's address. Their blackened faces also signal the racial enterprise of *The Lord of the Rings*. Moreover, the sequence at Helm's Deep in *The Two Towers,* in which an Orc carries explosives to breach the fortress's wall, may chime with contemporary audiences in relation to news reports of suicide bombers. Both the Orc's approach and the ensuing explosion occur in slow motion, with the Orc appearing center frame and visibly convulsing as each arrow strikes him. This scene of breaching boundaries captures the explosion from multiple perspectives and thus incorporates an action-spectacle "impact aesthetic" (King, 2000: 95) while conjured as an arresting image.

MORALITY

The corruption of morality is central to the Ring's power; it is also relevant to certain post-9/11 audiences in the way that it has affected concepts of US identity since 2001. Weber elucidates this more fully in her book *Imagining America at War*, identifying an ongoing public debate in the United States "that revolved around what is arguably a foundational question of US-ness—what does it mean to be a moral America(n)?" (2006: 2). She too posits a connection between cinema and morality in post-9/11 film, noting that "sometimes [...] traditional US moralities are confirmed in this cinematic space; at other times, they are confounded there" (2006: 4). Examining a range of films that emerged within the immediate post-9/11 timeframe, she notes that

> between 9/11 and the following summer (when the United States and a very few of its allies made the decision to invade Iraq in what became known as the Gulf War II), who Americans were as citizens and what America was as a national and international space was not only in flux [...] but in crisis. The shock many US citizens felt by the events of 9/11 led to a national debate about what it means to be an American individually, nationally, and internationally, and the terms of this debate were primarily moral. (Weber, 2006: 4)

Although issues of morality thus came to the fore through debates concerning the justification for invading Iraq, they later resurfaced in relation

to media images of abuse at Abu Ghraib. Clearly, the attention to morality, evident within *The Lord of the Rings,* is a further aspect that may find anchorage with audiences in the new millennium. Morality ties in closely with Frodo's quest in that he must continually resist the temptation of the Ring to destroy it at Mount Doom.

As Sam and Frodo approach their destination, Frodo becomes progressively more disorientated, signaled by unsteady, handheld camera and temporal disruption. An extreme overhead shot reveals him suspending the Ring above the flaming crevasse and apparently equivocating between desire for the Ring and throwing himself over the edge. The scene cuts to a close-up of the Ring before zooming in to an extreme close-up. This sequence of shots has a hypnotic effect on the spectator since we too are made to focus on the Ring. Rapid intercutting then reveals Gollum attacking Frodo, who finally succumbs to the Ring's influence and puts it on his finger. Gollum bites off Frodo's finger before falling into the crevasse, while Frodo almost falls in too. The implication of falling invites analogy with Kristeva's notion of death when, "from loss to loss, nothing remains in me and my entire body falls beyond the limit—*cadere,*[5] cadaver" (1982: 3). Even as the films' recurrent images of falling echo the falling bodies of 9/11, the subsequent collapse of Sauron's tower and an extreme low angle shot, as debris billows out toward the screen, may further remind the viewer of the Twin Towers' destruction.

CONCLUSION

Graham Fuller states that Tolkien's attention to death constitutes "the single most important theme in the book and the least likely to underpin a Hollywood blockbuster" (2002: 20). Yet, as he goes on to note, "The magical evasion of death permeate[s] the film[s]" (2002: 20). The final scenes of *The Return of the King* exemplify such evasion, the film portraying death as "another adventure" and signifying it as a new beginning in its depiction of a boat sailing away toward a brilliant sunrise. Indeed, Judy Ford and Robin Reid note that the film, "in subtle but unmistakable ways, changes Frodo's journey into the West [...] to suggest both greater certainty about the afterlife and greater optimism about the future of the world" (2011: 170). In fact, it repeatedly presents death in heroic circumstances and as a state from which one can return, indicated by Gandalf's resurrection and Frodo's wounding and recovery. Jackson's trilogy, screened in the aftermath of 9/11 and during the war on terror, therefore offers consolation for those bereaved by warfare in its spirituality and through its suggestions of an afterlife. In particular, the spectator may

identify with the grief expressed by its various characters—for example, in *The Two Towers*, King Théoden of Rohan says of his dead son, Théodred, "No parent should have to bury their child," and Arwen's father foretells of her mourning, if she marries the mortal Aragorn, in a sequence conjured as surreal and arresting. Here, a monochromatic montage conveying her grief includes a long shot of Aragorn's tomb, its gothic features and fallen leaves implying a sense of loss, then cutting to a close-up of Arwen set against a cloud-laden sky. The montage concludes with a slow-motion long shot, which discloses her traverse through bare woodland as a black figure against a shaft of sunlight, before cutting to the present and a close-up of her tearful face. The mournful sequence may provoke similar feelings in the spectator, reflecting the emotions of bereavement, in line with the theoretical and scientific premises outlined in the introduction. Thus, although battle-scene fatalities are conveyed as spectacle through rapid editing, digital effects, and multiple camera angles, individual deaths are extended either in slow motion (such as that of Boromir) or in lingering close-ups that intensify the effect of the characters' sorrow, as in the death of King Théoden's son.

The second dominant message of the trilogy concerns environmental damage. Whereas some artists have depicted the industrialization of the English landscape in aesthetic contexts, Tolkien's narrativization and Jackson's subsequent rendering of the destruction of the landscape depict it as an act of evil, with further negative connotations of these acts through the abject spectacles that pervade the film. Earlier, I outlined claims that *The Lord of the Rings* provided relief in the form of the fantasy genre in a post-9/11 climate. This chapter suggests that the dark themes and imagery of the trilogy provide "safe" ways to address new millennial concerns. In its focus on the notion of the Shire and the traversing of other spaces, the trilogy reflects post-9/11 anxieties of infiltration into home and territory and the transformation of familiar and sublime spaces into sites of terror. The transient loss of subjectivity, signified by Frodo's trancelike state, may relate to Tolkien's experiences of PTSD, which are also relevant to audiences of Jackson's version, though perhaps these lapses may also reflect the loss of self in the radicalization to terrorism. The notion of the other is therefore arguably inflected both in Tolkien's tale as an allegory of war and in Jackson's rendering of it as a mediation of threats to national identity. The films are one of the highest grossing franchises of all time, indicating that their recurring iconography of falling bodies, vertiginous heights, and claustrophobic depths, coming in the immediate aftermath of 9/11, chimed with contemporary audiences. Additionally, the scenes of abject spectacle served to mobilize associations with war and climate-change issues, as they may

have done for Tolkien's postwar readers in an era of progressive industrialization. Moreover, the overarching narrative paradigm of good overcoming evil, for example, in the Ents' revenge in the flooding of Isengard, the battle of Helm's Deep, and the destruction of the Ring conveys optimism, especially in light of Frodo's closing departure.

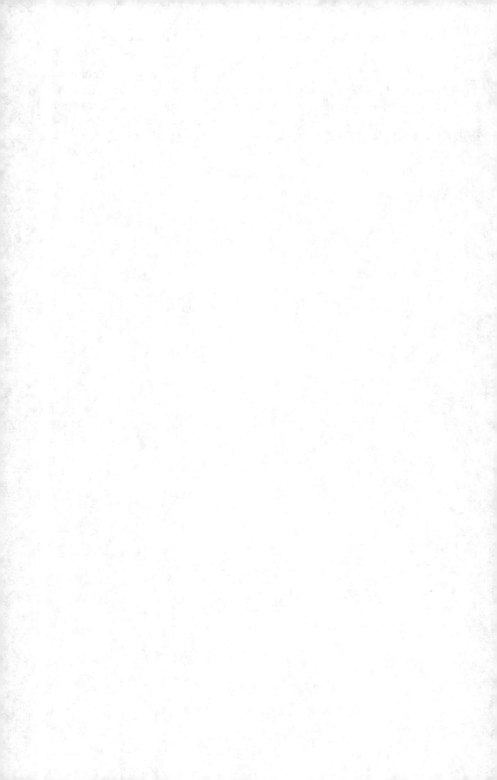

BEWITCHING, ABJECT, UNCANNY: MAGICAL SPECTACLE IN THE *HARRY POTTER* FILMS

FOLLOWING THE 2011 RELEASE OF THE FINAL FILM IN THE *HARRY POTTER* series, *The Deathly Hallows: Part 2* (Yates), the cinematic adaptations (2001–2011) of J. K. Rowling's novels (1997–2007) became the highest grossing franchise ever.[1] The films, inevitably eliciting comparison to their literary sources, display a general fidelity to the novels, although the different capacities of the visual medium obviously afford certain emphases not available in the novels. For example, Suman Gupta comments that "along with the music the visual effect of the Hogwarts environment provides a sense of continuity that is not wholly due to the descriptions in the books" (2009: 146). Gupta further highlights features of the mise-en-scène that become more prominent in the films, including the visual impact of colors, costume, and the Gothic settings, as well as a more distinct contiguity between the Muggle and the Magic worlds (2009: 146). A marked deviation from the final novel is its two-part cinematic version, and those films made after 2001 display an inflection of their new-millennial contexts, not always apparent in the written texts, in particular, in their references to 9/11 and terrorism. This gradual darkening of the franchise's visual and thematic tone further reflects in their increasingly somber and slower stylization of opening credits and musical score (composed by John Williams).

The *Potter* films follow a similar trajectory to *The Lord of the Rings* trilogy in that the first film, *The Philosopher's Stone*, appeared in cinemas

immediately following 9/11 and therefore seems unaffected by the contexts of its release. However, the franchise spans the decade following 9/11 and thus becomes increasingly visually and thematically convergent with the events of 9/11. Uncannily, the final film, *The Deathly Hallows: Part 2,* culminates in the destruction of its evil protagonist, Lord Voldemort (Ralph Fiennes), its release coming just two months after the death of Osama bin Laden. There are other parallels with *The Lord of the Rings,* and the two narratives were frequently subjected to comparison. Indeed, Campbell states that "it is impossible to imagine the current popularity of the *Harry Potter* books [...] had there been no *Lord of the Rings*" (2010: 748). Both entail quests to destroy an unseen evil force, their entire narrative trajectory travelling toward this conclusion and involving a rite of passage for their respective protagonists.

The *Potter* franchise's plotline follows three young friends, Harry Potter (Daniel Radcliffe), Hermione Granger (Emma Watson), and Ron Weasley (Rupert Grint), who are apprentices at Hogwarts School of Witchcraft and Wizardry. Their quest to overcome Voldemort involves the destruction of a number of Horcruxes, fragments of his soul, one of which exists within Harry. The implication of this, as in *The Lord of the Rings,* is the potential for evil in all and its attendant moral decisions. The quest differs from that of Frodo in *The Lord of the Rings* in that the *Potter* series instead pivots around one particular place, Hogwarts School, with only the final two films moving substantially beyond it. Even so, Hogwarts' isolated mountainous setting and surrounding Dark Forest provide opportunities for dark, sublime imagery. Moreover, although both have magical and supernatural elements, Jackson's trilogy tends toward spirituality, and its gloomy mise-en-scène is reflective of Tolkien's World War experiences. Conversely, the *Potter* films focus on the performance of sorcery and enchantment as beguiling and wondrous, though they too have religious connotations, for example, in Dumbledore (Michael Gambon) and Harry's resurrection from death. Furthermore, both franchises are concerned with destroying symbols of total power (the Ring and the wand), each being a metaphor for WMD in their respective cultural contexts.

In general, therefore, the *Potter* franchise centers on its bewitched visuals as display, anchoring the shape-shifting transformations of its characters, the conjuring of fantastic portals and other worlds, and the performance of magic as pure spectacle. Indeed, Harry's entry to the world of Hogwarts involves transition through a seemingly solid brick wall into a parallel universe. Within this magical realm, Harry traverses a variety of other spaces that, in different ways, wield both fascination and horror. Thus, although Hogwarts is a site of schooling, its focus does not lie in the conventional training of social and cultural norms. Rather, it encourages

the orchestration of objects in space and the moral and physical navigation of the self through space. Harry must learn to master different, other spaces, including a giant chessboard and mid-air Quidditch to prove himself, these instances exemplifying magic as fun (and thereby appealing to younger audiences). However, the films also adopt sinister and supernatural qualities in their more insidious inflections of 9/11 and the war on terror. Further, ghostly apparitions and the magical implications of going back in time provide opportunities for uncanny spectacle, the latter enabling the reversal of death or encounters with loved ones who have died. Other instances of temporal discontinuity incorporate the notion of the traumatic flashback. Indeed, a noticeable feature of the *Potter* films is the escalating appearance of Harry's psychic disturbances as he becomes progressively more affected by Voldemort's malevolent presence (akin to the effects of the Ring in *The Lord of the Rings* films). Although magical and supernatural spectacles dominate the films, there are also elements of disgust and threats to Harry's subjectivity, though these frequently assume a lighter tone than those of *The Lord of the Rings*, more so in the earlier films. The later films however feature scenes of bloody wounding, warfare, and violence and, as in *The Lord of the Rings*, death—and the means to evade it—are significant themes. Narratively, this change in tenor reflects the trio's passage towards adulthood, whereby they increasingly comprehend and countenance forces of evil and, contextually, the pessimistic mood of recession, war, and climate change surrounding the films' production.

Allusions to 9/11 and the war on terror occur frequently in the films, most obviously, when Harry falls under the psychic influence of his enemy Voldemort, but also in connection with memory, death, and danger. The utilization of acute camera angles and extreme perspectives is important in this respect since these often enhance the films' magical, abject, and uncanny aspects as spectacle. Direct movement toward the camera further accentuates threat for the spectator. Alternatively, extreme long shots exaggerate the spectacular nature of conflict and death, while digital effects produce "dynamic timespaces" by rendering normally inanimate spaces mobile (Wood, 2002: 375). These combined effects effectively dissect such scenes from the narratives as arresting images, thereby amplifying their potentially emotional resonances for post-9/11 audiences. Additionally, such episodes often deploy imagery that directly pertains to 9/11 and terrorism.

In respect of the novels, Lori Campbell too correlates Harry's quest for identity with their broader sociopolitical contexts, but locates these concerns in a "twentieth-century Great Britain coming to terms with its heroic past" (2010: 18). Arguably, the films speak to larger audiences in terms of their post-9/11 associations. Campbell also sees the "other-worlds" of the *Potter* novels as "externalizations of the hero's inner workings" (2010: 6). In short,

she aligns space with subjectivity, while Honeyman further notes that the child character may become the vicarious means by which the adult reader [or spectator] accesses the fantasy space (in Campbell, 2010: 14).

Visually, the films reconfigure the terrorist other as (abject) spectacle in the form of Voldemort and his various incarnations, as well as his shape-shifting followers. Moreover, while the films' utilization of magic is attractive to a younger audience, its transformative power, spiritual associations, and conjuring of an afterlife may also unconsciously offer consolation to adult viewers bereaved by the war on terror, or 9/11. This chapter thus suggests that the *Potter* films offer safe ways to subconsciously reenact or work through anxieties for contemporary viewers. Ostensibly, it argues that although narratively and generically tied to the typical fantasy quest (as a means to consolidate subjectivity), the films' fantasy spaces may resonate with contemporary audiences through the "arresting image," often enabled through Wood's concept of the "timespace." Engaging with theories of magic, the uncanny, and the abject, this chapter considers the films' settings and characters, their connections with magic, and the ways in which these may be meaningful for post-9/11 audiences.

ABJECT SPECTACLE

The abject becomes germane to the *Potter* films in several ways: partly, it surfaces at times when Harry undergoes physically repellent and near-death experiences in his progression toward a coherent adult identity. As in *The Lord of the Rings*, the negotiation of such spaces parallels the exclusion of bodily detritus, which is vital to the maintenance of subjectivity. At the same time, these encounters help elucidate Voldemort as a source of evil and to resolve the issue of Harry's identity. In confrontations with Voldemort and his followers, abjection sometimes functions differently, since attention often centers on the maintenance of protective magical boundaries as a means of exclusion. These include, for example, Harry's invisibility cloak, the protective shield that Hermione summons in *The Deathly Hallows: Part 1*, and the similar shield that Professor McGonagall (Maggie Smith) conjures in *The Deathly Hallows: Part 2*. In other cases, Harry's moral decisions are vital to his development and reflect the more generalized element of morality apparent in other post-9/11 fantasy films that may resonate with audiences.

More specifically, and corresponding to Kristeva's concept of maternal abjection, Harry is constantly drawn back to his parental world, the film repeatedly flashing back to scenes of him as an infant or as part of a family unit (his reflection in the mirror of Erised visually encapsulates this desire), the point of separation from his mother represented as particularly horrific. At the same time, Harry's identity is permanently compromised

because Voldemort's attack on him led to the implant of a Horcrux (part of Voldemort's soul) within his body. Therefore, Harry is unable to divorce himself entirely from the abject until he has fully accepted the death of his parents and rid himself of the contaminating Horcrux. As in the other films examined, the contaminating Horcruxes may thus symbolise the ambiguity between good and evil, meaningful to contemporary audiences in respect of political and military irregularities revealed since 9/11.

There is therefore a constant tension between Harry's need to attain subjectivity (and take his father's place) and his desire to return to the parental world. For although Harry's identity is distinct in the films' titles, narratively, his past is obscure. His quest, although one of destroying his evil opponent Voldemort, also consequently entails the discovery of his own origins. As John Kornfeld and Laurie Prothro note, "Harry's solitary search for his true family is a search for his own identity; his quest for home and family is the journey all young people take trying to find their place in the world" (2009: 135). Ultimately, though intimated in the House Sorting Ceremony, and by Harry's ability to converse with snakes in parsel-tongue, viewers realize by the sixth film that Harry's identity relates intimately to that of Voldemort. The narratives also draw more generally upon instabilities of identity for their various twists and turns. For example, several of the characters' identities change over the course of the eight films, either because they are "Animagi" (shape-shifters) or because of drinking polyjuice. Integral to the terror that Voldemort instills is his capacity to assume an amorphous, disembodied form.

ABJECT SETTINGS

Over the course of the eight films, the nature of abject space changes, the earliest ones being concerned with physical disgust and the later ones (made after 2001) featuring abjection in relation to boundary transgression and terrorist activity (reflecting issues of national security). The final two films especially resonate with images of death, conflict, and challenges to Harry's identity through increasing psychic disturbance, their darker visual style being politically inflected, and their imagery often resembling that of 9/11. Scenes of graphic bloodshed and cruelty become more noticeable, both aspects having abject connotations.

The earlier films' ability to trigger sensations of disgust in the viewer manifests frequently—Ron Weasley's vomiting of slugs in the second film is a typical example. In relation to these scenes, Lisa Damour argues that "repulsion is critical to the story line—but much of the time it's just for fun" (2003: 19). Thus, while indicating the fascination of abjection for children (and thereby entertaining for child audiences), the literal passage through it

has implications for adolescence, a time when mastery of the physical body is essential to attaining a coherent adult identity. Consequently, the bathroom tends to be a focal point for activity, and several sequences unfold here that reference bodily fluids and transformation as features of adolescence. Sometimes, these encompass dark and foreboding aspects, and scenes of gigantism as spectacle are often deployed to mobilize terror. Such instances include a giant troll in *The Philosopher's Stone,* where low-key lighting, lightning effects, and dark shadows imply threat while low-angle shots from Harry and Ron's perspective emphasize the troll's enormity. Bodily fluids pervade the imagery of the second film, too, which again features the girls' bathroom as an abject space since it is not only haunted by a nihilistic ghost called Moaning Myrtle (Shirley Henderson) but also conceals the entrance to The Chamber of Secrets, an underground labyrinth, allegedly home to a monstrous basilisk. The labyrinth itself has connotations of the inner body, while the snake's huge fangs, seen in extreme close-up, drip with saliva and venom. A tracking shot down its entire length emphasizes the enormity of its body, while it glides continually towards the camera, intensifying sensations of danger for the spectator. Having defeated the monster, Harry destroys Tom Riddle's (Christian Coulson) "memory" (found within a diary depicted as a physical space) by jabbing one of the snake's fangs into the bewitched book. Seen in close-up, blood gushes from its blank pages, while the psychic space that the book encompasses is further abject because it is a Horcrux.

Further examples of abject spectacle abound, including a gigantic three-headed dog in *The Philosopher's Stone* and an encounter with an anthropomorphized plant called Devil's Snare. Close framing and low-key lighting emphasize the trio's anxiety as the plant coils itself rapidly around their bodies, although they escape, falling further downward. The theme of falling thus recurs frequently, becoming increasingly discernible in the later films, but the use of magic always enables survival. The revelation that Voldemort is surviving in Professor Quirrel's (Ian Hart) body in *The Philosopher's Stone* precipitates further disturbing sights. As Quirrel unwraps his turban, he reveals the hidden face of Voldemort—like the three-headed dog, this double-headed body is highly disquieting. Conflict between Harry and Quirrel causes Quirrel's body to disintegrate, leading Voldemort to materialize as an arresting image of swirling, anthropomorphized black smoke. The reference to bodily disintegration and black smoke, absent in the novel, may be evocative for post-9/11 audiences in the way that many bodies were never recovered from the Twin Towers.

The spatial terror escalates throughout the second film, with events leading Ron and Harry to a giant spider's lair in The Dark Forest. Blue-toned lighting and long shots of the boys emphasize their vulnerability, as giant

tree roots seem to dwarf them. Echoing the sequence of Shelob in *The Lord of the Rings*, a flesh-eating tarantula named Aragog terrorizes the twosome, with close-ups highlighting the spider's monstrous features and black, glistening eyes. These are intercut with high-angle and long shots demonstrating its colossal size in comparison to that of the two boys. As Ron and Harry are about to leave, the tarantula tells them: "I cannot deny [the spiders] fresh meat when it wanders so willingly into our midst," the taboo of such consumption (of human flesh) having abject implications.

Thus, the early films largely invoke the abject in the context of its fascinating, disgusting, and forbidden nature. The later films adopt a more sinister tone, the theme of eating human flesh recurring in *The Deathly Hallows: Part 1* (Yates, 2010) when Voldemort commands Nagini, his pet snake, to devour Hogwarts' teacher, Charity Burbage (Carolyn Pickles) as punishment for her teaching about Muggles. This term refers to nonmagical folk, whom Voldemort and his followers see as "other," conveyed by analogies with the Nazi regime and reference to the "abomination of mixing Muggle and Magic blood" (*The Deathly Hallows: Part 1*). Additionally, Harry, Ron, and Hermione notice a sculpture within The Ministry of Magic, which alludes to the persecution of the Jews, a theme reiterated in the Ministry's printed propaganda on Muggles. Such discrimination, especially in its alignment with the Holocaust—as in *The Lord of the Rings*—may forge intertextual associations through multidirectional memory between the Holocaust and the war on terror.

The later films not only lean toward immorality and xenophobia but also evoke the other through suggestions of terrorism. Nihilism pervades the the series' fourth film, *The Goblet of Fire* (Newell, 2005), with its 9/11 resonances emerging in various ways. The film begins at the Quidditch World Cup, with Harry and the Weasley family arriving there by port-key. Here, Death Eaters ignite their tents, burning them to the ground, canted angles and rapid editing cutting to a long shot of the smoldering remains. Diegetic silence accompanies this latter image, clearly referencing the 2001 attacks, again a sequence that is absent in the novel. The scene cuts to Hermione reading a newspaper, the 9/11 connection made explicit in its headline. Seen in close-up, it states, "Terror at the Quidditch World Cup," the combination of the words "terror" and "world" presumably familiar territory to a post-9/11 audience. Subsequently at Hogwarts, a new Defense of the Dark Arts teacher, Mad-Eye Moody (Brendan Gleeson), teaches the young apprentices torture and killing curses—in one example, a protracted close-up sees a spider undergoing a torture curse, its screams amplifying its horrific nature. Indeed, the theme of torture becomes increasingly apparent, likely referencing concurrent events at the detention camps of Guantánamo Bay, Bagram, and Abu Ghraib, the revelations of which had by now emerged.

Harry's next test of his morality and courage is the Tri-wizard Tournament, the outcome of which leads Harry and fellow student, Cedric (Robert Pattinson) to its final stages. Together the two grasp the cup, unaware that it is also a port-key, which transports them to a surreal, low-lit graveyard. Here, the camera pans slowly across the scene to reveal a tombstone bearing the name of Tom Riddle, and then a huge cauldron beneath which a fire spontaneously ignites. In some of the series' most abject spectacles, viewers see Wormtail (Timothy Spall), Voldemort's assistant, carrying a hideously emaciated Voldemort in his arms. Wormtail throws Riddle's bones into the cauldron, severs his own hand, and adds it to the brew before cutting into Harry's arm, the use of low angles heightening the scene's surreal aspects. As Wormtail proclaims, "The Dark Lord shall live again," a close-up of Harry's blood dripping from the knife blade into the cauldron becomes a swirling mass from which Voldemort emerges in a scene of monstrous rebirth. The scene is abject, both in its connotations of birth and in Voldemort's

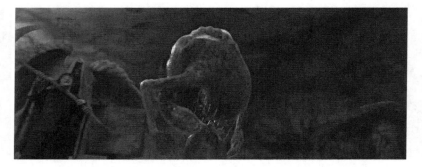

Figure 3 Voldemort's (Ralph Fiennes) rebirth in *Harry Potter and the Goblet of Fire*.

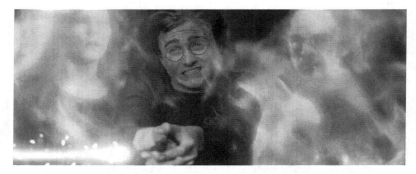

Figure 4 Harry Potter's parents in *Harry Potter and the Goblet of Fire*.

physically repugnant appearance, as well as in his symbolization of evil. A long shot reveals him as a slimy, fetal form, with protuberant bones and semitranslucent grey skin, while close-ups accentuate his hairless features and flattened nostrils that render him reptilian in appearance. Moreover, Voldemort lacks a soul, since it remains within the Horcruxes, and he therefore exists in a liminal state. As Kristeva states, "the body without a soul" represents fundamental pollution (1982: 109).

A protracted close-up of Voldemort's insertion of his wand into Wormtail's arm provides a further instance of bodily transgression and leads to the materialization of the Death Eaters as black whirls of smoke. After magically restoring Wormtail's hand, Voldemort turns his attention to Harry, challenging him to a duel. As their wands "connect" in conflict, Harry's deceased parents appear as shimmering, ghostly apparitions and conjure a protective shield to temporarily protect Harry, a scene reassuring both to younger and older viewers alike in its suggestions of a spiritual guardian presence.

The fifth film, *The Order of the Phoenix* (Yates, 2007), continues with references to 9/11, its language persistently suggestive of terrorism. These include, for example, "attack without authorization" and references to "the war," as well as a theme of recruiting followers to Dumbledore's Army, a group led by Harry to practice and perfect Defense Against the Dark Arts in readiness for Voldemort's attack. When Hermione asks Harry to lead Dumbledore's Army, Harry's response, "When you're out there, when you're a second away from being murdered or watching a friend die right before your eyes, you don't know what it's like" also references warfare. In addition, hallucinations increasingly haunt Harry with acute psychic disturbances manifesting themselves as surreal, disjointed flashbacks, narratively reflecting the fact that his body contains one of the Horcruxes, and also suggestive of PTSD. References to torture further surface in the "teaching" techniques of Professor Umbridge (Imelda Staunton), who forces Harry to write lines using a bewitched quill as punishment for questioning her methods. As he writes the words "I must not tell lies," we see in close-up the same words appearing on his hand as bleeding, painful wheals, a form of extreme discipline that she utilizes repeatedly.

Moreover, an increasingly prominent visual element of this film is the shattering of glass from tall edifices, which often takes the form of an arresting image. One example occurs in the sequence where the Weasley twins attack Umbridge with fireworks—the final explosion causes paper fragments and glass to shower outward in slow motion from Umbridge's proclamations, which are nailed high on the walls above. There is a silent pause before the proclamations tumble downward, accompanied by a deep, rumbling sound. A second example arises in the Department of Mysteries, whereby we see from a low-angle perspective the glass-balled "prophecies" tumble

downward and shatter, the sequence again including slow motion and dis-
jointed, surreal imagery. The conflict between Voldemort and Dumbledore
(Michael Gambon) in the Ministry of Magic features similar low-angle per-
spectives, disjointed editing, and slow motion as glass and paper shower
down from a great height. These scenes may therefore activate unconscious
associations with 9/11 in their deployment of arresting imagery.

The bleaker landscapes of *The Half Blood Prince* (Yates, 2009) see London
landmarks beset by the Death Eaters as well as rows of empty shops, reflect-
ing a recession-hit London. The somber tone of the film surfaces at the
outset, with lightning flashes cutting to a close-up of a still, unfocused eye,
establishing a forensic iconography that hints at the darkness to come. A
cut to a low-angle shot of distorted reflections of skyscrapers surrounded
by black storm clouds onto a glass-fronted building directly references 9/11.
Lightning flashes now draw attention skyward where Voldemort's face
materializes in the dark clouds, and a swarm of Death Eaters stream down
toward London. The theme of infiltration therefore persists, the entry of the
Death Eaters into familiar London sights epitomizing the notion of such
violation.

A cut to a high-angle shot from the perspective of the Death Eaters
adopts a Google-earth aesthetic, revealing London rapidly coming into
focus. This precedes a dizzying kinetic negotiation of its streets and ends in
a long-shot of a series of explosions that leave bodies scattered on the ground
and cause windows to shatter outward. The Death Eaters' next target is the
Millennium Bridge, seen in long shot, which subsequently collapses into
the Thames, the camera then pulling back sharply to an overhead long shot
to show the Death Eaters retreating skyward. A radio voiceover reporting
on the Millennium Bridge disaster leads into the following scene that cuts
to a close-up of a newspaper headline stating, "Bridge Collapses—Death
Toll Rises." This introduction, distinct from the utopian tendencies of the
earlier films, and absent in the novel, locates the film in the real world of
the twenty-first century, clearly associating it with terrorism. Indeed, death
dominates this film, from the demise of Aragog, Hagrid's pet tarantula, to
the murder of Dumbledore. A theme of loss also emerges in the film's finer
details, for example, in Horace Slughorn's recounting of the day that he
arose to find his goldfish bowl empty. The gloomy tendencies of the film
persist in the scenes of Quidditch, which see the pitch surrounded by stark
steel towers rather than festooned with their usual bright team colors. In
addition, the mise-en-scène is one of darkness and rain, with muted tones
and low-key lighting. References to terrorism occur throughout the film; for
example, security is evident as Filch (David Bradley), the caretaker, asks the
students for identification when arriving at Hogwarts, and searches their
belongings for weapons. In the closing scenes, as the Death Eaters cause

mayhem, and Harry lies injured on the ground, an extreme low-angle shot of Hogwarts from Harry's perspective, with dark clouds billowing behind it, encourages flashbulb memories in its semblance to the Twin Towers.

Increasingly, wands and broomsticks become murder weapons or symbols of power. Even Harry resorts to "bad" magic, mastering a curse that almost fatally wounds his adversary Draco Malfoy (Tom Felton). Again, the toilet becomes an abject space as Draco, lying in a pool of water reddening as blood seeps from his wounds, nearly dies until Professor Snape (Alan Rickman) saves him. The plot of *The Half Blood Prince* is pivotal since it reveals the existence of the Horcruxes that Harry must destroy to kill Voldemort. The Horcruxes, containing part of Voldemort's soul, are inherently abject, part of a fractured subject, and only viable by virtue of murder. One such Horcrux is allegedly located in a distant cavern to which Harry and Dumbledore may only gain entry by the shedding of blood. Dumbledore therefore cuts open his hand and smears blood over the cavern's walls to gain access. The cave is also abject in the hideous, corpse-like figures that emerge from the water to attack Harry and Dumbledore, with Harry temporarily submerged under water. Long shot sees the skeletal hordes attack, while an underwater, low-angle shot looks up through the gloom to see Harry surrounded by thin, writhing arms. Muffled sounds convey the sense of threat before Dumbledore conjures a wall of flames to destroy the monstrous entities. Indeed, the quest for the Horcruxes continually leads Harry into abject spaces. In another example, Harry and Hermione visit Godric's Hollow to search for the graves of Harry's parents. Beguiled by an apparition of Bathilda Bagshot (Hazel Douglas), really a corpse animated by Voldemort, the two, once more, almost become his victims. Thus, the search for Harry's origins leads him inexorably toward death.

The final two parts of *The Deathly Hallows* culminate in scenes of boundary violation (of Hogwarts) and visceral, bloody images of violence, death, and wounding, reminding viewers of the war on terror as well as of issues relating to national security. *The Deathly Hallows: Part 2* especially conveys a sense of doom, perhaps reflecting a concurrent international pessimism. Its somber mise-en-scène comprises muted color tones and dark, heavy skies and the two dominant sequences, the vaults of Gringotts Bank and the destruction of Hogwarts, each invoke imagery relating to 9/11 and the war on terror. The scene at Gringotts narratively concerns the trio's quest to locate one of the Horcruxes in the vault of Bellatrix Lestrange (Helena Bonham Carter). We see Harry, Hermione, and Ron through a series of rapidly intercutting tracking and panning shots as they enter the vast subterranean caverns of the bank vaults in a motorized carriage. The carriage suddenly upturns and ejects them at a great height, extreme overhead shots revealing their falling bodies. Another visual theme of the scene is the

threat of burial in Bellatrix's vault as its treasure begins to multiply magi-
cally. Harry's search for a missing diadem containing another Horcrux leads
him to the Room of Requirement where, once more, imagery of burning
edifices and falling bodies conveys associations with 9/11, visualized from
extreme overhead shots that show bodies falling into the flames. Low-level
straight-on camera positions also reveal flames billowing toward the specta-
tor (often assuming the form of a dragon), simultaneously enhancing both
spectacle and threat for the spectator.

The final destruction of Hogwarts has distinct connections with Klinger's
notion of arresting imagery through scenes of abject spectacle that correlate
closely with challenges to Harry's subjectivity. As Voldemort's forces gather,
Professor McGonagall resists their infiltration by creating a magical protec-
tive shield around the castle. Essentially, this serves as boundary, excluding
the "terrorist" other, in line with the security themes seen in the preceding
films. Despite its invisibility, we are able to visualize this sheath as spec-
tacle because the attack by Voldemort's followers renders streaks of flames
around it, conveyed either through a low camera angle and long shot from
within Hogwarts or, alternatively, as an overhead extreme long shot from
outside the shield. Such boundary consciousness and security failure are rel-
evant to contemporary concerns with national security (see Debrix, 2005;
Weber, 2006), the protective shield discernible in the final film reflecting
post-9/11 anxieties in relation to further "infiltration." Moreover, there are
specific allusions to the Twin Towers in the burning Quidditch structures,
an extreme long shot rapidly zooming in as they collapse, and flames billow-
ing out toward the spectator.

The symbolic interface between good and evil, rendered visually in the
shield, is also apparent in conflicts involving wands. We see this in the pen-
ultimate showdown between Voldemort and Harry, a long shot revealing
a display of vibrant color, conveying conflict as spectacle as their wands
issue flames of green, yellow, and orange. A cut to a close-up of Voldemort
sees the power of Harry's wand begin to overwhelm him, while intercutting
long shots repeatedly reveal Nagini sliding toward the camera, conveying
additional menace. The whole sequence occurs in slow motion, rendering
it an example of Klinger's "arresting image." At one point, color fills the
frame as spectacle, intercutting with close-ups of Harry's grimly determined
expression. Extradiegetic music builds up to a crescendo as Nagini rises up
toward the camera, a close-up revealing its open jaws and razor-sharp teeth
as if about to strike the spectator. An edit to a side-on shot then shows
Neville Longbottom (Matthew Lewis) raising his sword in slow motion,
before decapitating Nagini, blood spraying out toward the spectator as the
snake disintegrates into black swirls of smoke.

Longbottom's heroic acts further include a rallying speech to his friends: "People die every day, friends, family, we lost Harry tonight, but he's still with us, so's Fred, Remus, Tonks, all of them. They didn't die in vain." These words, as well as his heroic actions, are likely to chime with contemporary audiences, in relation to the deaths reported on a regular basis first in Iraq, then in Afghanistan, during the war on terror. In the final clash of wands between Harry and Voldemort, extreme high-angle shots reveal them falling over the edge of a tower. The blurring of the background indicates the speed of their descent, while rapid tracking shots follow their flight, Voldemort rendered as a black smoking form before both crash to the ground and reach for their wands. Here, the incandescence from their flaming wands dramatically intensifies, the scene then cutting to long shot of Voldemort, who now appears diminished in the frame. A close-up of his decaying face cuts to an overhead shot to disclose, in slow motion, his complete disintegration before the camera pulls back to reveal Hogwarts silhouetted against a brighter sky. The rays of sunshine beginning to filter through symbolize hope while the death of Voldemort in a film released shortly after the death of Osama bin Laden is inevitably meaningful to some viewers. Additionally, Harry's destruction of Voldemort's wand as a symbol of total power may provide a moral commentary on weapons of mass destruction.

Moreover, as Harry subsequently wanders through the ruins, surveying the dead and the wounded, his point of view locates groups talking and smiling. We also see Filch the caretaker sweeping up the rubble. These images offer signs of recovery and are reminiscent of the scenes in Manhattan following 9/11. The subsequent flash-forwards of 19 years further implies optimism and regeneration, and, as other films depicting 9/11 have done, relocates traumatic events in the distant past as part of a shared experience with the spectator (and thereby similar to narrative exposure therapy).

BEWITCHING AND UNCANNY SETTINGS, CHARACTERS, AND THEMES

In contrast to these scenes of death, disgust, and boundary transgression, the world of Hogwarts also generates fascination and fear in its uncanny incarnations of ghosts, anthropomorphism, and magic. Freud (1955b) identifies multiple forms of the uncanny but, in general, describes it as a "theory of the qualities of feeling" (1955b: 219), whereby sensations of unease are generated by examples such as the ghost, the double, and the automaton. Predominantly, such feelings reflect a fear of death, Freud commenting that "many people experience the feeling in the highest degree in relation to death and dead bodies, to the return of the dead, and to spirits and ghosts"

(1955b: 241). He also describes the uncanny as "that class of the frightening which leads back to what is known of old and long familiar" (1955b: 219).

Freud suggests that this combination of strangeness and familiarity resonates most strongly in relation to the mother's body, the original home, which is a "forgotten" place (as a site of trauma), but still familiar. He concludes that "an uncanny experience occurs either when infantile complexes which have been repressed are once more revived by some impression" (1955b: 249). In general, there are alliances between the abject and the uncanny (though the former is mostly associated with feelings of repulsion, and the latter with sensations of dread). In the *Potter* films, however, there is a fundamental proximity between the two, which pertains to Harry's mother. Freud states that, ordinarily, the traumatic memory of birth is repressed. For Harry, a secondary repression occurs at the time of his mother's murder, although he eventually reexperiences her death through flashbacks (thereby displaying symptoms related to PTSD).

Freud's comment that "there is a doubling, dividing and interchanging of the self" (1955b: 234) has relevance to the films' narratives since Harry's quest is one of clarifying his origin. The element of "interchanging of the self" is a particular danger in relation to Voldemort, Pamela Thurschwell explaining that "this too relates to primitive beliefs about death" (2000: 118). Moreover, ghosts and automata, uncanny in the way that they simultaneously acknowledge and repress death, figure prominently in the films, and the revelation of repressed and hidden memories is a significant visual and narrative element. The uncanny is also salient to discourses of magic, since Freud locates the uncanny in animism, a belief system that considers that all living entities possess a soul (1955a: 76).

According to Jack Zipes, "The very act of reading, hearing or viewing a fairytale is an uncanny experience in that it separates the reader from the restrictions of reality [...] and makes the repressed unfamiliar familiar once again" (2011: 2). Zipes goes on to say that during this experience, "there is estrangement or separation from a familiar world inducing an uncanny feeling which can be both frightening and comforting" (2011: 3). In a similar vein, this chapter contends that the emergence of the uncanny in arresting imagery often mobilizes feelings both of unease and of familiarity (in relation to 9/11), arguably enabling a working through of spectator anxiety in relation to contemporaneous concerns.

Inevitably, the rituals and linguistic utterances characterizing the magic of the *Potter* films evoke religious analogies or occult practice. Indeed, Marcel Mauss notes that "magic includes [...] a whole group of practices which we seem to compare with those of religion. If we are to find any other rites apart from those which are nominally religious, we shall find them here" (2001: 11). Certainly, the anthropomorphism evident in the

films correlates with animistic beliefs, though, arguably, there are also scientific connotations in the performance of magic, in particular, the notion of the chemical experiment "gone wrong," for we often see Seamus Finnegan's (Devon Murray) performance of wizardry culminating in an explosion that blackens his face.

More importantly, as well as offering a point of identification for child viewers, the use of magic is, as Griesinger further notes, "a narrative device in articulating hope" (2002: 458). This particular aspect characterizes most fantasy film, and in relation to this chapter partly explains the dominance of fantasy since 9/11 and the place that the *Potter* films occupy in the canon. A particular fascination of the films' magic arises in the way that bewitched spaces exist alongside real spaces. For example, Harry's journey to Hogwarts requires him to pass through a solid brick wall in the "real world" to access The Hogwarts Express on Platform $9^3/_4$. The seeming impossibility of the task is emphasized by a point of view shot from Harry's perspective that pans rapidly up and down the wall, accentuating its solidity. Indeed, while he passes effortlessly through in the first year, the subsequent year sees him crash alarmingly into it. Over later years, however, travel becomes increasingly sophisticated and immediate as Harry learns to "Apparate" and perfects the use of port-keys.

ANIMISM, ANTHROPOMORPHISM, AND THE UNCANNY

These magical properties often endow spaces and objects with uncanny effects because of their animistic or sentient features. Freud explains that "we appear to attribute an 'uncanny' quality to impressions that seek to confirm the omnipotence of thoughts and the animistic mode of thinking in general" (1955a: 86). For animism is, as Freud continues, a primitive belief in the existence of "spiritual beings both benevolent and malignant; and these spirits and demons they regard as the causes of natural phenomena and they believe that not only animals and plants but all the inanimate objects in the world are animated by them" (1955a: 76). Correspondingly, evidence of apparently sentient inanimate objects pervades the *Potter* films, providing obvious pleasures in magic as spectacle, even as the central narrative impetus depends on the premise of Voldemort's fragmented soul.

Indeed, in addition to its spontaneously shifting staircases, the characters that inhabit the portraits hung on the walls move autonomously, and photographs and newspaper images have a third, uncanny dimension, with their characters coming to life in mini-narratives. Moreover, various transport systems seem to have a mind of their own, the measure of a student's success frequently depending on control over these animated forms. For example, Neville's lack of broomstick skills, illustrated by point-of-view shots, rapid

camera movements, whip-pans and fast tracking shots, as well as extreme high- and low-angle shots, provide a source of humor to his fellow wizards. In contrast, Harry easily learns to maneuver midair, his flair for flying subsequently earning him the privileged position of seeker for the Quidditch team. While providing pleasure for younger audiences, the control of flight, a persistent element in the films examined here, is relevant to post-9/11 audiences.

Other enchanted transport systems include the owl postal service, the Floo system, port-keys and portals, The Knight Bus, and the vanishing cabinet of *The Half Blood Prince*. Initially, Harry and Ron have varying degrees of success in utilizing these systems. In *The Chamber of Secrets*, viewers see Harry's attempt to travel via the Floo system (through fireplaces) accidentally transport him to Knockturn Alley, a shadowy, low-lit place for "down and out" witches and wizards, and "one grate too far," according to Mrs Weasley. After their attempt to pass through the solid wall to Platform $9^3/_4$ fails in the second year, their subsequent journey to Hogwarts in Ron's flying car results in chaos as they crash into the Whomping Willow.

Like Ron's car, the Knight Bus, emergency transport for stranded witches and wizards, is anthropomorphized. Bizarrely decked with a chandelier and hospital-style beds, the bewitched triple-decker Knight Bus accelerates to hyperreal speeds and squeezes through small gaps in traffic (long shots suggest that it almost "breathes in"), existing invisibly amid the real world of London. Rapid editing, fast tracking shots, extreme camera angles, and a close-up of a fast-talking, disembodied head further contribute to the image as animistic, uncanny spectacle.

One of the first scenes on arriving at Hogwarts is the Sorting Ceremony. Here, the Sorting Hat, an inanimate object that too has its own identity and is apparently capable of reading minds, further sustains notions of the uncanny in relation to animism. Its role is to assess a student's qualities and allocate each to one of the four houses of Hogwarts. The Sorting Hat seems indecisive when placed on Harry's head, leading Harry to further question his origins, an element that is narratively important in relation to later anxieties about his similarities to Tom Riddle. Other examples of the anthropomorphic uncanny abound—ranging from mandrake roots (seen in close-up) that appear as screaming, hideous infants, to Ron's attempt to "transfigure" his pet rat. The resultant squealing, fur-covered goblet that retains a moving rat's tail is seen in close-up to accentuate its living qualities.

GHOSTS, AUTOMATA, AND THE UNCANNY

Ghosts and automata constitute another class of the uncanny and, for Freud, generate fear through associations with death. Freud notes that uncanny

feelings occur in relation to automata when "there is an intellectual uncertainty whether an object is alive or not, and when an inanimate object becomes too much like an animate one" (1955b: 233). The Wizard's Chess scene exemplifies this notion of the uncanny. Here, Harry and his two friends find themselves on a giant chessboard, and extreme low-angle shots and canted angles amplify the frightening effects of the gigantic chess-pieces as they move autonomously to violently destroy one another.

Although the numerous ghosts at Hogwarts, despite often emerging unexpectedly, do not generally alarm the students, the materialization of the Dementors, en route to Hogwarts in *The Prisoner of Azkaban* (Cuarón, 2004), generates extreme feelings of dread. In line with Klinger's analysis of the arresting image, the narrative here seems to slow down. Muted color tones, a rainy mise-en-scène, canted angles, and distorted sound effects amplify unease, while the movement of the black spectral forms occurs in slow motion. Close-ups of their long spindly fingers heighten a sense of menace, and their infiltration of the train may have connotations of hijacking for some viewers. Freud argues that "spirits and demons [...] are only projections of man's own emotional impulses. He turns his emotional cathexes into persons, he peoples the world with them and meets his own internal processes again outside himself" (1955a: 92). Such externalization of Harry's internal battles arguably works in a related way for the spectator, rendering visible the otherwise unknown terrorist other.

REPETITION, DOUBLING, AND TIME TRAVEL

Freud explains that a fear of death may also derive from the double, stating that the double's earlier meanings assured immortality but has "become the uncanny harbinger of death" (1955b: 235). Poly-juice and time travel offer opportunities for such repetition and doubling: in *The Deathly Hallows: Part 1,* Harry's friends transform themselves with poly-juice into seven identical copies of Harry, while *The Prisoner of Azkaban* sees Hermione acquire a Time-Turner, a device for time travel. In the latter, the Dementors attack Harry and Sirius Black (Gary Oldman) and initially overwhelm them, until a mysterious figure, whom Harry believes to be his father, conjures a "Patronus" spell, forcing the Dementors to retreat. The Dementors' attack is visualized as spectacular in the way that they withdraw the breath from Harry and Sirius, their breath visualized as a life force leaving their bodies. The Patronus spell, effectively producing a form of "timespace," creates a magical shield that deflects the Dementors and allows Harry and Sirius to recover. In an exact later repetition of the scene, albeit now entirely from Hermione and Harry's perspective as onlookers, Harry learns that the mysterious, powerful figure was his own.

The replication of the scenes from different perspectives and the appearance of each of the characters twice within the same frame generate feelings of déjà vu, both for the spectator and for the characters within the diegesis. In addition, Harry's identification with his father in the "Patronus" scene signals his increasing symbolic power, a significant moment in his transition to adulthood, whereby he represses the abject both literally (by repelling the Dementors) and figuratively (he enters the symbolic). Moreover, the Time-Turner enables Harry and Hermione to alter the course of events, whereby the Hypogriff (thought to have been executed first time around) escapes. Time travel thus operates as fantasy's mode of dealing with trauma in the way that it enables characters to revisit and change their past decisions and, perhaps, to reencounter the deceased. It may offer consolation for spectators too. Furby and Hines support this argument, asking, "Who would refuse the opportunity to return to a crucial moment in the past and change the course of history for the better?" (2012: 150).

MEMORY AND DEATH

In another form of time travel, Harry is able to go back into the psychic space of memory itself. He first does this in *The Chamber of Secrets* by entering the past through Tom Riddle's diary, an apparently blank book that Harry finds in the girls' bathroom. Discovering its ability to converse with him, a revelation rendered in close-up as spontaneously written responses appear in the diary, its invisible writer, Tom Riddle, draws Harry back 50 years into its memory. The book's pages suddenly flick open, as if caught in a gust of wind, before a blinding flash of light emanates from its pages and fills the screen. Harry disappears from view, leaving the diary on his desk, before there is a cut to a black-and-white mise-en-scène. Narratively, this scene relates to the exposure of Tom Riddle's past. Visually, the use of monochrome not only indicates that he has travelled back in time but also signals Hogwarts' strangeness (as uncanny memory).

In *The Half Blood Prince,* Harry further explores memory through the Pensieve, first summoning Dumbledore's initial encounter with Tom Riddle, memory signified as psychic space by visual distortion that produces a ghostly effect. Returning a second time, he sees Professor Slughorn in conversation with Riddle, a memory with which Dumbledore believes that Slughorn has tampered. The narrative import of this particular memory lies in its concealed revelations about the Horcruxes. Ultimately, this knowledge relates to Harry's identity, since one of the Horcruxes resides within Harry, thereby explaining the central enigma of the series. In the

final film, *Deathly Hallows: Part 2*, Harry uses the Pensieve to access Snape's memory. Again, these images are conjured as surreal and in slow motion—though this is a common visual strategy to signify memory, the atemporality conveys the scene as an arresting image of uncanny space and ghostly incarnation.

Perhaps the films' most uncanny spectacle arises in *The Deathly Hallows: Part 2*, when Voldemort first attacks Harry who then seems to enter another dimension, signified by an almost complete blanching of the scene and total diegetic silence. Here, Harry encounters the spirit of Dumbledore in a ghostly incarnation of Kings Cross station, these aspects being clearly suggestive of an afterlife. Klinger's notion of the arresting image is salient here, since sound is absent except for their conversation, and the image is particularly striking in its incongruent elements—as Harry peers beneath a slab he sees a disgusting, emaciated entity, its bloody flesh flayed and mediated as abject spectacle. Dumbledore explains that the abject being is the final Horcrux that existed within Harry.

CONCLUSION

As in the original novels, the film adaptations of *Harry Potter* chart the progress of its protagonist toward a coherent subjectivity and his quest to uncover his secret past. Harry also has a mission to defeat Voldemort, leading him into a series of abject, uncanny, and bewitching spaces that each present challenges involving tests of morality and physical and psychological endurance. As a subject in process, Harry displays a control of spaces through the articulation of his wand and the use of advanced magic, excelling in the mastery of flight. His sociocultural and psychosexual development is thus not discernible by conventional methods of schooling and social interaction but by his negotiation and command of bewitching, abject, or uncanny spaces. This negotiation often results in instances of spectacular arresting imagery that may mobilize spectator emotion through associations or memories pertaining to 9/11. Recovery from near-death experiences and the control of flight may therefore be meaningful for older audiences. In fact, at times, there are direct references to 9/11, including falling bodies, smoke, and shattering glass, that may trigger flashbulb memories of the Twin Towers' collapse.

The films' rendering of memory as a physical space has uncanny connotations in its capacity to enable repetition and revelation of hidden traumatic pasts, and the visualisation of psychic space, often indicating Harry's slowly fracturing identity, is especially illustrative of Klinger's notion of the arresting image. In this way, Harry's quest not only culminates in a coherent

subjectivity through the destruction of evil but may also unconsciously provide relief, hope, or a sense of resolution for some spectators, especially those bereaved by warfare and acts of terrorism. The most resonant scene for younger and older viewers alike is likely the death of Voldemort, eliciting emotion in the destruction of a feared and often invisible enemy.

PIRATE POLITICS AND THE SPECTACLE OF THE OTHER: *PIRATES OF THE CARIBBEAN*

THE FOUR FILMS OF THE *PIRATES OF THE CARIBBEAN* FRANCHISE (2003–2011) achieved phenomenal success at the box office, the latest incarnation, *On Stranger Tides* (Marshall, 2011), currently standing ninth in all-time worldwide box-office rankings,[1] and the franchise is the eighth-highest grossing film series of all time.[2] *Curse of the Black Pearl* (2003) garnered particular critical acclaim and was nominated for five Academy Awards, with twenty-eight wins and sixty-nine further nominations.[3] In total, the first three films, directed by Gore Verbinski, were nominated for eleven Academy Awards, *Dead Man's Chest* (2006) winning the Academy Award for its visual effects, with Johnny Depp nominated for Best Actor-comedy for *Black Pearl* and *Dead Man's Chest*.

The box office success of the four films not only reflects a generalized millennial proclivity for fantasy but also (together with most of the films discussed in this book) a trend toward the increasing serialization of films to exploit preexisting audiences. Unlike its franchise contemporaries, however, the first three *Pirates of the Caribbean* films are adapted from a Disney theme-park ride rather than a literary source, as is often the case, and therefore lack an overarching narrative. The fourth is based on a novel of the same name written by Tim Powers. Yet, like the *Harry Potter* films, the series spans the first decade of the new millennium (with scriptwriting for a fifth sequel underway) and is therefore useful in examining fantasy trends since 2001.

The films' popularity undoubtedly stems primarily from their charismatic stars, particularly from Johnny Depp's mesmerizing performance as pirate Captain Jack Sparrow, with Orlando Bloom, Keira Knightley, and Geoffrey Rush also in central roles. The depiction of other characters, utilizing CGI effects, is further relevant to the films' positive reception and terrorist subtext. Set in the late eighteenth and early nineteenth centuries, the films pivot around the exploits of Sparrow, a character that Depp articulates as eccentric, transgressive, and sexually ambiguous. Displaying a flamboyant swagger, exaggerated arm flourishes, and slurred speech, Depp also incorporated certain words and stock phrases as part of Sparrow's persona, including for example, the word "savvy." These have become synonymous with the character, the final scene of the *Black Pearl* ending with Sparrow's now-familiar line, "Bring me that horizon. Drink up, me hearties. Yo ho." The uncertainties about Sparrow's motivations, allegiances, and his general contempt for authority are embodied in his personal effects, with his compass pointing to whatever one most desires, rather than having any true geographical bearing. Sparrow's antiauthoritarianism also manifests in his striking appearance—long beaded dreadlocks, gold teeth, and dark, kohl-rimmed eyes. Depp's modeling of Sparrow on Keith Richards (who appears in the last two films as Sparrow's father) is well documented, as is Disney's aversion to this portrayal (*Vanity Fair*, 2010) though Leslie Felperin asserts that "it's partly [the] underlying excessive anti-authoritarianism that makes the franchise so appealing" (2006: 66). Counterpointing Depp's subversive Sparrow is Orlando Bloom as Will Turner, a straight, handsome, heroic figure, whom Jacqueline Furby and Claire Hines describe as "having the archetypal qualities of the swashbuckling adventure hero" (2012: 126). Further, Keira Knightley's Elizabeth Swann is a strong female heroine around whom the narrative of the first three films often revolves (Jess-Cooke, 2010: 214). As Rayna Denison notes, "Knightley's success in *Bend it Like Beckham* (2002) and Bloom's rise to fame with *The Lord of the Rings* trilogy made immediate appeals to youth and blockbuster audiences" (2004). In *Black Pearl*, despite first observing Elizabeth dressed in lavish gowns or in a state of undress, she later wears men's clothing, participates in swordfights, and acts independently, therefore shifting from being a passive feminine object of male visual pleasure to an active protagonist. Even so, Harry Benshoff and Sean Griffin claim that "whilst [the franchise] allowed Keira Knightley some occasional swordplay, [it] also reinscribed decades-old stereotypes about race and gender" (2009: 298). In the *Black Pearl*, we also hear the words, "It's frightful bad luck to bring a woman abroad sir," narratively not only reflecting pirate mythologies but also pointing to the gender issues that permeate the film. As Benshoff and Griffin further argue, the majority of action- adventure films "still try to appeal to heterosexual male spectators by

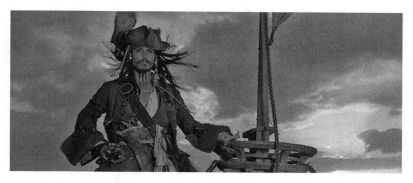

Figure 5 Captain Jack Sparrow (Johnny Depp) in *Pirates of the Caribbean: The Curse of the Black Pearl*.

objectifying their female performers" (2009: 298) and, certainly, the ripping of Elizabeth's bodice and her forced undressing at sword-point by various male characters in *Black Pearl* support this claim. In fact, a sense of female objectification persists throughout the franchise: when Jack discovers that one of the crew is Elizabeth, dressed as a man, he tells her, "Those clothes don't flatter you at all. It should be a dress or nothing" (*Dead Man's Chest*), and in *On Stranger Tides*, the tail of a pernicious mermaid, Syrena (Astrid Bergès-Frisbey) disintegrates, leaving her completely naked.

A second contributory factor to the series' success is its Academy Award-winning visual effects, afforded through digital technologies, including motion-capture CGI. These enable both settings and characters to assume spectacular characteristics, in *Black Pearl* reconfiguring the undead pirates as skeletal zombies, and in *Dead Man's Chest*, as hideous semi-human aberrations, resembling sea creatures. Other distinctive CGI special effects include the creation of the monstrous Kraken (*Dead Man's Chest*) and the conjuring of dramatic settings, such as the maelstrom in *At World's End* and the surreal afterlife of Davy Jones's Locker in *Dead Man's Chest*.

In respect of genre, the films' hybrid nature contains all the requisite ingredients for universal appeal: fantasy, action, adventure, piracy, and romance. *Black Pearl* also draws on the zombie genre, and magic and mysticism permeate the entire franchise. Transvestitism is an undercurrent, with some of the pirates dressing as women, and Elizabeth and Angelica (Penélope Cruz) masquerading as men, while Jack Sparrow is camp and effeminate, commenting to Mr. Gibbs (his first-mate) (Kevin McNally) in *On Stranger Tides*, "I'm just as bent as ever, hellishly so." In fact, in interview with Patti Smith for *Vanity Fair*, Depp revealed that when a Disney executive had asked him if Sparrow was gay, Depp replied, "All my characters are gay" (2010). In addition, the films have many humorous scenes

with comic dialogue and playful innuendo: during the sword-fight between Jack and Will at Will's workshop, Jack asks him, "Who makes all these?" "I do and I practice with them three hours a day," responds Will. "You need to find yourself a girl, mate," says Jack Sparrow, implying that Will has nothing better to do. Humor emerges in the parody of the pirate genre too. For example, there are several comic instances concerning rum consumption. In *On Stranger Tides*, Captain Barbossa (Geoffrey Rush) stores his rum in his wooden leg, casually unscrewing it and then drinking from it. Whenever Jack encounters Elizabeth after her desert-island bonfire in *Black Pearl* (when she ignited Jack's supply of rum to attract the attention of passing ships), he is repeatedly heard to mutter, "Quick, hide the rum." Further spectator engagement may result from the films' self-reflexive aspects, their intertexuality, and the rousing extradiegetic music devised by Klaus Badelt and Hans Zimmer (Binkley, 2011).

The filmmakers thus clearly designed the films to capture a broad spectrum of viewers. In fact, of all the films examined here, the franchise comes potentially closest to Kathy Smith's claim that fantasy provided relief in the aftermath of 9/11. Yet, in line with the tendency for much postmillennial fantasy to reflect its post-9/11 contexts (whether consciously or not), some scholars locate a politicized inflection within the series. Douglas Kellner claims that the third film, *At World's End* (2007), comments on the Bush-Cheney Administration, noting that "scores of scruffy people are being hanged, presumably without trial, because they have been accused of consorting with pirates. This is an obvious coding of pirates as terrorist and of the established regime as repressive and murderous" (2010: 163). Richard Bond also likens the pirates of the franchise to terrorists, arguing that "the historical and cultural context into which the pirate films were released was ripe for the re-emergence of a film that explored the potential for extralegal political action" (2010: 318). He goes on to say, "No longer do pirates fight because the world has rejected them (all the while secretly longing to rejoin the world) [...] Rather they fight for themselves in a world that has entirely turned against them—in a world that seeks to terrorize and destroy the pirates themselves" (2010: 318). Bond concludes that it is therefore possible to interpret the *Pirates of the Caribbean* franchise "as deeply embedded in the American war on terror" (2010: 319).

Although the films appear to have a lighter tone than that of other post-9/11 fantasies such as *Pan's Labyrinth* and *The Dark Knight* and lack the gravity conveyed in fantasy quests such as *The Lord of the Rings* trilogy and the *Harry Potter* series, clearly, there are narrative elements that strike a chord with scholars in respect of their contexts. Moreover, though the franchise maintains its humorous aspects throughout, it does become increasingly dark. As this chapter aims to demonstrate, arguably, there is also imagery

that may remind viewers of 9/11. Given that the first film completed production in October 2002, and that the US government intervened in certain other Hollywood productions of the time in respect of potential "war on terrorism" content (Valantin, 2005: 90), it is not surprising that any allusion to September 11 is understated. Yet, there are discernible resemblances to 9/11 that have potential to trigger "flashbulb" memories or to produce more subtle unconscious associations through arresting imagery, which is often facilitated through CGI effects. Further, the characterization of the pirates mostly involves some form of spectacular representation, as abject display and physical anomaly, or as exotic other in the case of Jack Sparrow. These modes of representation consistently mobilize the pirate figure as strange and different, thus supporting Kellner and Bond's contention for pirates as terrorists. This chapter therefore explores the various visual and narrative aspects of the films in respect of spectacle and considers how far the *Pirates of the Caribbean* franchise presents an oblique mediation of contemporaneous events.

THE FILM PLOTS

The first film, the *Black Pearl*, tells the story of blacksmith Will Turner, rescued from drowning by the crew of a ship led by Governor Swann (Jonathan Pryce) and Lieutenant James Norrington (Jack Davenport). Elizabeth Swann (Keira Knightley), the governor's daughter, looks after the unconscious boy and discovers a pirate's medallion around his neck, not fully realizing its significance until later. Looking off into the distance, we see from her point of view the tattered black sails of the Black Pearl, a ghostly pirate galleon. As Elizabeth blinks her eyes in disbelief, the film then fast forwards by eight years to reveal her now as a young adult. Her father encourages her to consider marrying Norrington and buys her a lavish, tight-fitting dress to wear at the occasion of Norrington's promotion. After the ceremony, Norrington broaches the subject of marriage with Elizabeth, but because of the tight-fitting bodice, she faints and falls over the edge of a cliff. At the same time, pirate Captain Jack Sparrow has landed on the quay when he sees Elizabeth fall. He dives in and rescues her, but Norrington, who recognizes a brand on Sparrow's arm as that of a pirate, threatens to hang him. Though Sparrow escapes temporarily, they recapture him, intending to hang him the following day. Meanwhile, the crew of the Black Pearl, headed by Captain Barbossa and summoned by the medallion as it strikes the seabed during Elizabeth's fall, attack Port Royal and kidnap Elizabeth. Initially, she leads them to believe that her name is Elizabeth Turner, daughter of a famous pirate William Turner and trades the medallion for a cessation of their attack on Port Royal. The pirates need the medallion to lift a curse that causes them to exist in a permanently undead state, returning to skeletal

form in moonlight. The medallion and its owner's blood must be restored to the chest for the curse to be broken. Because Will Turner loves Elizabeth, he releases Sparrow to help rescue Elizabeth. When Barbossa discovers that Will is the real owner of the medallion, he maroons Sparrow and Elizabeth on an island and takes Will to Isla de Muerta to break the curse. Marooned on the island, Elizabeth sets fire to Sparrow's hidden cache of rum, and Commodore Norrington, whom she persuades to save Will by accepting his former marriage proposal, rescues them. In the end, Will saves Jack from hanging but is pardoned and intends to marry Elizabeth, while Jack escapes to be reunited with his crew aboard the Black Pearl.

The second film, *Dead Man's Chest* (2006) has a darker tone to it, opening with the arrest of Will and Elizabeth by Lord Cutler Beckett (Tom Hollander) of the East India Trading Company and the incarceration of a prisoner who appears to have been tortured. Beckett imprisons Elizabeth, bargaining with Will to retrieve Sparrow's magic compass in exchange for Elizabeth's freedom. Meanwhile, Jack Sparrow has evaded capture by hiding inside a coffin, now seen floating out to sea and from which he emerges (as if from the dead) to join his crew aboard the Black Pearl. On board the Black Pearl, Jack encounters "Bootstrap Bill" Turner (Will's father) (Stellan Skarsgård), sent by Davy Jones (Bill Nighy), who warns him that Jones has summoned a leviathan, known as the Kraken, to shipwreck the Black Pearl. Meanwhile, Will locates the Black Pearl on a deserted island beach, where he is captured by cannibals along with the rest of the Black Pearl's crew. Sparrow promises the compass to Will in return for the key to a chest in which Davy Jones's heart has been secreted. Sorceress Tia Dalma (Naomie Harris) helps them locate the Dutchman, which is captained by Davy Jones and crewed by semi-human sea creatures. Will joins the Dutchman's crew to obtain the chest's key, which Jones keeps around his neck. Elizabeth escapes from prison and, dressed as a man, crews a ship to Tortuga, where she meets Sparrow. There, Jack assembles another crew, this time including Norrington. Will, Elizabeth, Sparrow, and Norrington locate the chest, with the last stealing the heart. Davy Jones summons the Kraken to attack their ship, and they abandon it with Elizabeth chaining Sparrow to the ship and leaving him to the fate of the Kraken. A guilt-ridden Elizabeth and Will consult Tia Dalma, who tells them that they can rescue Jack at World's End. The film concludes with the entrance of Barbossa as the captain to lead them there.

At World End (2007), Gore Verbinski's third contribution to the franchise, tells the story of Jack's rescue from Davy Jones's Locker by a crew that includes Elizabeth and Will and is captained by Barbossa. In pursuit are Cutler Beckett and Davy Jones. After recovering charts to World's End from Captain Sao Feng (Yun-Fat Chow) in Singapore, Barbossa steers the Black

Pearl to World's End where they access Davy Jones' Locker, rescue Sparrow, and return. Barbossa and Sparrow fight against Davy Jones and are caught in a maelstrom, conjured by Calypso, a sea goddess who assumed the guise of Tia Dalma. Will is fatally wounded but with Sparrow's help, pierces Davy Jones's heart before he dies. Jones falls into the centre of the maelstrom and Will is condemned to captain the Flying Dutchman, ferrying the dead to the next world.

The fourth film, *On Stranger Tides* (2011) follows Jack from London where he hears of an imposter summoning a crew. Sparrow finds the imposter to be his former lover, Anjelica, the daughter of Blackbeard (Ian McShane), who has lured Sparrow to procure the map leading to the Fountain of Youth. Blackbeard wants to locate the fountain because it has been forecast that he will be slain by Barbossa in revenge for his theft of the Black Pearl. Though Barbossa has since changed allegiance and now works as a privateer for the Royal Navy, he joins forces with Sparrow to gain revenge on Blackbeard. En route to the fountain, they ward off a group of beautiful but deadly mermaids but capture one, Syrena, as they need a mermaid's tear to activate the effects of the magical fountain. Jack leads them to the fountain where Barbossa attacks Blackbeard with a poisoned sword, upon which Anjelica also injures herself—Sparrow gives both of them the Fountain's water, but only Anjelica's contains the mermaid's tear, and Blackbeard dies. Barbossa returns to his old pirating ways as captain of the Queen Anne's Revenge, while Sparrow maroons Angelica on a desert island and then sets off with Gibbs to restore the Black Pearl (Blackbeard has reduced it to being a ship in a bottle).

DEATH, IMMORTALITY, AND OTHERNESS

If *Pirates of the Caribbean* seems a comic, apparently frivolous enterprise, it nonetheless has macabre undercurrents and depends on the fact that many of its characters are already dead, and the penalty for being "other" (in this case, a pirate), is execution. In fact, torture and death continually pervade the franchise, with scriptwriters Ted Elliott and Terry Rossio, in interview with Scott Holleran, describing how in *Dead Man's Chest*, they "set out to suggest the world of pirates is darker" (Holleran, 2007). Certainly, the second and third films display aspects of wanton cruelty. For example, Davy Jones forces Will Turner to flail his own son, the scene made more disturbing by the sneering twitch of Jones's tentacles and mouth, which suggests sadistic pleasure. In *On Stranger Tides*, Blackbeard kills a mutineer by dispatching bolts of fire at his dinghy, commenting to another pirate, "You know when I feel closest to our Maker? When I see pain, suffering and anguish. That's when the true design of this world is revealed." The English justice system

appears equally brutal: "Justice will be dispensed by cannonade and cutlass and all manner of remorseless pieces of metal," Lord Cutler Beckett tells Elizabeth's father, Governor Swann (*Dead Man's Chest*). In fact, the fear of death and its evasion through various routes to eternal life underpin the entire series, with the curse of the Black Pearl conferring immortality on its crew, and those opting for Davy Jones' Locker living forever. "Do you fear death? Do you fear that dark abyss? Join my crew and postpone judgment," Jones exhorts the pirates, thereby directly confronting viewers with death and the possibilities of an afterlife. Indeed, *On Stranger Tides'* central narrative premise hinges on the Fountain of Youth as a source of everlasting life.

Beside their preoccupation with mortality, the films utilize differences of class, gender, race, and able-bodiedness as a means to signal otherness. As Benshoff and Griffin note, there is a marked class differential, with elegantly dressed English soldiers set against rag-wearing pirates with rotting teeth. Among the pirates, every representational form of otherness appears, and is stereotypically conveyed through the conventions observed within discourses of freakery (see Garland-Thomson, 1996 and 1997), racism (see Shaheen, 2008), and Orientalism (see Said, 2003).

PIRATES AS ABJECT, MYSTICAL, AND EXOTIC SPECTACLE

Although the pirates are generally represented as anomalous other by virtue of class, ethnicity, and physical deformity, they also provide abject spectacle in their various associations with death. The corpse is a particular source of abjection because it reminds us of our own mortality and so threatens a sense of self. Kristeva (1982) explains that other sources of the abject are numerous and broad ranging but generally entail some form of boundary breakdown or violation. In this case, decay physically eliminates the boundary between self and interior other, and the body without a soul epitomizes the abject. As Kristeva notes, "The corpse, seen without God and outside of science, is the utmost of abjection. It is death infecting life" (1982: 4). The *Pirates of the Caribbean* franchise constantly draws on such notions of ambiguity, especially in relation to mortality. Soulless corpses abound, and there is a visual focus on the flayed skin of the zombie pirates of the Black Pearl and the corporeal ambiguity of the Dutchman crew. The pirates are otherwise depicted as abject spectacle in the suspended bodies that are visible in the *Black Pearl's* opening sequence.

Here, as Sparrow approaches Port Royal, three corpses come into view, seen in extreme long shot, hanging over the cliffs with an adjacent sign saying, "Pirates ye be warned," before the camera cuts to medium close-up, emphasizing their decaying abject qualities. In fact, the English officers automatically condemn Sparrow to death because he is a pirate. This is a

consistent feature of the four films, with the theme of pirate execution (or anyone associated with piracy) opening *On Stranger Tides* and *At World's End*. *At World's End* begins with a close-up of a noose that cuts to close-up of shackled feet, followed by a long shot displaying a line of prisoners standing before a row of nooses. The prisoners take a pace forward and the executioners place the ropes around their necks before an edit to the hangman cuts to reveal a row of dangling feet. At the same time, a Royal Navy official announces a series of decrees denying pirates any human rights, a scene that has relevance to the equation between pirates and terrorists in the similar outlawing of terrorists.[4] This sequence occurs several times, the mechanical repetition of the editing emphasizing the systematic nature of the prisoners' execution and perhaps alluding to the Nazi's extermination of the Jews. The camera then pans across to a huge pile of the prisoners' personal effects, further summoning up concentration camp scenarios and perhaps also implying analogies with the detention and abuse of suspected terrorists at Guantánamo Bay. As Roger Luckhurst suggests (2010), it may be possible to interpret one traumatic event through another (as is the case with *Crystal Skull* and *Pan's Labyrinth*).

The pirates take other abject forms. In one nighttime scene, illuminated by a full moon, we see the tattered black sails of the ghostly Black Pearl set against a midnight blue sky. Made possible by motion-capture technology, the pirates then appear to transform into skeletal zombies, their skin peeling away and their insides visible while one has an eyeball that amusingly falls out of its socket. In medium close-up, we see Barbossa drink red wine, which then dribbles from his open throat, exemplifying Kristeva's description of the abject. Here, "the skin, a fragile container, no longer guaranteed the integrity of one's 'own and clean self,' but scraped or transparent, invisible or taut, gave way before the dejection of its contents" (Kristeva, 1982: 53). Barbossa then tells Elizabeth, "You best start believing in ghost stories Miss Swann, you're in one!" (thereby also illustrating the film's reflexivity). As Dan Etherington notes of the film, "Although potentially problematic in terms of the film's appeal to a traditional Walt Disney Pictures audience, such strong content is paradoxically part of the film's success" (2003: 60). The pirates' indeterminate state of decay, while fascinating for younger audiences, thus directs viewers' attention to mortality through abject spectacle and is also suggestive of afterlife.

In addition to abject effects created by digital manipulation, pirates are anomalous in other ways. As Mr. Gibbs lines up Sparrow's newly assembled crew to sail the Interceptor (and rescue Elizabeth), the camera tracks alongside as Sparrow and Will Turner inspect them. "So this is your able-bodied crew," says Will to Jack. The lineup includes several frail-looking old men, a dwarf, a mute, and a woman, each pirate thereby displaying

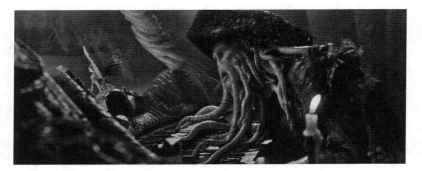

Figure 6 Davy Jones (Bill Nighy) in *Pirates of the Caribbean: Dead Man's Chest.*

some form of physical difference, often in line with determinations of the freakish, as designated by Rosemary Garland Thomson (1997: 53). In the same way that Garland-Thomson suggests that freakish bodies "function as magnets to which culture secures its anxieties, questions, and needs at any given moment" (1996: 2), the unusual body codes the pirate as outsider. Although the iconography of the pirate genre regularly includes eye patches and wooden legs, here disability extends beyond amputated limbs (though these feature too). Fantasy offers particular opportunities for articulating difference as freakery, now configuring the terrorist other as the crew of the Flying Dutchman, amorphous semi-human beings that resemble sea creatures. Davy Jones himself has writhing tentacles that form his "face" and giant claws for legs while encrusted sea creatures disfigure Bootstrap Bill's face. Both men are viewed mostly in close-up, with lingering shots of Jones's tentacles writhing autonomously, eliciting both fascination and repulsion. Jones uses his tentacles as hands, and in one macabre scene, he plays a musical organ with them, the unusual instrument taking the form of a giant, black clamshell. Low-key lighting and dramatic music heighten the scene's surreal effects, while Jones's tear-filled eyes (seen in close-up) and attention to the melancholic melody of a heart-shaped musical box indicate his feelings of loss and grief (and perhaps summon similar emotions in the viewer).

The correlation of physical difference with deviance has its roots in Cesare Lombroso's studies of criminality, whereby he connected certain physical traits with the criminal mind (2006: 222). If, as Kellner claims, pirates are terrorists, then here physical anomaly corresponds with the terrorist other. The consistent association between piracy and otherness contrasts with the orderly figure behavior and white uniform of the wealthy, upper-class English soldiers, thereby further alluding to the racial/colonial signifiers that Benshoff and Griffin suggest. Indeed, there is a racial element

in the contrast between the whiteness of the soldiers' costume and the dark rags (and, often, skin color) of the pirates. Typically, as Jack Shaheen has observed in Hollywood films, the other "is always outside the circle of civilization, usually threateningly exotic or dark-looking. He speaks a different language, wears different clothing [...] and lusts after the fair-complexioned Western woman" (2008: xii). Certainly, the chasing of Elizabeth through her home by the two pirates, Pintel (Lee Arenberg) and Ragetti (Mackenzie Crook) in *Black Pearl* mediates such connotations. Connected to this racialized otherness is the portrayal of Jack Sparrow as exotic spectacle, exemplifying the ambiguity that Erin Mackie identifies in the buccaneer figure. She notes that "the conditions of violence and exploitation that created the Caribbean [...] are embodied in the culturally mythic persona of the pirate whose ethical and aesthetic ambiguity becomes an iconic model for such justice-confounding and opportunity-bedevilling complicity" (2005: 29).

As well as having surreal and abject aspects, piracy also involves elements of mysticism and the supernatural, which first arise in the *Black Pearl* when Elizabeth is lying in bed contemplating the medallion that she took from Will. As she touches the pirate locket, a candle flickers and extinguishes as if some unseen force is present. The scene then cuts to one of Will in his workshop—he suddenly stops work and looks out of the window, his apprehensive figure behavior suggesting a sense of foreboding. As he looks down an alleyway, seen from his perspective, a black cat runs away into the gloom, further conveying a supernatural ambience. Magical undertones also surface when Elizabeth falls off the cliff—as she hits the seabed, the medallion floats out from beneath her dress and pulses so that its surface catches the light. At the same time, an edit to a scene above the water's surface reveals the wind blowing ominously and a barely perceptible tremor sweep across the sea as if the locket is sending a signal. Other supernatural scenarios include the beating of Jones's dissected heart in *Dead Man's Chest*, which also sees Tia Dalma as a mystical fortune-teller. In *On Stranger Tides,* voodoo elements emerge as Blackbeard constructs a replica doll of Jack Sparrow, while his bewitched sword causes ropes to move and knot themselves and sails to unfurl spontaneously.

Yet, despite the pirates having associations with the supernatural and being visually represented as other, a number of examples complicate the good soldier/bad pirate binary. First, several of the pirates are intelligent and articulate, especially Jack, who often uses seemingly complicated sentences and words to confound his enemies (though these are often nonsensical). His nemesis, Barbossa, also takes delight in verbosity, responding to Elizabeth's request for a cessation of hostilities with "I'm disinclined to acquiesce to your request" (*Black Pearl*). Second, Will Turner, depicted as honest, hardworking, and the complete antithesis of Sparrow, also has pirate

origins, while several events point towards Jack being "a good man" (Will Turner, *Black Pearl*). For example, in the *Black Pearl*, Sparrow dives into the sea to save Elizabeth from drowning and returns to the Isla de Muerta to rescue Will. In addition, the pirates have a code of practice to which they religiously adhere: "I invoke the right of parley," demands Elizabeth of her captors. "We must honor the code," they reply. In contrast, the English guards are dim-witted, and Sparrow outsmarts them constantly. Though Norrington first describes Jack as "the worst pirate I've ever seen," when Jack steals their fastest ship, the Interceptor, so that the Navy are unable to catch them, another officer then quips, "that's the best pirate I've ever seen." Ultimately, the line between "good" soldiers and "bad" pirates is blurred—and at times it is unclear which side Jack Sparrow supports as he switches allegiance between pirates and soldiers to suit his own ends. In fact, most of the main characters change loyalties over the course of the franchise, including Norrington, Will, Elizabeth, Barbossa, and Governor Swann. Furthermore, the film persistently encourages the spectator to identify with the pirates and their way of life, emphasizing the attractions of freedom in contrast to the stultifying, repressive, and barbaric regime of the English, which as Furby and Hines (2012: 127) point out, is implied metaphorically by Elizabeth's restrictive costume. This repression is comically hinted at in a line spoken by Elizabeth as she strikes one of the Black Pearl's Crew: "You like pain—try wearing a corset!" (*Black Pearl*). Indeed, Jack's ripping of her corset saves her life, symbolically suggesting the freedom of piracy. While one of the soldiers remarks, "I would never have thought of that," revealing his stupidity, Governor Swann shouts, "Hang him [Jack]," indicating the injustice indiscriminately meted out to pirates (and, by extension, terrorist suspects). Arguably, one might interpret the blurring of the good soldier/bad pirate binary as a questioning of US military action after 9/11 in the same vein as other fantasy films discussed here (*The Dark Knight* and *Avatar*).

SPECTACLE, MEMORY, AND ARRESTING IMAGERY

These combined aspects of stardom, humor, action, magic, and spectacular characterization are undoubtedly instrumental in the franchise's success and steer audiences away from the trauma of September 11. Yet, filming for the *Black Pearl* began in October 2002, just a year after 9/11, and there are visual and thematic instances within the series that are bound to evoke memories of, or generate associations with, 9/11. Potential for this arises in the franchise's constant references to dying and death, action sequences that feature explosions and falling, and less obvious underwater scenes involving surreal imagery that provoke more nebulous feelings of loss.

One such example occurs almost immediately after the film begins. The film opens to a gloomy mise-en-scène of mist and fog as it introduces a ten-year-old Elizabeth Swann (Lucinda Dryzek). Having pulled a young Will Turner (Dylan Smith) aboard, an abrupt cut to Elizabeth's viewpoint reveals a ship ablaze in the midst of the ocean, surrounded by burning debris. This reference to burning and fireballs recurs throughout the four films, and though an inevitable feature of the action-adventure film, nonetheless has the capacity to trigger associations with the Twin Towers' collapse.

The franchise also features a series of spectacular set pieces based on action that frequently involves Jack Sparrow's attempts to evade capture by swinging from various ropes and chandeliers and escaping the gallows at the last minute. In *Black Pearl*, a sword fight with Will Turner, motivated by Will's devotion to Elizabeth, has similar spectacular sequences. Moreover, the pirates' attack on Port Royal involves rapid editing, with one explosion occurring after another, and debris flying out toward the spectator. A wide array of different camera angles, especially low-angle perspectives, heightens the visual impact, the dramatic color palette further extending the spectacular imagery. In the attack, the pirates smash windows while gunfire also causes windows to shatter, such incidents consistently recurring within the post-9/11 fantasy film (we see it in the *Harry Potter* series, and in *Crystal Skull* and *The Dark Knight* too).

CGI sequences produce dramatic visuals in the maelstrom scene in *At World's End*. In line with Aylish Wood's contention for the existence of "timespaces," digital effects extend the scene temporally, adding a narrative dimension. As Wood posits, "Digital effects [...] when they extend the duration of spectacle or give extended movement to spatial element, introduce a temporal component to spaces" (2002: 373). Here, Sparrow and Davy Jones duel while balanced precariously on a ship's bow high above the deck, the stormy backdrop revolving as the ship is sucked into the maelstrom. An extreme overhead perspective reveals the two ships tilting inward toward the abyss of the whirlpool, their topmasts almost touching, while the rousing musical score and rapid editing intensify the drama. Intercutting images of firing cannons, stormy weather, and sword fighting, together with kinetic camerawork, extreme canted angles, and a constantly oscillating viewpoint create a climactic spectacle as the Dutchman and the Black Pearl circle around in combat. The tension is heightened as Jack Sparrow falls and is suspended from the mast, seen from an extreme low angle. An overhead perspective then sees Davy Jones plummet down into the center of the whirlpool, followed by the Dutchman. The creation of a "timespace" here thus extends the duration of the spectacle, mobilizing anxieties about descent into the abyss created by the maelstrom, and creating opportunities for scenes of falling.

The film concludes with a spectacular scene in which the Black Pearl and the Dutchman resurface and destroy another ship, The Endeavour, with Beckett aboard. Its devastation unfolds in extreme slow motion, with debris swirling through the air (a now readily recognizable cinematic allusion to 9/11) and a series of explosions and fireballs erupting behind Beckett as he descends the steps of the Endeavour. Sound distorts as a low camera angle from underwater looks up to reveal the outline of Beckett's body, now floating on the water, visible through the opaque flag of the East India Company (which he owned). Slow motion, a slowing of narrative pace, and a change in the scene's overall color palette from yellow to turquoise convey his death aesthetically as an arresting image while providing a commentary on the perils of mixing politics with business. In fact, "It's just good business," are Beckett's final words. If pirates are terrorists, perhaps Beckett is Bush and we can interpret "good business" as that which is either concerned with oil or war-profiteering in companies that were allied to the Bush-Cheney Administration (Kellner, 2010: 61).

As the film closes, Barbossa steals the Black Pearl, leaving Jack stranded and attempting to assuage the crew about abandoning him by producing a chart showing the location of the mythical Fountain of Youth (opening the film for its sequel *On Stranger Tides*). However as Barbossa unrolls the chart, its central section is missing. The film then cuts to Jack aboard a small dinghy, hoisting a pirate flag and examining what appears to be the missing section of the chart. A close-up of the map reveals the location of "Aqua de Vida," before the camera pans down slightly to take in the island of Cuba (the location of Guantánamo Bay), further alluding to a subtext of terrorism.

One of the most terrifying and visceral examples of spectacle involves the Kraken, a sea monster with giant tentacles, summoned by Davy Jones to attack Sparrow. It first attacks the ship that Elizabeth had crewed (on which Will now finds himself) and, in a rapidly edited sequence, is visible in an extreme low angle shot looking up toward a gigantic tentacle, which almost fills the frame and lashes down toward the spectator. A cut to long shot then shows the tentacle crashing down on the boat with debris flying out toward the spectator in slow motion. A long shot reveals the ship sinking, pulled down by the monster, followed by an extreme overhead perspective that shows the sailors falling into the monster's jaws. The sequence thus elicits terror through monstrous spectacle but is then followed by a scene in which Elizabeth's dress (which the sailors had earlier found aboard) incongruously appears floating on the sea surface, its sleeves outstretched as if worn by some ghostly presence. Like many of the underwater scenes, the juxtaposition of the monstrous Kraken of the previous scene against the arresting image of the floating dress creates a haunting, surreal effect. It carries obvious connotations of loss, once more resurrecting feelings associated with death.

The Kraken then attacks the Black Pearl, its tentacles writhing and penetrating the ship with sucking, viscous sound effects. Will and Jack intend to destroy the Kraken by igniting gunpowder kegs suspended close to the monster. Slow motion close-ups of giant tentacles are intercut with those of Jack taking aim. As he fires, the shot, visible in sharp focus, travels in extreme slow motion, temporally arresting the narrative pace, the crew looking up toward the exploding powder kegs, seen from a low angle. There are then multiple perspectives of the explosion, fireballs exploding toward the spectator and burning debris falling all around. As Elizabeth chains Jack to the Black Pearl, the Kraken rises up again, its gigantic multi-toothed jaws looming behind Jack, who turns around just as it sprays him with slimy mucous and appears to devour him. Throughout the franchise, the sea therefore presents attraction and threat, the magnitude of, and vulnerability to, spectacular menace such as the Kraken, perhaps generating unconscious associations with real-world catastrophes related to the ocean (the Indonesian tsunami of 2004 and Hurricane Katrina in 2005).

In connection with these spectacular images of action and death are persistent references to falling. This is first evident in *Black Pearl* when Elizabeth faints and topples over the cliff edge, filmed from an extreme overhead shot, which then cuts to a low-level perspective, the impact as she hits the water thus alerting Sparrow (who saves her). In the film's finale, Sparrow dives off the cliff and survives too, the event seen in extreme long shot. In *On Stranger Tides*, low-angle perspective sees Sparrow again leap from a high building as it explodes behind him, this occurring in slow motion with Jack silhouetted against the fireball behind him. An extreme low-angle shot then shows him falling, debris flying down toward the viewer, before an edit to long shot discloses him, still plummeting. An underwater perspective then looks up to see him outlined against the light from the fireball as he dives into the sea (creating a spectacular effect). Later in the film, Blackbeard forces Jack to jump over the edge of a cliff into a river, seen again in long shot, Jack once more surviving the fall. Akin to the other fantasy films discussed in this book, survival is therefore guaranteed in scenes of falling, arguably providing a way for viewers to deal unconsciously with media footage of those jumping from the Twin Towers.

In addition to the recurrent trope of falling, the franchise presents various manifestations of death as arresting imagery, not only in the form of zombies and other anomalous beings, but also as human souls. In *Dead Man's Chest*, as Will, Elizabeth, and the remaining crew flee the Black Pearl, their approach to Tia Dalma's home discloses the outline of hundreds of figures standing in the water, holding lighted candles, maintaining a vigil for those lost at sea. The camera pans across a scene of mournful, low-lit faces, having distinct resonances of similar 9/11 candlelit commemorations.

Later in the film, as the crew drifts on the Sea of Dead Souls, caught in the breach between the living and the dead, Pintel and Ragetti look overboard to see dead souls gliding beneath the water's surface (similar to the Dead Marshes scene in *The Lord of the Rings: The Two Towers*) while others float past in lantern-lit boats. Elizabeth is overjoyed to see her father among the souls, believing initially that they have returned from Davy Jones's Locker. "Are you dead?" he asks Elizabeth, and continues, "I think I am. But I am at peace," his words perhaps giving solace to post-9/11 viewers. This preoccupation with death continues on shore, where they encounter the dead Kraken, prompting Jack and Barbossa to reflect more philosophically on life and death. Jack climbs on top of the dead creature, a close-up of its huge staring eye revealing his reflection (and drawing attention to its mortal state). "The problem with being the last of anything, by and by, there'd be none left at all," says Barbossa as Jack looks gloomily at the dead creature. "Sometimes things come back mate. We're living proof, you and me," Jack replies. "There's never a guarantee of coming back, but passing on, that's dead certain," says Barbossa. In contrast to the pervasive allusions to an afterlife, this scene is therefore pessimistic, addressing death directly.

The most obvious allusion to 9/11 occurs in the sequence in *Black Pearl* when Sparrow and Elizabeth are marooned on an island together. To effect their escape, Elizabeth ignites any remaining barrels of rum to attract search parties, causing the surrounding palm trees to catch fire. A medium close-up of Sparrow and Elizabeth cuts to extreme long shot as they walk away from the fire to the other end of the small island. In the distance, the burning trees and billowing grey smoke are visible. The distant fire remains on screen in a protracted shot as Sparrow approaches the spectator before the camera cuts to a sharply focused close-up of him. The narrow depth of field means that the background fire is still apparent but is now out of focus, giving an impressionistic view of it, which is highly suggestive of the burning Twin Towers, especially in its proximity to the water's edge, the smoke billowing out across the sea.

Moreover, although Barbara Klinger's subject of analysis in her contention for arresting imagery, *The Piano* (Campion, 1993) seems an unlikely parallel with the *Pirates of the Caribbean*, the frequent underwater visuals of the franchise lend themselves to such comparison. Klinger describes how the surreal effects in *The Piano* emerge in connection to sound distortion and the slowing of the narrative. Here, there are analogous incongruities and surreal effects, compounded by the dampening of sound that arises from submersion. These have already become apparent in the scene of Elizabeth's floating dress and Beckett's aesthetically presented death. They further include a sequence in *Black Pearl* where the zombie pirates walk along the seabed to storm the ship, the Dauntless. Filmed from a low-level horizontal

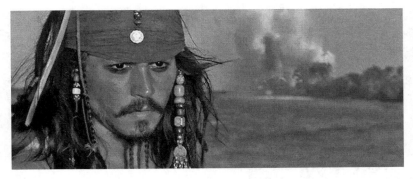

Figure 7 Sparrow and Elizabeth Turner (Keira Knightley) marooned in *Pirates of the Caribbean: The Curse of the Black Pearl.*

underwater perspective, the blue-toned scene of the slowly encroaching army appears surreal. A second bizarre, if comical, underwater sequence occurs as Will and Sparrow walk on the seabed beneath an upturned dinghy, with Will's foot trapped in a lobster cage. A third underwater event sees Will trapped below deck when Barbossa attacks the Interceptor. First, the Interceptor's main mast crashes down toward the spectator, visible in a low-angle shot, but the action is then repeated from a number of angles, occurring in slow motion as an "impact aesthetic." Will is trapped underwater, the tension of this heightened by intercutting with a scene disclosing a long-burning fuse. We then observe in long shot and slow motion a series of explosions that ejects debris outward. Long shot then cuts to sequential close-ups as the ship explodes.

A further underwater sequence at Isla de Muerta is distinctly arresting too. *In Black Pearl*, when Sparrow first approaches the island, the remains of other sunken ships are visible, their masts jutting out of the water like cemetery crosses while the restricted grey and black palette intensifies a sense of foreboding. "Puts a chill in the bones how many honest sailors have been claimed by this passage," says Mr. Gibbs to Jack Sparrow. The next shot cuts to an extreme low angle that looks up toward the ships' remains as sharks swim in between them, thus positioning the viewer on the seabed, effectively from the perspective of those drowned. The sequence is accompanied by sound distortion and has no real narrative significance, with the narrative slowing to enable a prolonged gaze up toward the wrecks lying above. It thereby creates a sense of bleakness and loss, triggering a similar emotion to that which Klinger discusses in relation to *The Piano*, as well as feelings of claustrophobia.

Surreal imagery is conjured too in *At World's End*, whose theme of death persists throughout the narrative as it ostensibly traces the journey toward,

and return from, the afterlife. As Barbossa says to Will Turner, "It's not get-
ting to the land of the dead that's the problem, it's getting back." On board
the ship that sails to the world beyond are Will, Elizabeth, and Barbossa,
among Jack's other former pirating comrades. To access World's End,
Barbossa steers the ship toward the edge of a waterfall. From an extreme
overhead perspective positioned directly above the falls, the spectator sees
the ship plummet over the edge and disappear from view. The screen cuts to
black before then cutting to white, the inference being of a passage through
death (we see a similar visual device in the Kings Cross scene in *Harry Potter
and The Deathly Hallows: Part 2*).

Following this journey to the afterlife, we see a side-on extreme close-up
of Jack's nose and hear the sound of sniffing. The camera pans alongside
the sniffing nose, which is maintained in extreme close-up, set against a
white backdrop, thereby creating a highly surreal effect. The following scene
then bizarrely features Jack envisioning a crew comprising identical copies
of himself. Jess-Cooke and Verevis discuss the sequence in respect of its
self-reflexion, noting that "effectively rewriting himself in a variety of imag-
ined contexts, Sparrow registers the discourse surrounding this character
(and more generally, the Pirate franchise) as 'paratextual'" (2010: 215). By
this, they explain, Sparrow's multiplication points to "the ways in which
the franchise responds to its own reception" (2010: 215). By example, they
refer to the use of a Depp automaton as Sparrow on the original Disneyland
Pirates theme ride.

An extreme overhead long shot now reveals Jack as a minute fleck next
to the Black Pearl, stranded on white sand. Here again, surreal aesthetics
suggest this realm as an afterlife, with smooth white stones apparently trans-
forming into crabs that move the gigantic ship down to the shore. This
surreal sequence, with its blanched colors, is thus distinct from, and com-
pletely incongruous with, the dark and supernatural tropes that otherwise
characterize the film.

Further illustrating spectacular digital effects and arresting imagery, and
of narrative necessity to reenter the world of the living, Jack and his crew
capsize the ship. We hear muffled, creaking noises, while movements occur
in slow motion. An extreme low-angle shot looks upward to see bodies cling-
ing to the ship's edge, outlined against the light above, before cutting in
closer to see the silhouetted figures dangling. We then see the boat entirely
submerged and floating upside down, illuminated by the glow of light above
it, and creating an otherworldly sight. The screen then appears to rotate
through one hundred and eighty degrees at sundown, these effects once
more enabling the creation of a "time-space" (Wood, 2002). A sudden flash
of green light occurs as an underwater low-camera perspective looks up to

see the boat, which seems to be ascending swiftly toward the surface, with rapid editing disclosing a montage of falling bodies and gushing water. The spectator's viewpoint simultaneously ascends through the water's surface to see the Black Pearl suddenly reemerge into the living world, with Elizabeth commenting on the sunrise (this, like the scenes of optimism in the finale of the *Harry Potter* and *The Lord of the Rings* films, likely conveying a sense of hope to viewers).

CONCLUSION

While superficially a pirate-action-adventure enterprise, the *Pirates of the Caribbean* series offers multiple layers of meaning through its representational, reflexive, and intertextual resonances. On the one hand, the films afford strong roles for women, but on the other, revert to stereotypical gender, class, and race distinctions, often integrating these with pirate representations. The franchise is also interesting in its critique of capitalism and reflection of the banking crisis, Barbossa telling Elizabeth, "We are cursed men, compelled by greed but now we are consumed by it" (*Black Pearl*). In fact, there are repeated references to money, not only in connection to treasure, as one might expect of a pirate film, but also in relation to the cost of "port tariffs, berthing fees, wharf handling, and pilotage" (especially in *Dead Man's Chest*, released in 2006, at the height of the economic recession). There is also frequent mention of "debts" to be paid. In fact, though Benshoff and Griffin state that "major Hollywood blockbusters continue to revolve around literal treasure hunts, as in the *Pirates of the Caribbean* franchise" (2009: 208), in *Black Pearl*, the pirates actually seek to return the treasure. Clearly, *Dead Man's Chest*, in particular, reflects its contemporaneous socioeconomic and political climate and criticises the combination of business enterprise with official duties.

As a generically multi-hybrid blockbuster, spectacular digital effects abound, providing "timespaces" and arresting images in scenes that invariably relate to loss and death. Most noticeable are its frequent underwater scenes, which furnish opportunities for arresting imagery through sound distortion, the natural slowing-up of movement, surreal effects, and visual incongruities, these again emerging in death- or loss- related sequences. At times, the imagery directly echoes that of 9/11, and audiences may find a connection with other disasters that are contemporary to the films' releases too. For example, in *Dead Man's Chest*, when Norrington comes to join the crew at Tortuga, his comment, "I nearly had all of you at Tripoli. I would have if not for the hurricane," may reference Hurricane Katrina. Certainly, scenes of spectacular threat counter the freedom associated with

seafaring and piracy, the former perhaps unconsciously generating memories of sea-associated disasters for viewers. Thus, although the series' popularity undoubtedly rests on its star performers, visual effects, and humor, its sustained engagement with themes of death and immortality, which attracts audiences to its sequels in ever-increasing numbers, perhaps reflects a potentially therapeutic aspect beyond pure entertainment.

CHAPTER 4

RESURRECTION, ANTHROPOMORPHISM, AND COLD WAR ECHOES IN ADAMSON'S *THE CHRONICLES OF NARNIA; THE LION, THE WITCH AND THE WARDROBE*

OF C. S. LEWIS'S SEVEN NOVELS COMPRISING *THE CHRONICLES OF NARNIA* (1950–1956), the film adaptations thus far include *The Lion, the Witch and the Wardrobe* (Adamson, 2005), *Prince Caspian* (Adamson, 2008), and *The Voyage of the Dawn Treader* (Apted, 2010), with further adaptations under consideration. The first film, *The Lion, the Witch and the Wardrobe*, was the most successful of the three, its total worldwide gross of $745,013,115 currently standing at 44 in all-time, worldwide box-office rankings, while it was the third worldwide highest-grossing film of 2005.[1] It was also nominated for three Academy awards, winning one for Best Makeup. Conversely, *Prince Caspian* and *The Voyage of the Dawn Treader* fared moderately, currently ranking at 144 and 146 respectively in all-time top-grossing box office.[2] Like *The Lord of the Rings* and the *Harry Potter* film franchises, *The Chronicles of Narnia* films have undoubtedly benefited from the novels' success, Lewis's *The Lion, the Witch and the Wardrobe* having sold in excess of 85 million copies.[3] Since the novels were written in the 1950s, the films

offer opportunities for nostalgic revisitation by older audiences, who read the books as children, as well as interest for new readers. Moreover, the first adaptation in 2005 followed the final episode of *The Lord of the Rings* trilogy (2003) and was released concurrent to the *Harry Potter* films, arguably tapping into an audience demographic that was receptive to the fantasy epic. James Russell further identifies a niche marketing strategy for the film in the United States that "targeted Evangelical Christians, much of it suggesting that *The Lion, the Witch and the Wardrobe* was a potent evangelizing opportunity and a profound expression of principled Christian faith" (2009: 60). The more generalized cultural contexts for the novels' ongoing appeal were also disposed toward the creation of the filmic versions. Corresponding with Colin Campbell's (2010) thesis for the West's current affinity for Eastern values, their popularity inevitably reflects the overall turn from history to myth, while Devin Brown delineates the mythic framework of the novels more specifically (2003).

For recent audiences, the film's representation of Aslan as a savior and the White Witch's embodiment of evil may provide avenues through which to explore the war on terror, especially in relation to spirituality. Certainly, if its religious allegory foregrounds its US marketing strategy, more obvious attractions for children include the performance of magic, the notion of a magical realm accessible through an ordinary piece of furniture, and its array of fantasy characters, in particular, its anthropomorphic animals. Although devoid of major stars, one attraction for adult and younger audiences alike is the character of the White Witch. Indeed, for Kim Newman, Tilda Swinton "is perhaps the most perfect casting choice of the decade" as the Witch (2006: 47). For the novel's readers, the film's visualization of the transition from wardrobe to magical realm, with the incongruous appearance of the iconic Victorian lamp in a snow-filled landscape, is rendered just as Lewis described it and retains its symbolism as a guiding force. Moreover, the capacities of computer-generated imagery (CGI), especially motion-capture technology, animate the novel's talking creatures and provide a credible fusion of human and animal in the creatures that populate Narnia. There are particular aspects of the animals' depiction that may strike a chord with post-9/11 audiences, even as the use of CGI lends certain scenes a tendency for arresting imagery and "timespace" aesthetics. Other sources of spectacle include its petrified "dead" creatures that come back to life and its extensive and augmented battle scenes. Corresponding with *The Lord of the Rings* and the *Harry Potter* films, its rite-of-passage narrative structure (Murray Walker, 1985) culminates in good overcoming evil through the death of the White Witch. Although the film avoids scenes of bloodshed, it does contain instances of death, which are conveyed in ways that elicit maximum viewer emotion. Moreover, it also includes torture and implied cruelty, its

RESURRECTION, ANTHROPOMORPHISM

range of "others" falling back on the deformed, dark, and deviant beings that populate other fantasies. Visually, the first film is less bleak than its fantasy contemporaries, though there is a progressive darkening throughout the franchise, and all three films are dependent on CGI.

FILM PLOT

The Lion, the Witch and the Wardrobe, the first novel written, but the second chronologically in the series, was also the first film adaptation. Set against a backdrop of World War Two, it features four children of the Pevensie family—Peter (William Moseley), Lucy (Georgie Henley), Edmund (Skandar Keynes), and Susan (Anna Popplewell)—who are sent away during the Blitz to stay with Professor Kirke (Jim Broadbent) in an old country house. Lucy discovers a portal through the back of a wardrobe, which leads her into the world of Narnia, a fantasy realm of talking animals and perpetual winter, governed by Jadis, the evil White Witch (Tilda Swinton). Edmund too finds his way into Narnia, later followed by Susan and Peter. The Witch intends to capture the four children and turn them into stone statues to prevent them from taking over her rule of Narnia and promises Edmund sweets if he succeeds in luring them to her. His failure to do so leads the Witch to imprison him, though he manages to escape, and the four children join forces with Aslan, a magical lion. Part of Narnia's law is that traitors will belong to the Witch and will die, and, to save Edmund from such a fate, Aslan offers himself as sacrifice instead. Aslan, however, is resurrected and thereafter leads the battle against the Witch. The latter is slain and the children grow up to become adults and rule over Narnia, although, one day, they find their way back through the wardrobe to discover that they are still children. Thus, in addition to its elements of spirituality, war, and magic, time distortion is a significant feature of both novels and books.

RECEPTION OF *THE LION, THE WITCH AND THE WARDROBE*

In comparison to other fantasy franchises, such as the adaptations of Tolkien and Rowling's novels, the *Narnia* franchise has, to date, not performed as well. Moreover, whereas the *Potter* and *The Lord of the Rings* film series maintained a consistent level of critical and commercial success throughout (and actually improved in the final films), the latter two films of the *Narnia* franchise have been markedly less lucrative than the first. In part, *Prince Caspian* may have been affected by the concurrent release of *Iron Man*, *The Dark Knight*, and *The Kingdom of the Crystal Skull* in 2008, all major commercial successes with established histories and featuring well-known

Figure 8 Lucy Pevensie (Georgie Henley) in Narnia, in *The Chronicles of Narnia: The Lion, the Witch and the Wardrobe.*

stars. Comparatively, the *Narnia* films have no major stars, there are fewer key characters, and the restricted age range of the protagonists may also limit appeal for family audiences. Also differing from *The Lord of the Rings* and the *Harry Potter* series, the *Narnia* films have attracted less favorable critical attention, with reviews dismissive of their "blockbuster" approach to C. S. Lewis's themes and their exaggeration of the battle scenes. As Newman notes of the first film, "It is torn between a need to stay faithful to much-loved source material and a desire to be the foundation of a fantasy blockbuster franchise" (2006: 47). Alice Mills too comments negatively on the films' escalation of the battle scenes, stating that "*Prince Caspian* goes further [than the first film] in the same direction" (2008). In addition, whereas Disney distributed the first two films, 20th Century Fox undertook rights for *Voyage of the Dawn Treader*. Ethan Alter comments that Fox's reduced budget for *Voyage of Dawn Treader* impinged on the film's potential sense of wonderment, noting its "under-populated set pieces, and the generic costume and set design" (2011: 31), and further considers that the film's change of director had a negative effect. Thus, although the adaptations retain many of Lewis's magical and spiritual elements and follow the original stories relatively closely, critical attention centers on their additions to, and departures from, the books. Both Paul Tankard (2007) and Megan Stoner (2007) elucidate some of the reasons for these differences, providing detailed comparisons between the first film and the novel. Although the *Narnia* films aspire to emulate other fantasy epics, one obvious limiting factor that Stoner highlights is the brevity of the novels, the first film adaptation extending its 200-page literary version to almost two and a half hours. She further notes the small physical size of the Kingdom of Narnia, comparing it with the vast diverse landscapes of Tolkien's *The Lord of the Rings*, which also encompassed a considerably more convoluted narrative

and a range of psychologically complex characters. As a result, Jackson's *The Lord of the Rings* trilogy accesses a broader audience, whereas the Narnia novels are directed at children. Nonetheless, Adamson's *The Lion, the Witch and the Wardrobe* is one of Disney's most lucrative films, suggesting that, as well as the appeal for children of its magical settings and talking animals, it may provide a popular cultural means to access spirituality for certain audiences. In addition, its themes of war and resurrection, rendered in spectacular CGI sequences, and a narrative where good overcomes evil, are relevant to contemporary viewers.

THE LION, THE WITCH AND THE WARDROBE

Indeed, although the novel's opening only briefly mentions war, devoting merely one sentence to it, the film extends it to a lengthy sequence of fighter planes bombing London and the Pevensie family's escape to an air-raid shelter. The film thus immediately immerses the viewer in war imagery and establishes a fast-paced introduction, and, though readily identifiable as depicting World War Two, the use of color and sharply defined CGI visuals seems discordant (we usually associate World War footage with black and white and poor-quality visuals). Thus, in line with the film's tendency for action-packed sequences, it directly engages the viewer with the concept of war through CGI spectacle. The departure of the children to escape war-torn London thence draws on another recognizable intertextual fantasy trope, that of an extreme overhead shot of a steam train travelling through the countryside. Thus, whether intentionally aiming to target the *Harry Potter* demographic or not, the film's opening adopts an almost identical perspective to that of the *Potter* series and similarly leads the viewer on a journey to a seemingly remote place. Moreover, the Professor's home too has resemblances to Hogwarts, with its endless corridors and wooden staircases, while later, circling helicopter shots of the four children traversing the Narnian landscape distinctly recall imagery of *The Lord of the Rings*.

On arriving at the Professor's house, the bored children play hide and seek, during which Lucy accidentally finds the portal to Narnia through the back of a magical wardrobe. Narnia is visualized exactly like it is in the book, the sight of the Victorian street lamp, incongruously set in the centre of a snow-covered forest, retaining its nostalgic appeal for the novel's readers. As Fowkes notes, "The lamp signals the potential interaction of the contemporary and the fantasy world. The lamp functions as a further transition from the wardrobe to the magical world and provides a landmark that lights the way back" (2010: 152). Lucy's ensuing encounter with Mr. Tumnus (James McAvoy) is disclosed through rapid editing, kinetic camera work and off-screen, multidirectional sounds that increase in volume, thereby conveying

his approach as threatening. This differs from the novel, according with the film's tendency to over dramatize events, though when Tumnus does appear, he seems quite innocuous (in comparison, for example, with the masculinized faun in *Pan's Labyrinth*). On Lucy's return to the Professor's house through the wardrobe, she realizes that the other children have not noticed her absence and that time has become distorted. The capacity for time to lengthen becomes more noticeable at the end of the film when the children have become "adults" but on returning through the wardrobe find themselves to be children again. This manipulation of time has obvious appeals for older and younger audiences alike and forms part of fantasy's iconography, prominent, for example, in the *Potter* films. As Furby and Hines note, "as fantasy film viewers though, we can travel into the past or to the future, and enjoy a fantasy of freedom from our real world restrictions of movement in time" (2012: 151). Otherwise, as Karen Lury suggests, in narratives concerning children and war, "The framework through which the story is told is marked by temporal abnormalities and informed by narrative forms which might seem odd or inappropriate such as the fairytale: history is told differently, presented as magical and irrational" (2010: 111).

All four children find their way into Narnia, where they meet various anthropomorphic animals, including Mr Beaver and his "wife." The children discover that the Witch has taken Tumnus to her castle, Mr Beaver warning the children that "few that go through those gates come out again." "But there's always hope," responds Mrs Beaver, indicating the optimistic trajectory and spiritual implications of the narrative, which were important for readers in a postwar context and also for contemporary viewers. Mr Beaver tells them, "Aslan is on the move, the King of the wood. Aslan's already fitted out your army." "Mum sent us away so we wouldn't get caught up in a war," responds Susan. There is thus constant reference to warfare and, though the novel is usually considered a religious allegory, others view it in light of either Lewis's wartime experiences or of the Cold War contexts of its initial readership (Chapman, 2012; Melton, 2011).

THE LION, THE WITCH AND THE WARDROBE AND ITS COLD-WAR CONTEXTS

In her discussion of children's wartime fiction, Kristine Miller states that "children's fiction often [...] turn[s] away from the brutal reality of soldiers and civilians under fire by reframing both the battlefield and the Blitz as fantastic, heroic, and magical" (2009: 274). She goes on to add that war stories also approach violence, "to re-establish the place of embattled individuals within the unstable social and political circumstances of a nation at war" (2009: 274). In relation to contemporary readers, she contends that

"at this historical distance, the Blitz offers modern children a chance to do as Lewis's magical lion suggests: to 'read a different incantation' in the past that might help them to understand current events more fully" (2009: 277). (Miller is here referring to the war on terror.) Arguably, the release of the film versions of Lewis's novels in a post-9/11 climate provides similar reso-nances for current viewers as the novels may have done for postwar readers.

In relation to its context of war, Roger Chapman also argues that the novel "may have resonated with its initial readership because it corre-sponded with a Cold-War mentality" (2012: 2). Although he notes that "in the early sales of the Narnia books, when the Cold War was a dominant theme on both sides of the Atlantic, *The Lion, the Witch and the Wardrobe* outsold all the other companion volumes," the first novel's sales currently remain well ahead of the other Chronicles' stories. Chapman suggests that this may be due to the times in which it was written and that it may have "resonated with early readers in ways the other volumes did not" (2012: 2). He proceeds to outline various ways in which the story is inflected with its Cold-War contexts, stating that it is about "four children [...] participat-ing in a liberation campaign in a foreign land" (2012: 2). He goes on to equate their quest with "the larger Western world [which was] launching a quest to oppose the spread of Communism" (2012: 3). Aligning the White Witch with Soviet menace (she is located in the east), he notes that "this matches the Cold War imagination, specifically the East-West dichotomy and the notion of 'cold' as symbolizing a negative political situation" (2012: 4). Chapman further identifies the use of "secret police" and suggests that Lewis is accessing a contemporary zeitgeist rather than a medieval one. He politicizes the characters still further by correlating Aslan with America and suggesting the four children as "symbols of Great Britain. In other words, the story can be viewed as mirroring the post-war Anglo-American alliance" (2012: 7).

Chapman's association of the novels with their Cold-War contexts has commonalities with the first film's success and its relationship to the war on terror. Arguably, *The Lion, the Witch and the Wardrobe* too resonates with the contexts of its release, coming four years after 9/11 and one year after the Abu Ghraib revelations. Like *The Lord of the Rings*, its war scenes between the White Witch and Aslan and the children reflect contemporary terrorism where the spectator may now interpret the "ogres with monstrous teeth, and wolves, and bull-headed men" (Lewis, 2001: 163) as terrorists. The perfor-mance of the second and third films may correspond with their temporal distancing from 9/11 (in the same way that the equivalent novels did not resonate so strongly with readers), combined with the lesser popularity of the novels (as well as the mixed reception of the first film).

TALKING ANIMALS AND TORTURE

Connected to a reframing of the novel and its Cold-War contexts as a film within a 9/11 framework is a peculiarity of the film's anthropomorphism, which is not apparent in the book. Steve Baker outlines the ways in which talking animals are carriers of meaning. He states that "in these stories the animal, and most particularly *the pictorial image of the animal*, does not signify 'animal' at all. Instead it is treated as the transparent signifier of something quite different" (2001: 136). Baker explains that these significations may include, for example, a child's coming to terms with its own sexuality, or the "chrysalis from which a most attractive person emerges" (2001: 136). In relation to Disney, and relevant here, he acknowledges the affinity that child viewers have for animals, because they "tend to identify with the playful, instinctive nature of animals" (2001: 137). Baker argues, however, that "the visual image of the animal, however minimal or superficial the degree of its 'animality,' invariably works as a Derridean supplement to the narrative. It is apparently exterior to the narrative, but it disturbs the logic and consistency of the whole. It has the effect of *bringing to light* the disruptive potential of the story's animal content" [original emphasis] (2001: 139). Referring to Art Spiegelman's book, *Maus*, Baker suggests that "these animal masks serve either as an enjoyable or else as a useful graphic device for making more palatable a narrative that is essentially about *human* values and identities" [original emphasis] (2001: 139). There are several ways in which this analysis is relevant to the *The Lion, the Witch and the Wardrobe*, with meaning that emerges in the various accents deployed in the animation of its CGI creatures. The Beavers' friendly provincial articulation lends empathy, and the spectator identifies them as being intrinsically "down to earth" and "good." The English upper-class fox first arouses the other characters' suspicion, because, according to Beaver, he bears a faint resemblance to the wolves. "Relax, I'm one of the good guys," the fox assures them. "You look an awful lot like one of the bad ones," responds Mr Beaver, reflecting a form of ethnic stereotyping in relation to terrorism. However, when its intentions of protecting the children become clear, then the spectator too sees the fox as "good." In a narrative that is populated with English-speaking characters and that focuses on Britishness as a trope, the depiction of the wolves (which are followers of Jadis and therefore evil) as having American accents is revealing in terms of human values and identities. Slow-motion editing, CGI effects, and snarling sounds conjure the wolves as terrifying, and their motion directly toward the spectator increases their threat. Their surveillance of the Beavers' cozy dam home, with its tiny illuminated windows, also heightens their menace, and an overhead perspective reveals them encircling the Beavers' home. Their subsequent attack mobilizes associations

with infiltration of home and territory in a manner similar to that implied of Frodo's home in *The Lord of the Rings*. As the children and the Beavers escape from the tunnel, they encounter a group of petrified animals. "He was my best mate," says Mr Beaver, introducing a theme of loss that is associated with warfare. Also significant to post-9/11 audiences are the sequences in which the wolves ensnare the fox and "torture" it to ascertain the childrens' whereabouts (a scene that is also absent in the novel). The film therefore accesses the child viewer emotionally through the use of digitally generated animals to simulate suffering, while reminding older audiences of scenes of torture inflicted on the detainees of Abu Ghraib just a year before the film's release. "Your reward is your life," Maugrim (the pack-leader) tells the fox, which is seen in close-up, yelping and whimpering in pain. In a similar vein, the image of Edmund and Tumnus, shackled, in the Witch's castle, may resonate in relation to the imagery of Abu Ghraib, the camera slowly tilting up in a lingering shot of the large chain and huge ankle irons securing Edmund.

In addition to the anthropomorphism of animals, nature too assumes sentient qualities, this aspect also a new introduction by Adamson and reflecting twenty-first-century anxieties about the environment. One such scene discloses tree blossom blowing in the wind to assume human form. In another, Susan and Lucy communicate the news of Aslan's death through the trees, which seem to assume sentient qualities once more, slow-tracking shots revealing the blossom and leaves blowing across Narnia and materializing as a ghostly presence to inform Peter of Aslan's death.

Stoner identifies further significant deviations from the novel that undoubtedly endeavor to broaden audience appeal. As well as the escalated battle scenes, she describes three added chase scenes in the film, which she claims are "contrived to keep the audience on the edge of their seats" rather than progress the narrative (2007: 77). These include the scenes in which the wolves attack the Beavers' dam and chase the beavers and the children through underground tunnels, highlighting an affinity of post-9/11 fantasy film for subterranean spaces. A second instance occurs when a sleigh chases the children, who believe it to be the White Witch, but which transpires to be Father Christmas. A third inserted scene is one that reveals the children trapped by melting ice on a frozen river, which leads Stoner to observe the film's "pronounced interest in action and peril" (2007: 77). Here, the wolves, one of which has taken Mr Beaver hostage, surround the children and the two beavers. When one of the wolves seizes Mr Beaver, he heroically prepares to die to save the children but is saved by the collapse of a frozen waterfall, which serves as a dam for a ice-covered river. The fracturing of the ice releases the river and activates a tsunami-type wave, the image of which may chime with viewers. An extreme low-angle shot from the children's

perspective is directed upward at the enormous wall of ice as it begins to splinter and collapse, releasing torrents of water, before extreme overhead shots look down on the group, miniaturizing them. The sheets of falling ice descend in slow motion, and a low-level viewpoint of the children, framing them in long shot, reveals the presence of a huge wave surging behind them. As the wave crashes over them, the action unfolds in slow motion and is repeated from various perspectives. It is thus conjured as an "impact aesthetic," and its CGI effects ostensibly create a "timespace" in the way that they extend the scene's narrative dimension. The construction of the sequence as "arresting" is important in the manner in which it may mobilize associations with the Indonesian tsunami, which also occurred in the previous year (2004). Moreover, as they escape by clinging on to an ice floe, the emotional relief generated by the scene is augmented by a dramatic musical swell. Suddenly, however, Peter and Susan realize that Lucy has disappeared. They are therefore transiently fearful, believing that she has drowned, when she suddenly reappears. A return from, or evasion of, death is thus a distinct characteristic of the film and may be meaningful for post-9/11 audiences.

DEATH AND RESURRECTION

Furthermore, instances of death and resurrection are portrayed through spectacle rather than as bloody or abject events. One reason for this is the film's PG rating, though Brian Melton further explains that an "example of Lewis excluding something from Narnia due to his wartime experience is the complete absence of mangled bodies from the battlefields of Narnia. Lewis developed a visceral abhorrence for corpses at an early age" (2011: 131). Such spectacular imagery surfaces when Edmund first nears the White Witch's palace, its eerie approach featuring dark, petrified creatures that appear similar to tombstones and punctuate the snow-covered landscape. Later, the White Witch attacks Edmund himself, piercing him with her sword, his death marshaled through arresting imagery, as a low-angle shot discloses him falling in slow motion, accompanied by sound distortion.

Aslan's death is perhaps the most significant and is a focal point for analysis of the film as religious and spiritual allegory, though some scholars question certain inconsistencies with such an interpretation (Ruud, 2001: 16). Primarily, the sacrifice of his own life to save Edmund, and his subsequent resurrection, parallels the story of Christ. The film depicts his killing by an array of deformed and ugly ogres and miscreants in the form of a tribal ritual. A number of close-ups intensify the emotive impact of the sequence, and Aslan looks directly at the camera/viewer just before his death, followed by a further extreme close-up as the Witch drives a sword through him. The ensuing scene of Lucy and Susan's sorrow is lengthy and may elicit similar

emotion in the viewer. There are also verbal allusions to death: for example, when escaping the wolves, Mr Beaver insists on taking food, telling his companions, "Well, you never know which meal's going to be your last."

The film however consistently provides a means to evade or recover from death. Aslan's return is rendered as a blinding flash of light (as the sun rises) with clear spiritual connotations, and he tells Susan and Lucy that, "even death itself will turn backwards." Not only is Aslan resurrected, but other characters too return from death. Father Christmas provides Lucy with a potion that will heal any injury and she uses it to save Edmund, and Aslan breathes over the petrified creatures to bring them back to life.

CONCLUSION

Whereas Lewis's *The Chronicles of Narnia* have been variously interpreted as medieval, religious, magical, and political, the postwar contexts of *The Lion, the Witch and the Wardrobe* inflect the novel with aspects of Cold-War paranoia (e.g., in the references to the "secret police"), and elements of warfare, all characteristics that remain distinct in the film version. In general, the corporeal aspects of death are muted (no blood is visible), whereas themes of resurrection remain significant. Particularly noticeable in the film is the exaggeration of warfare as spectacle, while inserted scenes, namely, the torture of the fox, and the iceberg scene, are specifically relevant to contemporary audiences. The nuances of these sequences and the way in which they are depicted through arresting imagery may generate connections for some viewers with their post-9/11 contexts. Otherwise, its scenes of magical, enthralling spaces, talking animals, and ice-covered settings provide obvious attractions for younger viewers and nostalgic recollections for older audiences.

THE AESTHETICS OF TRAUMA: TEMPORALITY AND MULTIDIRECTIONAL MEMORY IN *PAN'S LABYRINTH*

UNLIKE OTHER FILMS DISCUSSED IN THIS BOOK, *PAN'S LABYRINTH* (2006) IS an artistic international coproduction rather than a Hollywood blockbuster. Directed by a Mexican filmmaker Guillermo del Toro, it merits inclusion in this study because of its critical acclaim rather than its box-office ranking, winning three Academy Awards and three BAFTAs, including Best Film not in the English Language,[1] and thereby providing, as Butler notes, "another indicator of fantasy's burgeoning contemporary fortunes" (2009: 8). The film premiered at Cannes and, after limited initial release in December 2006 (17 screens in the United States and 75 in the UK), opened widely in the United States in January 2007, eventually achieving $83,258,226 world-wide box office. While José Arroyo described the film as "a wonderful marriage of Hollywood genre and European art film" (2006: 68), it fared less well commercially than its US fantasy contemporaries, not only as a result of its artistic tendencies and initial restricted release, but also because of its certificate 15/R rating. Nonetheless, it is the fourth-highest grossing foreign film in the United States[2] and ranks highly amongst film critics, with Mark Kermode describing it as a "masterpiece" (2006: 20), although it has also attracted some criticism (Miles, 2011).

The film, directed at adult audiences, is set in postwar fascist Spain and contains scenes of graphic mutilation and torture, which culminate in the

murder of a young girl by her stepfather. As in several other films considered elsewhere in this book (including *Pirates of the Caribbean* and *The Kingdom of the Crystal Skull*), its historical setting seems unconnected to the contemporary war on terror. Yet, its dark undertones correlate with other post-9/11 fantasies, the film displaying muted monochromatic effects, horror iconography, and a preoccupation with death. Roger Clark and Keith McDonald too suggest, "More so than its Hollywood contemporaries, the film provides a stark and often disturbing representation of war alongside its more fantastic elements" (2010: 454). Moreover, Caryn James of the *New York Times* claims that it is one of several foreign language films using "a sneaky indirection that allows them to resonate with the most volatile questions of today. Current fears about loss of freedom and civil liberties, the fallout of the war on terror, echo through *Pan's Labyrinth*" (2007). In a similar vein, Roger Luckhurst notes that audiences viewed the film just two years after the scenes of detainee abuse emerged from Abu Ghraib. He therefore proposes that "*Pan's Labyrinth* is watched through the lens of Iraqi occupation, another strange post-war condition where the war is seemingly without end" (2010: 18). Taking into account Luckhurst's study, and referring, as he has done, to the work of Michael Rothberg on multidirectional memory, this chapter considers how the scenes of graphic mutilation, torture, and overt disgust provide a variation on the mode of spectacle deployed by the Hollywood blockbuster. Although these scenes do not necessarily provoke specific flashbulb memories of traumatic events of the new millennium or operate as arresting images, they nonetheless afford a comparable opportunity to work though post-9/11 issues, especially in their depictions of torture and intimations of child abuse. Del Toro achieves this resonance by the appropriation of various literary references (Kermode, 2006: 23) and artistic influences (from Francisco de Goya and Arthur Rackham to Celtic art) (del Toro, 2006) that combine to create spectacles of aestheticized horror.

PLOT

The film centers on the life of a young girl, Ofelia (Ivana Baquero), who is transferred to a remote military outpost commanded by her sadistic stepfather, Captain Vidal (Sergi López), an officer of the Spanish army. Set in 1944, just after the Spanish Civil War, the film traces the efforts of a group of Spanish Republican rebels who are resisting Franco's regime, and expounds in graphic detail their torture at the hands of Vidal. One of the rebel fighters, Mercedes (Maribel Verdú), works as a maid for Vidal and when Vidal discovers this, prepares to torture her too, though she retaliates and escapes. Ofelia's pregnant mother, Carmen (Ariadna Gil), falls ill and eventually dies, adding to Ofelia's trauma. Subsequently, Vidal discovers that

Carmen's doctor (Alex Ángulo), is also aiding the resistance and slaughters him. The film visualizes Ofelia's escape into a fantasy world, which offers her some reprieve from the harshness of her father's cruel regime. Within her imaginary realm, scenes of which intercut seamlessly with her traumatic reality, a magical faun assigns her three tasks. If Ofelia completes them successfully, the faun promises her that she will return to the underworld as a princess. Ofelia accomplishes the three tasks, and, although her cruel stepfather fatally wounds her in the closing scenes, she becomes immortalized as Princess Moanna in her fairytale kingdom.

MULTIDIRECTIONAL MEMORY

Thus, though the film has no obvious visual connection to 9/11, it contains examples of traumatic experience and features graphic images of torture, making it potentially significant for audiences in activating recollections of the Abu Ghraib photographs. Because of this, Roger Luckhurst (2010) proposes Rothberg's model of multidirectional memory as being at play. Rothberg examines the writings of Nazi-concentration-camp survivor, Charlotte Delbo, whose trilogy, *None of Us Will Return*, documented the traumatic impact of the camps. Although Delbo had completed the first volume soon after the Liberation, she did not publish it until 1965. This was somewhat later than her 1961 publication, *Les Belles Lettres*, which similarly documented the Algerian War (1954–1962). Rothberg suggests that the reason for publishing in the 1960s, rather than immediately after World War Two, was due to "the urgency of the charged political climate of the 1960s, with its anti-colonial struggles that tore at the fabric of Europe" (2006: 159). He concludes that the emergence of Holocaust memory into the public sphere "took place through dialogue with—instead of opposition to—proximate histories of violence" (2006: 160). In other words, "attention to texts such as *Les Belle Lettres* suggests a productive, non-zero-sum logic in which memories emerge in the interplay between different pasts and a heterogeneous present," to which Rothberg ascribes the term the "multi-directionality of memory" (2006: 162). As Luckhurst further clarifies, "Holocaust memory in France began to emerge belatedly in the context of debates about torture's traumatic return in the Algerian War in the 1950s" (2010: 18).

TORTURE AND MEMORY

Luckhurst adopts Rothberg's model of multidirectional memory to examine *Pan's Labyrinth*, suggesting that the film provides an example of "how fantasy, Gothic and over-determined historical traces have converged to navigate experience in an era of torture" (2010: 11). In the same way that

Rothberg forges a link between memory of the Holocaust and the Algerian War through literature, Luckhurst suggests that the atrocities of Franco's regime, depicted in *Pan's Labyrinth,* may mobilize associations with images of torture that emerged more recently at Abu Ghraib. In his book, *Torture and Truth* (2004), Mark Danner elucidates more fully the abuse enacted upon suspects at the terrorist detainee camps, providing detailed accounts of the degradation and suffering endured by Iraqis, which were supported by prisoner testimonies and official documents. He explains that these were sanctioned as legal because of alleged "ticking clock" scenarios (which legitimizes torture of an individual where the lives of large numbers are at risk), or otherwise, through ambiguously worded documents and edicts from those higher in the chain of command, that were open to interpretation. The images emerged in 2004 and underwent widespread circulation in the media. One particular photograph of a hooded detainee, standing on a box, arms outstretched, and wired up to fake electricity sources, epitomizes the violence at Abu Ghraib and perhaps remains the one image that is most etched into collective consciousness. Particularly disturbing is the apparent pleasure that the military take in carrying out these acts. Several of the images in Danner's account reveal soldiers grinning at the camera while pointing toward a dead detainee (2004: 220). Others show female soldiers, also smiling at the camera, while gesturing toward prisoners coerced into humiliating sexual acts (2004: 222). In more extreme cases, there are reports of some detainees who have been beaten to death (Gibney, 2007) and of forced sodomy, while Danner reports that "in the fall of 2003 Abu Ghraib contained within its walls [...] well over eight thousand Iraqis" (2004: 3).

AESTHETICS, TEMPORALITY, AND TRAUMA

Two years later, *Pan's Labyrinth* addressed the atrocities associated with the Spanish Civil War and the Franco regime through a fairytale narrative, conveying instances of bodily mutilation, sadistic cruelty, and torture. This violence is interspersed with fantasy imagery, the film fluctuating between two different worlds in which transitions are not obviously signaled. In other words, the spectators find themselves suddenly within Ofelia's fantasy world rather than having any awareness of how they got there. Clark and McDonald interpret this spatial duality as representative of Spain's political history (2010: 54) since the two realms are coded quite differently. One involves a series of imaginary, enclosed spaces that are occupied by fantastic and grotesque creatures, whereas the other features a harsh reality of historically determined brutality and austerity. Lighting enhances this distinction, with warm lighting suffusing the make-believe internal realm and blue-toned illumination and a muted monochromatic palette conveying

menacing spaces (mostly related to Vidal). As the film progresses, these two worlds become increasingly convergent, and the lighting codes change. Del Toro (2006) elaborates upon a further difference between the two spheres, describing how cinematography that is associated with Vidal and his soldiers tends to be linear in movement and the mise-en-scène angular and straight-edged, whereas objects and camerawork that relate to Ofelia and the film's women are more fluid and rounded. Though the two worlds are visually distinct, they fold seamlessly into each other, facilitated mostly by editing techniques that elide any obvious physical transition between spaces, though the film also utilizes computer-generated "timespace" portals. Such seamless transitions are prominent in films where their protagonists display trauma: both *Inception* (Nolan, 2010) and *Shutter Island* (Scorsese, 2009) feature traumatized individuals whose internal mental realms are conveyed on screen as distinct physical spaces. In *Pan's Labyrinth*, the precipitant for Ofelia's distress is, initially, her upheaval to a rural Spanish military outpost, followed by her mother's death during childbirth (we also learn that her father had died earlier). Although there are several other potential sources of trauma in the depictions of torture, it is not always clear whether Ofelia has witnessed them, though the uncanny echoes of the real world within her fantasized realm seem to suggest that she has.

Therefore, allied to the film's spatial oscillation is a distinct temporal incoherence, which is also experienced by the spectator who identifies with Ofelia and hence accompanies her in the transitions between reality and fantasy. This easy slippage between realms exposes the spectator to sudden instances of cruelty, which are suggestive of the way that traumatic memory unexpectedly erupts into the present. Indeed, Luckhurst describes how "the scenes of torture that invade so rudely into the 'art-house' register feel like intrusions of very contemporary disorders of violence" (2010: 18) (referring to Abu Ghraib). Certainly, there are parallels in the way that the widely disseminated photographs of Abu Ghraib encroached abruptly into the ordinariness of everyday life.

In her book *The Child in Film*, Karen Lury explores the representation of children within wartime settings in relation to such chronological discontinuity. Referring to *Pan's Labyrinth*, she argues that the child's presence allows filmmakers to produce a different perspective on war and to articulate the experience of war through disjointed, atemporal encounters that do not necessarily reflect the chronologically accurate unfolding of events. She also posits that adopting certain features of the fairytale facilitates the child's point of view, stating that

> the presence of the child allows film makers to reflect on what can and what cannot be said and to create filmic worlds in which the child's perspective is

orchestrated via the representation of different embodied encounters and the adoption of an alternate mythic temporality, specifically the 'once upon a time' of the fairytale. (Lury, 2010: 6)

In part, Lury's argument for distorted chronologies rests on the "child's apparent inadequacy in relation to language," which leads to a "stuttering temporality" (2010: 7). Otherwise, as relevant to *Pan's Labyrinth*, Lury goes on to say that the child's experience of war unfolds through a series of imaginary spaces and encounters that deploy fairytale iconographies and temporal discontinuities where elemental aspects (such as fire and earth) come into play. Arguably, such fracturing of temporalities may reflect the chronological disruption caused by warfare in instances of bombing, evacuation, and violence, which leads to disjointed realities as well as to traumatic psychological ellipses. Whereas fantasies such as Jackson's *The Lord of the Rings*, the *Harry Potter* films, and *The Lion, The Witch and the Wardrobe* are less inclined toward the repeated temporal instabilities that dominate *Pan's Labyrinth*, they are, nonetheless, susceptible to time distortion as a signifier of trauma. Similarly, such incoherency reflects Ofelia's trauma, the scenes of extreme cruelty and maternal suffering brutally interspliced with those of her fantasy world.

Ofelia's construction of a fantasy world as a means of escaping her harrowing existence is akin to observations that Nicholas Stargardt makes in his book *Witnesses of War*, in which he describes how children who lived under the Nazi regime used reenactment to mimic atrocity, and renarrativized traumatic events by assimilating them into games and fantasies (2006: 378). Correspondingly, Ofelia transposes the horror of everyday life into fantasy versions of terror. Materializing as a range of spectacular others, including a faun, a gigantic toad, and the sinister-looking, child-eating "Pale Man" (Doug Jones), the terror evoked by Vidal is expressed in the way these characters each elicit fear or revulsion. Thus, in line with Plantinga's (2009: 206) claim for an overlap between physical and social moral disgust, Ofelia reimagines atrocity through repulsive appearance or actions. As Lury notes, "The child figure does not, or cannot, provide authority on the facts of war, yet the representation of its experience as visceral, as of and on the body, demonstrates how the interweaving of history, memory and witness can be powerfully affective" (2010: 7).

The film opens with a slow rotational camera shot that reveals Ofelia lying down as blood drips from her nose, the scene's blue tones shading into monochrome and thereby suggesting horror undertones. The blood, however, recedes as if time is reversing, exposing the spectator to the film's first example of distorted temporality. As the camera then zooms in rapidly to an extreme close-up of her eye, a voiceover introduces the film with

"a long time ago," thereby establishing the film as fairytale and explaining the chronological reversal as a storytelling convention. The scene moves to a magical underground realm where the prologue reveals that "there are no lies or pain" and tells of a princess's escape into the blue skies of the world above. "Blinded by the sunlight, her memory is erased, and she suffers cold, sickness and pain, and eventually dies," the voiceover continues. Having established the fairytale realm, the film then reverts to reality as we see Ofelia and her mother travelling through woodlands in a convoy of vehicles.

From the outset, the film signals the existence of another dimension to the spectator as we observe Ofelia and her mother journey to the outpost where her stepfather is stationed. Stopping en route, Ofelia wanders away from her mother where she finds a piece of stone bearing the carving of an eye. The stonework has fallen from a gravestone and, when repositioned, forms part of a face (although it is not clear whether this is imagined or not). A huge dragonfly then emerges from the mouth of the face on the gravestone and entrances Ofelia, who believes it to be a fairy. The dragonfly hovers at the edge of the frame, as if watching them, as Ofelia and her mother return to the car, the camera-angle from the dragonfly's point of view beginning to construct an alternate fantasy world for the viewer. The viewer's identification with, and acknowledgment of, Ofelia's other world is significant because the film is directed at adult audiences, and, as Lury suggests, "In films involving war, children are often ciphers for adult anxieties, fantasies and fears" (2010: 106).

As they arrive at their destination, the Captain looks at his pocket watch: "Fifteen minutes late," he comments, hinting at his preoccupation with time and orderliness. This obsession recurs throughout the film and contrasts with the atemporality and fluidity of Ofelia's fantasy world, while also intimating to the spectator his rigid, harsh persona. Moving further into the realm of Ofelia's imaginary universe, we see her chase the dragonfly, as she now foregrounds the frame (while the adults unload their luggage in the background). With the camera still focusing on Ofelia, she follows the dragonfly into the garden, and hence into an ancient labyrinth. As Mercedes takes Ofelia back to the house, another high camera angle from the dragonfly's perspective observes the two, before a slow zoom frames it in close-up. The heightening of the sound of the insect's wings further immerses the viewer into the realm of fantasy, while thereafter, an edit, cutting abruptly to Ofelia's stepfather, sharply differentiates the two opposing spheres of Ofelia's external reality and internal imaginary world.

Later, as Ofelia lies on her pregnant mother's stomach, her imaginary realm further unfolds to the viewer—the camera seems to sink down into her mother's abdomen to visualize the unborn child. At the same time,

Ofelia's voiceover recounts a tale about a magical rose whose thorns were full of poison, a bleak story where "men talked amongst themselves about their fear of death and pain, but never about the promise of eternal life, and every day the rose wilted." The scene is cast as pessimistic and threatening, essentially a dark, shadowy tale within another (and therefore reflexive), with Ofelia's imagination once more reflecting the desolation of her external reality. A sound bridge connects Ofelia's voiceover with a scene of Vidal cleaning his watch, again juxtaposing Ofelia's fantasy and real worlds.

The film repeatedly intercuts between Ofelia's fantasies and scenes of the Captain's cruel and ruthless slaughter of anyone suspected to be a member of the Resistance. The first of these instances involves the Captain stabbing a broken bottle violently into the face of a local farmer, believing him to belong to the Resistance, though the man claims he is merely hunting rabbits. The brutality is disclosed in close-up and the scene is protracted, thereby accentuating its viciousness. Vidal then shoots the man's father at point-blank range before an extreme low-angle camera perspective looks up toward the soldiers, their figures set against a dark sky illuminated by a crescent moon, investing the horrific scene with fantasy elements. When Vidal searches the farmers' bags, he finds the dead rabbits, further indication of his absolute ruthlessness (and by extension, Franco's regime).

As Ofelia lies in bed, the house assumes an organic quality, creaking in a rhythmic pattern as if breathing, and thereby articulating a child's perspective. In the darkness, the dragonfly, seen in extreme close-up, now flies across the screen and further inculcates the viewer into Ofelia's psychic world. The distinctive crescent that is apparent in the murder of the two peasants reappears, and the dragonfly, now apparently transformed into a fairy, summons her back into the labyrinth. Here, she descends a spiralling staircase into a deep underground space (the underground realm of the opening scene) where she encounters the fantastic figure of a faun, and is given three tasks to accomplish to prove that she has not become mortal and to return her to her rightful place as Princess Moanna. The faun is a towering, ambiguous figure, and both Ofelia and the spectator are uncertain of its motives until the final scenes. It tells her that a crescent moon birthmark on her shoulder is a sign of her royalty and gives her a book, the Book of Crossroads, the pages of which initially appear blank. As the camera pulls away to reveal Ofelia standing alone in the darkness of the labyrinth, an edit abruptly cuts back to a scene of the Captain unpacking a cut-throat razor (seen in close-up) and inspecting its blade closely. Having witnessed his violent nature earlier, the close-up alerts the viewer to the possibility of further brutality. As he walks away from the spectator toward a mirror in the background, a vertical wipe then repositions him in the foreground, providing one of the many examples of visual dislocation that characterise the film. Close-ups of his reflection in

the mirror witness him sliding the blade precisely (almost sensuously) across his throat, amplifying his menacing persona. In such sequences, the camera often positions the viewer as an omniscient presence, whereas the magical scenes unfold from Ofelia's perspective, and, since we are encouraged to identify with her at these times, we experience her reality as traumatic.

In a further example of discontinuous editing, we see Ofelia meandering in the woods, first walking away from the camera before a vertical wipe sweeps across to visualize her now approaching instead. Thus, not only do magical creatures and fantastic spaces convey her fantasy world, but also the elisions, conjured by filmic devices, mediate a sense of unreality. Moreover, the repeated disjunctures illustrate Lury's point concerning the atemporality of the narrative. Additionally, the narrative derives much of its potency from the spatial scenarios that integrally relate to its atemporality, the first of which materializes in Ofelia's initial task. As she wanders into the woodland, script and images appear on her magic book, instructing her to insert three magic stones into the mouth of a giant toad that lives in the roots of a fig tree. Both the number three and the toad (which traditionally changes into a prince) are familiar iconography of the fairytale, though the toad here is hideously transformed (Bettelheim assigns the number three psychoanalytic meaning in respect of the dimensions of the psyche, namely the ego, id and superego (1991: 103)). According to the book's instructions, she must then retrieve a golden key from the toad's belly. To avoid dirtying her new dress, (given to her earlier by her mother to wear at a banquet provided by Vidal), she removes it and enters a vast cleft at the tree's base. The tree's form and the cleft's shape mediate similarities to the female reproductive body and echo the gynecological themes of the entire narrative, whose trajectory is directed toward rebirth. Descending down into its root system, Ofelia finds herself in a vast underground cavern, crawling with giant insects. Covered in mud, she negotiates the labyrinthine tunnels beneath the tree in search of the toad. Like the Orc births at Isengard in Jackson's *The Lord of the Rings*, this sequence conveys disgust as abject spectacle, the use of sound effects continually promoting a sense of revulsion and also evoking connections to warfare. Ofelia's anxious face, often viewed in close-up, heightens the viewer's sense of apprehension. As she crawls through the underground lair, close-ups reveal her hands submerged in the deep mud and huge larvae crawling up her arms. Lury discusses the significance of mud in films about children and war, stating that "the contact with inanimate matter enhances the visceral, bodily sense in which the child has been 'thrown into an encounter with the world. Nothing [...] comes between the child and its experience of the earth" (2010: 133). A long shot of Ofelia, followed by a slow zoom-in toward her, reveals her visible fear and is compounded by the amplified sounds of her uneven breathing. A slow camera retraction

Figure 9 The toad in *Pan's Labyrinth*.

now reveals a giant toad in the frame's foreground, lighting emphasizing its glistening surface. "Aren't you ashamed living down here?" she asks the toad, whose enormous, extensive tongue lashes out and deposits viscous slime on Ofelia's face (Figure 9). She offers the toad the three stones, which magically transform into insects, and again its computer-generated, slime-covered tongue unfurls to catch the insects. The slow-motion action conveys the scene as abject spectacle and arguably implies a sexual element in its phallic connotations. The toad then vomits profusely, regurgitating an insect-riddled mass, sound effects continuing to augment disgust. However, the vomit, although repulsive, also has an aesthetic quality, created by the pattern of insects studded on its amber glistening surface and enhanced by the warm lighting. As Julian Hanich claims, "Disgust can be produced and intensified aesthetically: through the choice of potent disgusting objects [and] the use of close-ups" (2009: 293). Certainly, framing positions the viewer close to the vast pile of vomit, since it fully occupies the frame, and invites contemplation as a kind of spectacle. In a similar vein to the portrayal of the Pale Man later in the film (and to the killing of the farmer earlier), this scene thus exemplifies how pictorial aspects of spectacle may relate to terror. Ofelia retrieves the key from the vomit and then escapes into the darkening woods and, though visibly sickened and traumatized by her experience, is compelled to continue with the quest to escape the reality of her existence. As the film cuts back to the external world, a change to blue color tones reveals her now drenched in mud. She retrieves her new dress, which is also completely filthy. The spectator's anxiety now turns to Vidal's reaction—for, as witnessed in his precise and meticulous attention to his appearance, he abhors filth. Indeed, the fantasy scenes involving filth complicate the good/evil and clean/dirty binary codes governing Plantinga's discussion of representational practice. This is because the obsessive cleanliness of the

4usion

Captain implicates a more sinister form of purification: namely, that of ethnic cleansing, which is clearly signaled by his words, "I want my son to be born in a new, clean Spain."

Del Toro (2006) identifies multiple rhyming scenes and iconographies throughout the film, with analogies between the fantasy and the real worlds. In this respect, Ofelia's fantasy about the key corresponds with a close-up of a key in the real world as Vidal opens the food store at the mill to allow rations for locals. Narratively, this object is also significant in that it later reveals Maribel's deception to Vidal when the rebels raid the food supplies. The two worlds echo each other still further as Ofelia opens her magical book to see its pages begin to seep blood, forming a shape resembling the "fallopian-tube" imagery that generally pervades the film (del Toro, 2006). The image of the blood fills the frame, its feather-like patterns, and deep red color creating an aesthetic spectacle, while its uterine form foreshadows her mother's imminent death during childbirth. Increasingly, the fantasy and real worlds infiltrate each other, the faun appearing one night in Ofelia's room, his shadow cast ominously over Ofelia, and further relaying doubts about his intentions. He gives her a mandrake root, with instructions to place it under her mother's bed, and also hands her two fairies, warning her "You're going to a very dangerous place." Her second task is to locate a dagger from one of three cupboards, accessible with the key that she had retrieved earlier. The faun tells Ofelia that where she is going, there will be a sumptuous feast, although one condition of Ofelia's task is that she must not eat any of this food.

Ofelia's quest to retrieve the dagger leads her into a room that she accesses by drawing a chalk "door" on her bedroom wall. Here, the Pale Man, an eyeless corpse-like creature, its eyes on a plate before it, sits at a large rectangular table. Behind it is a huge square chimney, the geometry mimicking the formal lines of the dining room where Vidal is holding a banquet. As del Toro elucidates, the parallel table scenes both feature "a monster sitting at the head of it" (2006), while the sumptuousness of Vidal's banquet contrasts with the rations distributed to the local peasants. Replete with imagery of the Holocaust, we now see a fire roaring behind a barred oven, resembling a furnace, and hear the sound of children screaming. A pile of old shoes foregrounds the frame, the scene clearly referring to the Nazi concentration camps and thereby intertextually accessing other traumatic histories. The camera pans upward from Ofelia's viewpoint to see etchings of the Pale Man grasping children as if about to consume them. The corpse-figure, its folds of excess, sagging skin alluding to starvation, only becomes animate when Ofelia succumbs to the temptation of eating the forbidden food. It then presses its own eyes into its palms, grasps the fairies that accompany Ofelia, and devours them, blood dripping from its mouth. The grotesque

Figure 10 The Pale Man (Doug Jones) devouring fairies in *Pan's Labyrinth*.

spectacle of the Pale Man consuming the two fairies resembles a painting by Francisco de Goya, *Saturn Devouring One of His Sons* (1819–1823), (itself drawn from an earlier 1636 painting by Rubens), and the stigmata visible on its hands signify the Catholic Church (del Toro in Kermode, 2006: 23). Del Toro explains in an interview that the Catholic connotations reflect "the participation of the Church in the entire fascist movement in Spain" (in Guillen, 2006). However, the relationship implied between the devouring of children and Catholicism may also be meaningful to audiences in relation to the John Jay Report (2004) that documented child abuse by Catholic priests in the United States.[3] The earlier imagery of the toad assaulting Ofelia with its elongated phallic tongue is further suggestive of such an association.

Meanwhile, in the real world, Vidal hears explosions in the distance, and the soldiers rush outside to see a dark cloud-laden sky and fires burning in the far mountains in the film's only scene that could generate direct associations with 9/11. As Vidal and his men ride out to ascertain the cause of the fire, the spectator witnesses him pull apart the open neck wound of one of the rebels—as the injured man raises one hand in a futile act of defense, Vidal shoots through it. (Del Toro states that this was taken from a real account of the Civil War) (del Toro, 2006). Subsequently, Vidal tortures another of the captured rebels. The torture scene unfolds slowly as Vidal first unbuttons his shirt, the ritualistic performance of this preparation heightening terror both in the character and in the spectator. In fact, the act of torture is sensualized, with lingering close-ups of his instruments of torture—first a hammer and then a pair of pliers. The scene now cuts to a close-up of an ice pick, which Vidal slowly rotates, as if with pleasurable

intention, while also allowing its point to be illuminated. He tells the captive rebel that "we'll have developed a closer bond, much like brothers," implying a menacing intimacy, and informs him that, if he can count to three (the fairytale iconography here perversely distorted), then he will be released. Both characters and spectator understand this to be unlikely, since the rebel has a pronounced stutter and is so terrified that he is shaking violently. Indeed, on his third attempt, he is unable to utter the word three, and the screen cuts to black just as Vidal strikes him with the hammer. The viewer therefore does not witness the torture, merely its bloody aftermath. In a virtual echo of this sequence, Vidal also interrogates Mercedes, the similarity to the previous torture scene suggesting to the viewer the same outcome. He likewise slowly unbuttons his shirt, but then turns away to pull down his trouser braces, hinting at a possible sexual threat. Once more, close-ups disclose his slow, measured handling of the instruments, suggesting that the use of torture will be a pleasurable experience for him. However, in a parallel of Ofelia's fantasy, when she succeeded in locating the dagger, Mercedes has a knife hidden in her skirt. "You won't be the first pig I've gutted," she tells Vidal, as she slices through his mouth (thereby offering sadistic pleasure for the spectator too).

The eroticization of Vidal's violence has connections to the Abu Ghraib images, since their disturbing content, aside from the acts of torture themselves, is the pleasure implied by the soldiers' grinning faces. This pleasure often appears to be allied to the coercion of sexual acts and their photographic recording and is evident in the way the soldiers continually address the camera. Insofar as the sexualizing of violence is concerned, Judith Butler suggests that the coerced sodomy of the Abu Ghraib detainees "may be a situation when the Islamic taboo against homosexual acts works in perfect concert with the homophobia within the US military" (2009: 90). Though her focus is on the ethics of such photography, she too identifies the disturbing nature of the images' moral indifference. The question of morality is another aspect of the film's torture sequence that may resonate with viewers because the injured rebel of the first torture scene begs the doctor to relieve him of his suffering. Even though the doctor knows that Vidal will punish him, he opts for a moral course of action and euthanizes him, challenging Vidal's chastisement with the words, "to obey? Just like that? For the sake of obeying, without questioning?" These comments may be meaningful to viewers in respect of the interrogation techniques deployed at the detainee camps where edicts and guidelines passed down the chain of command were ambiguous and morally questionable.

Increasingly, the film's real world and imaginary spheres become convergent, a point that is evident when Ofelia's mother throws a mandrake into the fire. Previously, we have seen Ofelia tending to the mandrake,

which appeared to be a sentient, living being. Under instruction from the faun, Ofelia places the mandrake in a saucer of milk beneath her mother's bed, believing that it would resolve her mother's sickness. The Captain is outraged when he discovers the mandrake and commands Ofelia's mother to destroy it. As the latter throws the root into the fire, she tells Ofelia, "You'll see the world is a cruel place and you'll learn that even if it hurts." Identifying with Ofelia, the spectator observes the mandrake from her point of view as it appears to scream and writhe in the flames. Simultaneously, Carmen collapses in agony and begins to miscarry. Though neither Ofelia nor the viewer witnesses her death, we see the servants leaving her room with blood-soaked bed linen, again harking back to the earlier parallel scenario of Ofelia's blood-stained book.

Although Lury further determines this scene of fire as one of a child's encounter with an "elemental force," similar to the prior "mud" sequence, it has profoundly horrific implications when viewed from Ofelia's perspective and, for the spectator, may summon imagery of the Twin Towers or that of the Nazi camps. Indeed, we see all the unreal events from her viewpoint, thus continually aligning the viewer with the child protagonist. Therefore, although Lury states that "in films involving war, children are often ciphers for adult anxieties, fantasies and fears" (2010: 106), the film also encourages the viewer to reexperience those anxieties, albeit in fantasy form.

In the closing scenes, the Republicans attack the mill, and Ofelia, on instruction from the faun, carries her brother to the labyrinth. The explosions, as the rebels attack, create golden backdrops of light in aesthetically pleasing visual effects, while CGI enables the trees of the labyrinth to transiently separate, forming a "timespace" portal through which Ofelia can enter. When the faun demands the baby as sacrifice, Ofelia refuses, and, although Vidal shoots her, she gains immortality. As Vidal walks out of the labyrinth, where the rebels await him, a single shot to the head kills him. Thereafter, Mercedes hums a lullaby (the same one that opened the film), and Ofelia's blood drips from her hand into the spiral groove of the labyrinth's floor, appearing bright red against the muted monochromatic tones. This melancholic scene engenders empathic grief in the spectator but is alleviated by Ofelia's surreal transformation to Princess Moanna and her reunion with her parents.

Thus, while the film culminates in Ofelia's death, there is some sense of resolution in that her self-sacrifice enables her to return to her magical universe as a princess, and she achieves a coherent identity through moral actions. This ending, though not "happy," clearly derives from heroic acts during warfare that culminate in death and further accesses the common fantasy theme of immortality. Moreover, the killing of Vidal exemplifies

fantasy's dominant narrative paradigm of good overcoming evil, thereby also providing closure for audiences.

CONCLUSION

Pan's Labyrinth, as an art-house film rather than a blockbuster fantasy, is limited in the types of spectacle normally associated with Hollywood post-9/11 fantasy, such as the "impact aesthetic" or specific 9/11 iconography. Rather, its displays of striking imagery take the form of extreme torture or obscene disgust, both aspects marshalling viewer engagement through aesthetic modes. Although primarily a commentary on the cruelties of the Franco regime, its range of frightening fantasy others reflect those of the film's real world, namely, the monstrous Captain Vidal, and both mobilize anxieties contemporary to post-9/11 audiences, specifically those concerning the photographs of Abu Ghraib, and revelations of child abuse by the Catholic Church. Whether this was a conscious decision or not during the production of the film, del Toro acknowledges the violence of 9/11 in his introduction to the DVD commentary (del Toro, 2006).

In this way, as Lury states, "The child provides access to incidents that are banal and traumatic, events that we may recognize as symbolically dense and significant—historically, emotionally and politically—but which cannot satisfactorily be 'made sense of' by the child" (2010: 143). Lury also contends that "the child's presence as a small, emotive figure, can be used to 'stand in' for many deaths. In these instances, the child's narrative function is to effectively act as a metonym for wider suffering" (2010: 107). Certainly, the narrative's atemporality and disjointed spatialities, which signify Ofelia's traumatic experiences, are shared by the viewer. Much of the striking imagery also derives from the elemental and gynecological allusions that saturate the visuals, and that emerge in Ofelia's rebirth and immortalization, themes that are commensurate with the other films examined in this book. Kam Hei Tsuei further suggests that the film's fascist backdrop "helps to explain why Hollywood chose to distribute and market the movie to American audiences—that is, as a way of both appealing to the strong anti-Bush sentiment in the country and showing at the same time that fascism is something that happens somewhere else, that in the US such barbarism is unthinkable" (2008: 225).

REFRAMING THE COLD WAR IN THE TWENTY-FIRST CENTURY: ACTION, NOSTALGIA, AND NUCLEAR HOLOCAUST IN *INDIANA JONES AND THE KINGDOM OF THE CRYSTAL SKULL*

INDIANA JONES AND THE KINGDOM OF THE CRYSTAL SKULL (SPIELBERG 2008) was the fourth installment of the Indiana Jones franchise, coming to screens 19 years after its predecessor, *Indiana Jones and the Last Crusade* (Spielberg 1989). Like the earlier films, *Crystal Skull* was highly success-ful on its release, opening widely at 4260 theatres in the United States and achieving $126,917,373[1] on its first weekend (May 22, 2008). With worldwide box office registering $776,636,033[2] by November 2011, it cur-rently remains high in the ranking of all-time top-grossing films. Obvious reasons for the film's popularity lay in an intensive marketing strategy that capitalized on its lucrative franchise history, combined with the established partnership of Steven Spielberg and George Lucas, and the star casting of Harrison Ford, an actor synonymous with the Indiana Jones mythol-ogy. Trailers and posters promoting the film, which is set in the 1950s, conjured a nostalgic ambience that, together with the promise of typical Indiana Jones-style action, romance, fantasy, and spectacular adventure,

inevitably appealed to its original viewers as well as to a younger generation, while the inclusion of younger actor, Shia LeBoeuf, was a further strategy to widen audiences. The trailer features a significant moment for viewers of the previous films as a close-up focuses on Indy's iconic fedora lying on the ground. A cut to a shadow of a figure donning the hat, together with the refrain of the distinctive "Indiana Jones" musical score (composed by John Williams) elicits immediate associations with the earlier films. The film is thus doubly nostalgic, not only in its visual allusions to the 1950s, but also in its self-reflexivity. Furthermore, the language used within the trailer assigns a superhero quality to Indy—text such as "He protected the power of the divine," "He triumphed over the armies of evil," and "He saved the cradle of civilization," clearly position him as a heroic figure. In this way, his characterization arguably resonates with audiences in providing a reassuring and familiar superhero for a vulnerable new millennium. Although initially seeming distant from twenty-first-century concerns, the themes, imagery, and narrative of *Crystal Skull* may also unconsciously affect post-9/11 viewers in other ways. Primarily, the film accesses the trauma of the 1945 bombing of Hiroshima and Nagasaki and resurrects the threat of nuclear holocaust and the Cold War. As Aaron DeRosa suggests, "Although the tragedy of [September 11] was drastically different in size, scope, and implications from the 1945 bombing of Hiroshima and Nagasaki, America has come to imagine them through the same lens of national trauma [. . .] and registered, in part, as a traumatic repetition of the atomic blasts in America's cultural consciousness" (2011: 58–59). Moreover, the film's setting in 1957 is significant in that it marks the launch date of the Russian Sputnik 1, the world's first artificial satellite, initiating a popular cultural perception that the United States was vulnerable to attack. Locating the "other" in Soviet Russia, the film reconfigures terrorism in the character of Irina Spalko (Cate Blanchett). Despite its consciously antitechnological approach (real stunts rather than CGI were used wherever possible)[3], there are sublime computer-generated sequences that profoundly echo 9/11 imagery, specifically, a nuclear blast that is conjured as arresting spectacle. In addition, its two central visual tropes include underground abject spaces that contain decaying corpses and extended chase sequences that veer precipitously on or over the edges of high cliffs. Although analogous scenes of peril figured in the earlier films, here they assume new significance in light of the 9/11 attacks.

In fact, in their book *Projecting Empire*, Chapman and Cull locate an ongoing political subtext in the entire *Indiana Jones* franchise. Elaborating on the imperialist implications of a range of films, they comment that "*Raiders* explores the anxieties that attended America's role as a global superpower and the threat to national security from a highly ideological enemy seeking the ultimate weapon" (2009: 173). Chapman and Cull identify the Ark in

Raiders as a metaphor for the atom bomb, a point to which attention is also drawn in *Crystal Skull*'s many intertextual references. They conclude that

> in this context, [Raiders'] ending, sometimes read as a reference to a Watergate-style conspiracy (the US government officially denies possession of the Ark), might also be seen as offering a sense of reassurance (America controls the most powerful weapon on earth). (2009: 173)

In pursuit of a politicised interpretation of the film, Chapman and Cull thus contest *Raiders* as solely nostalgic but instead see its location in South America as being significant in relation to contemporaneous US military support for

> 'a right-wing regime in El Salvador [. . .] anti-communist rebels in Nicaragua, and [invasion of] Grenada. (2009: 176)

The quest for the *Crystal Skull* similarly leads Indy to South America, signaled through the franchise's usual visual strategy of a flight-path projection on a map, but which first routes through Cuba (whether deliberate or not, this may be significant to viewers in relation to Guantánamo Bay). Moreover, whereas Chapman and Cull suggest that *Crystal Skull* seems "like nothing so much as a throwback to the Cold War propaganda of the 1950s" (2009: 184), its paranoia and the ambiguity of certain characters reflect the anxieties emergent since 9/11, especially because the quest to find the skull begins with the infiltration of US territory in Nevada. The incongruity of the KGB in other locations, such as the university campus where Indy lectures, further compounds a theme of boundary transgression, consistent with heightened US border consciousness since 9/11. Indeed, Joseph McBride sees *Crystal Skull* as "a far more politically aware and sophisticated movie than its proto-Reaganite progenitor, *Raiders of the Lost Ark*" (2009: 7). In addition to the obvious alignments between the nuclear blast and the Twin Towers, there are other subtle nuances suggestive of post-9/11 allegory. For example, in a discussion between Indy and Mutt in the underground burial chamber where they locate the Conquistadors' deformed skulls, Mutt comments, "But God's head isn't like that," thereby obviating the possibility of any belief system that differs from his own. The film also comments negatively on capitalism through the character of Mac, who confesses to Indy that he is a double agent for financial reasons, though this may be reflective of economic recession. Mac's motivation for finding the temple at Akator, which differs from that of Spalko (who merely wants psychic power for military application), is to steal the gold stored there. Thus, although *Crystal Skull* first appears to be merely a version of a 1950s alien invasion narrative, it may—by expounding a Cold-War scenario—chime with contemporary audiences who are experiencing a parallel threat in the war on terror. This chapter considers how the film does this and also examines the subtle inflections of other new millennial catastrophes and concerns.

PLOT

The film's plot involves a quest to locate an ancient crystal skull belonging to one of 13 alien skeletons that are located in the legendary Amazonian city of Akator. According to the narrative's mythology, whoever returns the missing skull to its alien owner will gain supernatural psychic powers. The opening scenes situate the viewer in a 1950s' America where KGB agents, headed by Spalko, have captured Indy. Spalko forces Indy to break into a military installation in the US desert of Nevada to locate a crate containing alien remains that have been recovered from Roswell some 10 years earlier. He escapes the Russians but finds himself on an atomic test site where he narrowly survives a nuclear blast. After a debriefing by FBI agents who suspect him of being a Russian spy, Indy learns from Charles Stanforth (Jim Broadbent), dean of Marshall College, where he lectures, that he has been suspended from his duties. Indy subsequently teams up with Henry "Mutt" Williams (Shia LaBeouf), who informs him that the Soviets have also kidnapped his old friend, archaeologist Harold Oxley (John Hurt) as well as Mutt's mother (Karen Allen) to help them locate the missing crystal skull. Together, Indy and Mutt recover the skull, but Spalko and the Soviets recapture the two men, transporting them to a camp deep in the Amazonian jungle. Here, Indy again meets his partner from the previous films, Marion Ravenwood (Mutt's mother). Ultimately, Spalko succeeds in returning the missing skull to Akator with the intention of exploiting the aliens' paranormal power for military purposes. The combined psychic transfer from the aliens however overwhelms Spalko, causing her to disintegrate and, along with the other Russians, enter into another dimension. Indy, Marion, Mutt, and Oxley flee the collapsing temple at Akator to witness an alien spaceship rising from the ruins. The film ends with Indy's iconic hat blowing into the church where he and Marion are married and landing at Mutt's feet. Mutt picks up the hat and is about to place it on his head when Indy snatches it back, thus providing a cue for the franchise's reported forthcoming fifth sequel.

VISUAL STYLE AND NARRATIVE STRUCTURE OF
CRYSTAL SKULL

As well as its nostalgic elements, and in line with the previous films, *Crystal Skull* therefore engages with myth, mysticism, and otherworldliness. In keeping with its 1950s setting and the theme of ancient civilizations, and to maintain congruity with the previous films, an aspect of *Crystal Skull*'s visual style, commonly muted in the long buildup to its release, was an allegedly low-tech approach. In the event, some 450 CGI shots were utilized (Lang,

2008), the film nonetheless sustaining aesthetic coherence with its predecessors. Also consistent with the narrative trajectory of the previous film, *The Last Crusade*, *Crystal Skull* continues a father-son theme but reinvents it by casting a new character, Mutt, as Indy's son. Further, the film generally maintains the episodic nature (Buckland, 2006; Chapman and Cull, 2009) and mythic patterns (Gordon, 2008) of the series. Warren Buckland discusses these episodes in *Raiders of the Lost Ark*, noting how each segment is "marked by cliff-hangers" (2006: 133). Buckland also observes a focus on the characters' outward physical actions. In a similar vein, each segment of *Crystal Skull* provides a self-contained form of spectacle—these include the film's opening desert sequence where cinematography and framing are important in constructing nostalgic spectacle. In a second segment, the location of the crate containing the alien species is portrayed as a mystical event, while Indy's escape and the ensuing nuclear blast constitute an example of sublime spectacle. Action dominates the motorcycle escape sequence, whereas the underground graveyard episode, typical of the *Indiana Jones* franchise, features abject spaces. The rescue of Marion and Oxley and the struggle for the crystal skull leads to a car chase through the Amazon jungle alongside a sheer cliff edge and eventually leads the group over the brink of a series of waterfalls, combining both action and sublime aesthetics, while the final segment at Akator incorporates further awe-inspiring effects.

However, although *Crystal Skull* sustains an episodic narrative structure, some aspects of change merit further discussion. For example, the interior personality traits (of warmth toward his father) that Chapman and Cull (2009) observe in Indy's character in *The Last Crusade* become more noticeable in the *Crystal Skull*. In addition, a cyclical facet concurrently emerges, with numerous references to, and reflections on, youth, aging, bereavement, and personal grief. In a scene where Indy is reminiscing with his friend, Charles Stanforth, about the deaths of Marcus Brody (the previous dean, played by Denholm Elliott, who died in 1992) and his father, Henry Jones Senior (Sean Connery), Indy comments, "It's been a brutal couple of years, eh Charlie, first Dad, then Marcus." A slow zoom to close-up of photographs, first of Brody and then of his father, visually accentuates this display of interior reflection. Charles then responds "We seem to have reached the age where life stops giving us things and starts taking them away." Such aspects are inevitably meaningful for viewers of the original films (who, like Indy, will also be older). The multiple references to Indy's age are mostly humorous: for example, on discovering that Soviet KGB agents have kidnapped him, his fellow captor, George 'Mac' McHale (Ray Winstone), comments "We've been in worse situations." "We were younger then," retorts Indy. However, the references to the "brutal couple of years" and personal loss may reverberate with viewers in respect of the various catastrophes of

the new millennium, especially the wars in Iraq and Afghanistan. This unfolding cyclical aspect of *Crystal Skull* becomes particularly apparent in the introduction of Mutt as his son and in Indy's marriage to Marion in the closing scenes.

While *Crystal Skull* thus varies from the earlier films in respect of introspective character traits and the introduction of a cyclical narrative element, it nonetheless pivots visually upon spectacular imagery and almost constant action. Such scenes comprise three main forms: first, spectacle deriving from a nostalgic mise-en-scène and dynamic cinematography; second, action sequences that are mobile, often CGI enhanced, and which add a narrative dimension; third, sublime and abject visuals that temporarily halt the narrative flow as arresting images. These various forms are invariably interrelated since the film's nostalgic aspects and Cold-War scenarios consistently mobilize associations with contemporary disaster through sublime effects and kinetic sequences.

CRYSTAL SKULL AS NOSTALGIC FILM

The film's nostalgic aspects emerge primarily in the mise-en-scène, particularly the use of intense, saturated color (especially noticeable in the opening scenes), and the 1950s soundtrack. Fredric Jameson considers the nostalgic film a postmodern phenomenon, describing, for example, how *Star Wars*, although clearly not a memory of real history, recalls certain moments of cultural experience. He explains that "one of the most important cultural experiences of the generations that grew up from the 1930s to the 1950s was the Saturday afternoon serial of the Buck Rogers type [...] *Star Wars* invents this experience in the form of a pastiche" (1985: 116). Thus, he continues, the film is not a recreation of the actual past, but because "the adult public is able to gratify a deeper and more properly nostalgic desire to return to that older period and to live its strange old aesthetic artifacts [sic] through once again," the film is thereby "metonymically a historical or nostalgia film" (1985: 116). Jameson also discusses *Raiders of the Lost Ark*, claiming that it occupies "an intermediary position: on some level it is *about* [original emphasis] the '30s and '40s, but in reality it conveys that period metonymically through its own characteristic adventure stories (which are no longer ours)" (1985: 116). In a similar manner, *Crystal Skull* invites nostalgia for the 1950s, this time creating a pastiche of the era's B-movie serials, while also conjuring a mise-en-scène characterized by retro-style vehicles, 1950s-style costume and music, and, akin to the previous three films, visual conventions that enhance these effects. For example, traditional stylizations of planes on maps that track Indy's journeys across continents echo both the 1950s as well as the earlier films. Narratively, the film's allusion to the B-movie serial

combines themes of alien invasion, espionage, and Soviet infiltration, and situates the terrorist other as the Soviet KGB.

The nostalgic mise-en-scène of the initial sequence, combined with dynamic cinematography, constitutes the film's first example of spectacular imagery. Mirroring the opening graphic match that characterizes the franchise's previous films, *Crystal Skull's* image of the Paramount Pictures logo dissolves into a mound of earth that replicates its shape. From the mound emerges a gopher, which stands up, looks around, and then dives offscreen toward the viewer to escape a 1950s roadster that is fast approaching from the left of the frame. The extradiegetic sound of Elvis Presley's *You Ain't Nothing but a Hound Dog* promotes an upbeat tempo to the film and, together with the gopher's rapid movement toward the viewer and the more lateral acceleration of the car across the frame, effects a highly energetic introduction. The point at which gopher and car cross transiently fills the screen with motion-enhancing blur before the camera then cuts back to long shot to show the roadster now racing away from the spectator toward the right of the frame. As it rapidly diminishes into the distance, the camera rises vertically to display the iconic American landscape of New Mexico in a panoramic shot. The camera simultaneously sweeps around and zooms in rapidly from an extreme long shot of the roadster, which is now travelling laterally from right to left across the frame, compounding the kinetic effects to create a spectacle dependent on velocity (of car and camera) and comprehensive negotiation of the frame.

The zoom reveals four teenagers, excitedly challenging the driver of the lead vehicle of an army convoy that is travelling alongside to participate in a race. Medium close-ups inside the convoy vehicles reveal in profile the humorless demeanor of the army personnel, thus creating a tension between the teenagers and the soldiers (the latter forming associations with recent media images of the war in Iraq). Poetic devices, such as a reflection of the roadster in the chrome hub of the revolving wheel of the leading army vehicle, immediately followed by a reflection of its driver in the side mirror, which then shifts to accommodate his perspective of the roadster, potentiate this dynamism (as well as draw attention to nostalgic iconography). The driver of the convoy car finds the temptation to race the roadster irresistible, a close-up of his foot pressing down heavily on the accelerator suggesting a less serious side to his personality. The exuberant atmosphere generated by the excited teenagers, the catchy music, the high-spirited driver, and the desert setting with its clear blue skies initially promotes a warm nostalgic ambience. However, the army convoy suddenly deviates from the highway, and the Presley soundtrack dies away to a distant ominous echo as a sign comes into sight, foregrounding the frame and bearing the words "Atomic Cafe" emblazoned in saturated color. The film's light-hearted opening thus

fades as the army personnel divert toward a US military installation. An ascending long shot shows a Stars and Stripes flag coming into view, and the overlaid text "Nevada 1957" sets the date and location. The personnel from the convoy now gun down the guards to the military installation, signaling its violation and serving as metaphor for new millennial concerns about infiltration of the US national boundary.

Indy's ensuing appearance is set up through a series of visual strategies and edits that conceal and delay (thus heightening viewer anticipation). Firstly, releasing Mac from the boot of the lead car, a guard then indifferently tosses Indy's iconic hat to the ground before hauling out another character. A rapid cut to an extreme overhead shot shows a circle of army guards surrounding the figure who has also been thrown to the ground. A closer low-level shot of the hat frames it centrally before cutting to display a shadow of a figure whom we presume to be Indy placing the hat on his head. Foreign dialogue is audible and, as a cut to medium close-up reveals Indy for the first time, he exclaims, "Russians!" and the viewer, now, at the same time as Indy, realizes more fully the political implications of his capture.

A second distinctive kinetic camera sequence occurs later as Indy is transported to a military base for decontamination (after exposure to radiation) and debriefing. Here, two cars cross the frame from left to right while simultaneously, a plane looms toward the spectator and two further aircraft cut laterally across the background. The camera then sweeps round to follow the cars' trajectory, the entire sequence replicating the dynamism of the film's opening.

ACTION SEQUENCES AND "TIMESPACES"

Following Indy's release from the car boot, the setting moves to a vast warehouse (the same one in which *Raiders of the Lost Ark* ended), which is a repository for US government research. Here, the camera pulls back from an extreme high-level position as the huge doors, emblazoned with the figures 51, open to reveal thousands of stacked crates, the protracted pullback serving to highlight the vast number of covert US government operations (there being a similar real-world implication for the viewer). Spalko orders Indy to help the Russian military locate one specific crate, which, unbeknownst to him, contains alien remains from Roswell. To recover the crate, which he knows is highly magnetic, Indy empties the gunpowder from various weapons and hurls it into the air. While deriving from the scientific qualities of magnetism, the powder appears to transport magically through the air, establishing some of the key attributes of the film, namely, psychic and supernatural activity. Further, all metallic objects proximate to the crate are drawn toward it so that they appear uncannily animate. The film here thus addresses the Eastern qualities postulated by Campbell (2010) as one of the

reasons for fantasy's domination, its magical dimension undoubtedly contributing to its appeal for younger viewers. At the same time, the CGI effects provide a kinetic spectacle that sustains the narrative.

In the ensuing action-packed chain of events, Indy then effects his escape, running along the tops of the crates, jumping between vehicles, and crashing through a glass window into an operations room below the warehouse. The prolonged sequence culminates in his exit by rocket-propelled sled into the desert, these various scenarios further implementing a causal-logic in the way that they project Indy into new spaces and situations, in line with Aylish Wood's explanation of "timespaces."

With reference to *Crystal Skull*, spectacular CGI effects consistently open up new avenues for its characters, maintain narrative coherence, and propel the narrative forward. This is especially discernible during the cliff-top car chase, the ants' nest scenes, and the closing sequence when both Spalko and the spaceship enter another dimension. The first of these involves a high-speed chase through the Amazon jungle (though the sequence was filmed in Hawaii and digitally enhanced), with two vehicles speeding alongside each other, those of Spalko and the Russians, and of Indy and his friends, who constantly jump between the vehicles to retrieve the skull. Like other fantasy films of the twenty-first century, including *Avatar*, *Wall-E* (Stanton, 2008), and *The Lord of the Rings* trilogy, *Crystal Skull* not only alludes to 9/11 but also addresses ecological destruction, albeit somewhat briefly. An extreme long shot sees the Soviets devastate swathes of the rainforest before more closely revealing gigantic machinery cutting relentlessly through the rainforest.

A more prominent feature of the chase sequence is the way that the action unfolds on the edge of cliffs or over the brinks of waterfalls. As the Soviets and Indy, Marion, Oxley and Mutt drive in parallel, each trying to obtain the crystal skull, the camera follows the car chase in an overhead tracking shot from over the edge of the precipice. The effect of this is to place the spectator in a position of extreme danger, revealing and emphasizing the scale of the fall below. The film's preoccupation with falling recurs when Marion deliberately drives the car over the cliff's precipice to evade the pursuing Russians. A cut to an extreme low angle reveals the car toppling before a tree cushions its fall, the vehicle gently gliding into the water. In line with Wood's premise, this imagery thus extends the temporality of the spectacle while effecting an escape for the characters (thereby enhancing the narrative dimension). As in the case of other post-9/11 fantasy films discussed in this book, the scene also offers a version of falling from which characters survive. As the car enters the water, the tree springs back and dislodges the Russians who are climbing down the rock face. From an extreme long shot, we see their falling bodies, thus transposing the fate of falling onto the enemy.

A further scene in which CGI spectacle extends time, and thus becomes a "timespace," occurs when Spalko replaces the crystal skull that was missing from one of the aliens and demands the extraterrestrials to tell her "everything that they know." The ensuing psychic transfer is rendered visible as beams of lights, which stream from their "eyes" to Spalko's. In a moment of horrific spectacle, Spalko's eyes begin to glow and then appear to spontaneously combust, flames streaking vertically upward before she completely disintegrates. Oxley explains that she has entered another dimension, "not space, but the space between spaces," the implications of such spaces (also pervasive in other fantasy films such as *The Chronicles of Narnia: the Lion, the Witch and the Wardrobe*, *The Lord of the Rings* trilogy, and the *Harry Potter* series) constituting notions of an afterlife. Fantasy film's constant allusion to life after death is thus reassuring for new millennial viewers.

ARRESTING IMAGERY AND SUBLIME SPECTACLE

As the group escape the crumbling temple, a circling dust storm gathers momentum and a gigantic flying saucer emerges from the ground. Indy stands to the lower left of the frame, his form appearing dwarfed by the gigantic spaceship, creating sublime imagery through extremes of dimension. As it takes off it too enters "the space between spaces" while the air becomes filled with a maelstrom of swirling boulders, which suddenly stop moving and drop downward, creating further imagery recalling 9/11. The camera then cuts back to Indy's perspective to observe a river spilling over the edges of the crater, created by the spaceship, and flooding the area. These latter digital effects again temporally distend the spectacle of the flooding crater as well as generate associations of the flooding of New Orleans during Hurricane Katrina. The spaceship scene, when the narrative momentarily stops and assumes a surreal quality, presents a clear example of Klinger's arresting image and Wood's concept of the "timespace" since its CGI effects "lengthen the time that spectacular elements remain convincing before drawing attention to themselves as illusions" (Wood, 2002: 372). As Klinger similarly describes in *Titanic*, the scene demonstrates "how central awe-inspiring visuals are to contemporary image-making, particularly when they are achieved through special effects" (2006: 28). Klinger explains how in *Titanic*, "the essential moment of disaster—the ship's sinking—is cinematically spectacular and highly emotional, filling the audience with amazement and dread" (2006: 28).

Similar emotions are generated by the atomic blast scene in *Crystal Skull*, which carries analogous qualities to the ship's sinking in that the image not only remains a potent reminder of Hiroshima and Nagasaki but also conveys through such association the real implication of the words "weapons

of mass destruction" to post-9/11 audiences. As DeRosa notes, "September 11 registered, in part, as a traumatic repetition of the atomic blasts in America's cultural consciousness, a trauma from which America can never fully recover until it recognizes the true relationship of these events to one another" (2011: 59). At the same time, the image provides a moment of awe-inspiring contemplation, Indy reflexively representing the spectator. The blast sequence has several components, the first disclosing a mobile temporally extended blast wave from overhead. The second event sees debris shattering out toward the screen, creating an "impact aesthetic." The third part of the sequence involves the more static spectacle of the mushroom cloud. The scene begins in an uncanny pastiche of 1950s America (and further accenting a nostalgic element) where Indy finds himself in a mock nuclear test village complete with mannequins just before a nuclear blast. As he shelters in a lead-lined fridge for protection, the ensuing explosion culminates in one of the film's most significant "arresting images." Sound is important in that there is a fractional silence between the countdown (heard through a loudspeaker), a flash of blinding light (presumably the detonation), and any further visual or sound effect. This is followed by sequential close-ups of each of the dummies as they are incinerated, the sound of the blast, and then a flattening of the buildings. Indeed, this visual depiction calls attention to DeRosa's analogies between the atomic blasts of Nagasaki and Hiroshima and the destroyed World Trade Center whereby "America's response to 9/11 has consistently fallen back on the rhetoric of bombings and nuclear devastation" (2011: 60). DeRosa also notes the origins of the term Ground Zero, "connecting the 9/11 attack through time and space to the World War 11-era testing sites in the Nevada desert, and to America's bombing of Hiroshima [...] [where] too most of the victims that died on those days were vaporized" (2011: 61). Here, debris flies out toward the spectator, creating an "impact aesthetic," while a transiently silent blast wave, seen from an overhead perspective, sweeps across the desert. A low camera angle then reveals the fleeing Soviets' vehicle with the wave of destruction behind it. An overhead shot of the vehicle then cuts back to low angle to show a surge in the debris behind the car, which is then engulfed. Digital effects therefore extend the temporal effect of spectacle, enabling the amplification of destruction. The shock wave in this latter image is distinctly reminiscent of footage of the debris clouds emanating from the Twin Towers after their collapse. For some viewers, this scene may also trigger unconscious memories of the Indonesian tsunami of 2004, an event that various documentaries have since constantly revisited. The image of the surging wave behind the Russians' vehicle is therefore potentially affective in multiple respects.

The blast wave then causes a further "impact aesthetic" as the refrigerator containing Indy first crashes toward the spectator and then a side-on shot

Figure 11　The nuclear blast in *The Kingdom of the Crystal Skull.*

recaptures the action so that it appears to be happening more than once. Indy frees himself from the refrigerator and the narrative pace begins to slow down. Slowly walking up a slight incline, Indy looks up toward the nuclear cloud, the scene viewed from a low perspective. The camera angle becomes more pronounced, tilting to an increasingly low angle as he continues to gaze upward

This upwards gaze is distinctly reminiscent of footage of the Twin Towers' destruction, which inspired a similar moment of incredulity in onlookers. Indy appears as a small figure at the bottom right of the frame, dwarfed by the atomic mushroom cloud, in a scene that has sublime qualities. Its visual elements of magnitude, power, and capacity to elicit "astonishment" cohere with Edmund Burke's analysis of the sublime, whereas its implications of destruction evoke simultaneous feelings of terror. Here, in a similar vein to David Holloway's (2008: 93) interpretation of Spielberg's earlier Cold-War remake, *War of the Worlds* (2005), the CGI spectacle of nuclear holocaust elicits both awe and dread. Whereas *Crystal Skull* is more opaque in its 9/11 references than *War of the Worlds*, nonetheless, such visual strategies inevitably become meaningful for audiences familiar with the equally sublime experience of the Twin Towers' collapse. The commonly mediated and understood motifs that also permeate other cinematic analogies of 9/11 (such as dust clouds, falling debris, and the incredulous upward gaze of characters) are thus readily comprehensible to viewers. As in *Raiders of the Lost Ark*, where the Ark is a metaphor for the atom bomb, there are further references to nuclear warfare. For example, when Spalko attains the crystal skull from Indy, her words, "Now I am become death, the destroyer of worlds" replicate those uttered by Robert Oppenheimer on creating the atom bomb. Although there is therefore metaphoric alignment between psychic power and the atom bomb, the distinction between the intangibility of

the former and the radical visible effects of the latter further invites viewers to reflect on the absence of weapons of mass destruction in Iraq.

A second example of sublime imagery occurs in the scenes of falling. Following the car chase sequence, which ended with Marion maneuvering their car down a cliff face, the group find themselves fast approaching a series of waterfalls. The first indication of this is Oxley's comment, "Three times it drops," as he looks off into offscreen space, the audience comprehending the implications of his words marginally before the characters (the viewer grasps that there are three waterfalls, thus heightening tension). The camera cuts to reveal the characters' point of view of the edge of the fall, before an extreme high-angle camera position reveals their location at the top of a massive waterfall. An overhead camera perspective then tracks toward the brink of the falls at a faster pace than the car before tilting to an overhead shot. The car comes into view just as the spectator is positioned directly over the edge of the rapids as if also about to lurch over in a sequence that is identical to one in *The Dark Knight*. In the same way that the latter's cinematography creates a sensation of plunging over the edge, the perspective here similarly hovers over the brink of the rapids, before a side-on shot discloses the car miniaturized against the waterfall in an image of sublime spectacle. The following of descent by feelings of relief in the spectator as they survive the series of falls occurs repeatedly as a tension-building strategy, each time accompanied by sublime effects. In the final descent, point-of-view shots from the characters' perspectives give way to an overhead camera perspective that again accelerates toward the abyss of the falls. From an extreme long shot, we then see the bodies falling out of the car, rendered minute against the vast cataract in a further example of sublime imagery and recalling footage and photographs of those falling or jumping from the Twin Towers.

ABJECT SPECTACLE

As well as its precipitous drops and recurrent tropes of falling, *Crystal Skull* also features a series of dark underground caverns, and subterranean spaces, which are an inevitable element of films revolving around an archaeologist. Moreover, these underground spaces invariably entail scenes of abjection, usually involving decaying corpses and skeletons, while snakes and large carnivorous insects are a particular aspect of the franchise's recurring iconography (Indy has a phobia of snakes). The first of *Crystal Skull's* abject spaces occurs when Indy and Mutt descend into the burial chamber of the conquistadors, following Oxley's clues concerning the whereabouts of the crystal skull. The scene typically incorporates the iconography of the horror genre, with a particular focus on darkness, death, and decay. As they proceed

through the caverns, which seem to lead to a dead end, a slow zoom into Mutt's face intercuts with a zoom into the darkness, which seems almost impenetrable. Out of the darkness looms a skull, its mouth open as if screaming in terror. By torchlight, they come upon further skeletons before discovering the conquistadors' mummified corpses. Upon finding the skeletal remains of the Conquistador Francesca de Orellana, Indy removes its gold facemask to disclose its skull, a close-up revealing its wide-open mouth. As he opens another of the casings, a close-up of a corpse's face, which initially appears perfectly preserved, sees it disintegrating rapidly upon exposure to the atmosphere. This too perhaps reflects on the processes of ageing and physical deterioration, while there is also a profound sense of claustrophobia in these abject underground spaces. Such scenes may have resonances for a post-9/11 audience, the connotations of enclosure recalling mobile phone and video footage as darkness and smoke enveloped those near the Twin Towers. Its other more insidious interpretation is of those buried beneath the Twin Towers, imagery that films such as *World Trade Center* (Stone, 2006) articulated more directly.

This visual connection with 9/11 recurs in the scene where they enter the temple at Akator, which again has connotations of entombment. As the characters access the temple, they descend a series of spiralling steps that begin to retract into the wall, this creating a sense of urgency in their descent since if they do not reach the bottom in time, they will fall. Although adding to the tensions of an action adventure fantasy, such scenes may also unconsciously replicate reports concerning the panic to descend the stairs within the Twin Towers.

A further example of abject spectacle occurs when the cliff top car chase ends as the cars crash into a giant ant colony, where giant red carnivorous ants attack the Russians. A ground-level camera perspective tracks the ants, their sound and size augmented by the proximity of the camera position. The ants attack Dovchenko (Igor JiJikine), streaming into his mouth and completely engulfing him. We see his writhing form, blanketed by the ants, and hear the sound of his screaming as they transport him down into their nest (presumably to eat him). This abject spectacle therefore also has connotations of going underground.

CONCLUSION

Whereas *Crystal Skull* is humorous and lacks the thematic and visual darkness of its fantasy contemporaries, for example, *The Dark Knight*, its harking back to Cold-War anxieties harnesses concerns that are relevant to the time of its release. The film certainly steers audiences in this direction in relation to its imagery, which often alludes to catastrophes of the new millennium,

including 9/11, Hurricane Katrina, and the Indonesian tsunami. Important in this respect are the film's opening scenes of a nuclear test, while its adventure narrative recounts conflict with, and the overcoming of characters from Soviet Russia. Indeed, the annihilation of terrorist-type figures is a significant aspect of fantasy films appearing after 9/11, *Crystal Skull* being released toward the end of the Bush administration when efforts to locate Osama Bin Laden had to that point failed. Essentially, the film's aesthetic of nostalgia enables a return to a past and a reliving of Cold-War anxieties, using CGI to recreate spectacular sublime events that mobilize associations with 9/11. Like many of its fantasy contemporaries, *Crystal Skull* sees its heroes overcome death against the odds, first in Indy's survival of the nuclear explosion and, later, in escaping the collapse of the underground caverns housing the alien crystal skulls, both scenarios recalling the events of 2001. As in fantasy's prevailing paradigm, good overcomes evil, the latter configured here as the Soviet KGB, despite the overall plot hinging on alien presence.

Steffen Hantke claims that the alien invasion narrative has seen a return since 2001, and although primarily examining television, he observes that between 2001 and 2009, there has been "an increasingly noticeable interest in alien invasion films from the 1950s and 1960s, which also extends to other science fiction films from the same period" (2010: 144). Hantke relates these invasion scenarios to the disasters of the new millennium, including Hurricane Katrina and 9/11, while locating his argument within a broader visual context, thus calling attention to "the use of the 1950s analogy as a critique of the social and political climate in the United States in the wake of 9/11" (2010: 149). Clearly, *Crystal Skull* falls within this remit since the plot repeatedly displays uncertainties about who is to be trusted. Indy's former colleague and friend, Mac, transpires as a double agent, though at times it seems unclear as to which side he supports—for, though working for the Russians, he still displays an allegiance to Indy. Further, in conversation, Charles Stanforth tells Indy, "You have reason to question your friends these days. I barely recognize this country anymore. The government's got us seeing Communists in our soup," a comment that Joseph McBride too sees as a "thinly veiled reference to our post-9/11 world" (2009: 7). The FBI also question Indy's loyalty in an era of paranoia, and there is a sense that Indy's interrogation by them forms part of a larger conspiracy. For example, when questioned by them in reference to the opening of the crate by the Russians (Indy had been a witness to its sealing ten years earlier), he recalls. "I was tossed into a bus with blacked out windows and twenty people I wasn't allowed to speak to [...] so you tell me, what was in the box?" The uncertain line between good and evil, perhaps in connection to the broader moral questioning of US tactics in the war on terror, as well as the radicalization of

individuals is discernible in Spalko's threat to Indy: "We'll turn you into one of us, and the best part—you won't even know it's happening." In addition, *Crystal Skull* draws on insecurities concerning US boundary consciousness following 9/11, exemplified when Indy asks his interrogators, "What the hell is going on here—KGB on American soil!?" Most significantly, the alien crystalline skeletons are not threatening to Indy since they have remained dormant for centuries—the real terror is generated by the nuclear blast detonated by the United States, the film thus interrogating the conventional filmic binary of "good Americans" and "bad Russians." Certainly, when Mutt first meets Indy, there is confusion between FBI agents and Russian spies, highlighting the proximity between good and evil and mobilizing associations with the rationale for the invasion of Iraq and the subsequent atrocities committed there. Moreover, even though Spalko is a Soviet KGB agent and described as "Stalin's golden girl," Cate Blanchett's star persona is a familiar and reassuring form and barely constitutes real terror. She is viewed mostly in long shot and is therefore readily contained within the frame, unlike other terrorist-type figures such as the Joker and Voldemort, who exceed it constantly. Nonetheless, as in the "melting of the villains" (Chapman and Cull, 2009: 179) as a typical outcome for evil others in the first three films, *Crystal Skull* sees Spalko spontaneously disintegrate, this demise now perhaps more meaningful in respect of the obliteration of bodies following the Twin Towers' collapse.

Crystal Skull is antitechnological, operating on the viewer in relation to nostalgia, both for the previous films and for the past that it embodies. This nostalgia envisions a post-1950s Cold-War rhetoric that has parallels with the war on terror in its pervasive but also largely intangible threat. By presenting that menace in the form of a known entity, its mediation of terror arguably makes it manageable. Akin to many other recent fantasy films, falling is a persistent theme of *Crystal Skull*, and the effect of psychic disturbance and losing one's mind recalls some of the attempts to break detainees' identities at Guantánamo Bay as well as the effects of trauma. Therefore, as Chapman and Cull (2009) contend in connection to the earlier *Indiana Jones* films, and despite *Crystal Skull*'s nostalgic retrospection, its visual spectacles, narrative nuances, and themes of paranoia and infiltration ostensibly reframe the Cold War as a contemporary political scenario.

THE ECSTASY OF CHAOS: MEDIATIONS OF 9/11, TERRORISM, AND TRAUMATIC MEMORY IN *THE DARK KNIGHT*

THE DARK KNIGHT (NOLAN, 2008) GARNERED CRITICAL ACCLAIM AND box-office success on its release, currently, at the time of writing, the twelfth-highest-grossing film of all time.[1] It was nominated for eight Academy Awards, winning in the categories of Best Sound Editing and Best Supporting Actor (awarded posthumously to Heath Ledger). Yet, like other fantasy films released since 2001, its content reveals a profound nihilism that allegorizes 9/11 and the war on terror. This is immediately evident in its theatrical release poster, in which Batman is set against a blazing skyscraper, viewed from a low-angle perspective. Not only does *The Dark Knight* incorporate imagery reminiscent of 9/11, but it also draws on events at Guantánamo Bay, Bagram, and Abu Ghraib where, in 2004, the release of photographs revealed abuse of its detainees (see Danner, 2004). Locating aspects of terrorism in the character of the Joker, as well as the film's themes and visual style, this chapter explores *The Dark Knight*'s mediation of 9/11 and the war on terror, and their relationship to traumatic memory. Engaging primarily with Jean Baudrillard's study of terrorism (2003), it equates the Joker's behavior with chaos theory in that his actions provoke scenes of spectacular destruction. It suggests that the film recreates specific imagery, embedded within the memory of 9/11 witnesses, and that it therefore resonates with contemporary audiences through the mechanics of flashbulb memory and arresting

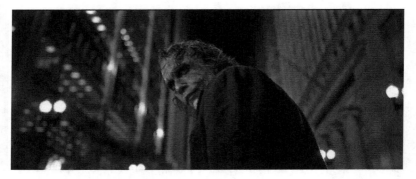

Figure 12 The Joker in *The Dark Knight.*

imagery, while its renarrativization of such visuals may enable audiences to address memories of 9/11.

PLOT

Its plot centers on the activities of Batman (Christian Bale), who is working in conjunction with Lieutenant Gordon (Gary Oldman) and new district attorney Harvey Dent (Aaron Eckhart). Their aim is to thwart the Joker's attempt at throwing Gotham City into chaos. Their attempts to stop the Joker lead to the latter seriously injuring Harvey Dent and killing his girlfriend, Rachel Dawes (Maggie Gyllenhaal), as well as causing terror in general. Indeed, Nolan's nightmarish vision of the Joker persistently suggests his capacity as an agent of chaos, and *The Dark Knight's* cinematography and mise-en-scène continually operate to signify aspects of 9/11. Study of *The Dark Knight* has thus centered on its 9/11 allusions, although there is little consideration of the specific relationship between the visual vocabulary of *The Dark Knight* and traumatic memory of 9/11. This chapter considers the film's allusions to 9/11 and the ways in which its characterization, spectacular aesthetics, and themes may be meaningful to viewers. The relevance of trauma theory to this argument is twofold: first, the real-time mediation of images of the 2001 attacks and their capacity to elicit emotional effect and incite trauma in viewers, and second, *The Dark Knight's* potential to reevoke such effects through flashbulb memory, the arresting image, or a simulation of traumatic memory.

BAUDRILLARD AND *THE SPIRIT OF TERRORISM*

Baudrillard (2003) offers some contentious perspectives concerning the effects of 9/11 on viewers namely, that media imagery of the Twin Towers'

collapse elicits fascination as well as creates trauma. He suggests that the dissemination of such imagery implicates the media in 9/11 because "the media are part of the event, they are part of the terror, and they work in both directions" (2003: 31). He invites further controversy by implying that the West was more generally complicit in such terrorist activity, partly because of its position of power. This complicity, he contends, was something that "we wished for," and even dreamt of because "no-one can avoid dreaming of the destruction of any power that has become hegemonic to this degree" (2003: 5), and continues, "At a pinch, we can say that they *did* it, but we *wished for* it" (2003: 5). His premise for such masochism partly centers on the apparently "suicidal" collapse of the Twin Towers as well as on the fictionalized versions of destruction that saturated cinema before the real events of 9/11 (2003: 7). He claims that an additional contributing factor to the West's involvement in the events of the terrorist attack is the escalating complexity of its technological systems—effectively creating a single network that makes it vulnerable to collapse. Consequently, the technology to which the lone suicide bomber has access profoundly augments the effect of his/her death. Baudrillard therefore aligns the West's vulnerability to terrorism with chaos theory, describing 9/11 as having "an initial impact causing incalculable consequences" (2003: 23).

CHAOS AND *THE DARK KNIGHT*

Such an analogy also proves relevant to *The Dark Knight*, which centers on the exploits of the Joker, a terrorist who generates chaos and trauma. Not only is he a self-confessed "agent of chaos," but he is also an instrument of spectacular mayhem conducted through seemingly small and mundane actions. For, although the Joker orchestrates chaos—extreme disorder and random effect—his actions also visually illustrate the more complex mathematical dynamic of chaos theory[2] that Baudrillard ascribes to the 9/11 attacks.

Related to chaos theory is a certain predictability to his activities, which are similar to terrorism. David Whittaker describes terrorism's fundamental quality as being "a planned, calculated and indeed systematic act" (2001: 5). Like the nineteen bombers who trained three years to hijack and crash the four aircraft on 9/11 (Whittaker, 2004: 59), the Joker meticulously plans his scenarios. Therefore, implicit in the convoluted techniques that he employs and akin to those of al-Qaeda is a network of terrorist support that remains largely invisible. Moreover, his carefully executed strategies continually encourage the audience to take pleasure in transgression. For, although the Joker is chaotic, he is also compelling, and, often, the narrative unfolds from his perspective. As a result, his various misdemeanors result in spectacular

incidents that generate excitement while simultaneously having the potential to evoke traumatic memory through references to 9/11.

EMOTION AND THE ARRESTING IMAGE

Often, the film conveys these spectacular incidents as "arresting images" (Klinger, 2006: 24), thereby mobilizing spectator emotion through associations. The slowing of the narrative and dreamlike qualities that typify the arresting image are relevant to *The Dark Knight* in the scene featuring the fire fighters. Here, the film's sound temporarily disappears and a slow pan of an apocalyptic scene of fire fighters, silhouetted against burning buildings, conveys the sight as traumatic memory. The silence dissects it from the film's narrative as an arresting image, thereby amplifying its spectacular and emotional resonances, making this imagery reminiscent of Ground Zero. Moreover, the surreal aspects that characterize the arresting image occur in the sequence in which the Joker leans out of the stolen police car and sways maniacally. The scene's pace seems distorted and the acuteness of the silence implies his madness and isolation, such effects lacking any narrative value other than to reinforce notions of the fanatical and unpredictable nature of terrorism.

CHAOS AND TERRORISM IN *THE DARK KNIGHT*

While exploring fears of terrorism through generalized associations, the theme of ambiguous identity that pervades the film is symptomatic of such anxiety. Arguably, the film also raises questions concerning counter-terrorist measures. In some ways, it continues the analogy established by Susan Faludi (2007), who draws parallels between media depictions of President Bush and fictional superheroes. Here, Batman serves as a metaphor for the Bush Administration, especially in relation to interrogation techniques at Guantánamo, Bagram, and Abu Ghraib. By this, I refer to Dick Cheney's statement following the 9/11 attacks when he said, "We'll have to work the dark side [...] it's going to be vital for us to use any means at our disposal basically, to achieve our objectives" (in Mayer, 2009: 9–10). The implication of Cheney's statement, substantiated by subsequent revelations about the detention camps, is the tacit approval of inhumane treatment against the detainees.

Partly, the characterization of the Joker as other alludes to terrorism— Richard Jackson describes how creating a politics of fear by "maintaining a 'discourse of danger' is a key function of foreign policy" (2007: 188). He goes on to discuss this goal through the socially constructed fear of an alien "other" (2007: 188), an aspect that clearly emerges in relation to the Joker.

Nonetheless, he remains a central figure of *The Dark Knight*, his transgressive behavior driving the plot forward. An ominous extradiegetic sound, intensifying in volume, accompanies his acts of violence, both heightening tension as well as signaling imminent horror to the viewer. According to one character, mob boss Maroni (Eric Roberts), the Joker "has no rules," while the Joker himself comments, "Nobody panics if things go according to plan, that [...] if tomorrow I tell the press a truckload of soldiers will be blown up. Nobody panics because it's all part of the plan [...] but upset the established order and everything becomes chaos, I'm an agent of chaos." This latter comment, as well as pointing to losses in the post-9/11 Iraq and Afghan conflicts, clearly establishes him as a disruptive force. At many points in the film, the Joker causes places of order to become chaotic. One example is apparent visually in his attempt to kill the Mayor at Commissioner Loeb's memorial. A number of overhead, high-angle camera shots emphasize the uniformity of the police officers' positions. Suddenly, the emergence of the Joker causes the scene to become chaotic, a subsequent high-angle shot showing the police officers dispersing randomly.

The Joker is also disorderly in appearance and behavior: his hair is wild, his loose clothing tends to flap open and fly back, and his face is prone to distortion. His tongue darts in and out of his mouth, while his often-maniacal laughter reveals yellowing teeth. Even his voice has an erratic, wide-ranging tonality in comparison to Batman, who talks in a deep monotone. In general his disheveled appearance is antithetical to the chiseled features of his adversary. In their analysis of *The Dark Knight*, Alan Lovell and Gianluca Sergi (2009), attribute a "sensual pleasure" to the Joker, describing a chaotic style, with unexpected movement and a voice that is alternatively high and low (2009: 32–33), though the instability of his character is more consistent with Baudrillard's discussion of chaos theory. For example, in the hospital scene with Harvey Dent, he boasts, "Look what I did to this city with a few drums of gas and a couple of bullets," referring to the explosions that killed Rachel and destroyed Dent's face.

In addition to his sadistic impulses, the Joker appears masochistic and thrives on the thought of his own demise as well as on that of others. In several scenes he invites Batman to "hit me, hit me—I want you to do it," his suicidal drive partly intended to corrupt Batman's moral stand but also alluding to the terrorists who executed 9/11. In further references to the suicide bomber, one of the prisoners with whom the Joker is detained complains of stomach pains. An examination of the prisoner's abdomen reveals a wound sewn together with crude stitching, covering the outline of what appears to be a flashing mobile phone that is just visible beneath his skin. This turns out to be a detonator, implanted by the Joker, which triggers an explosion and destroys the building.

In fact, the Joker seems to be motivated only by causing chaos and suffering, the film effacing any political and religious motivations or context for terrorism. In one of the film's clearest allusions to 9/11, Alfred (Michael Caine) comments, "Some men aren't looking for anything logical like money...they can't be bought, bullied, reasoned or negotiated with...some men just want to watch the world burn." This implied desire for wanton suffering is contiguous with the motives of al-Qaeda, which attacks civilian targets with the intention of killing as many people as possible (Hewitt, 2003: 120). The Joker thus conforms to generalized concepts of the terrorist, the film portraying him as a fanatic intent on causing maximum disruption and loss of life, like the real-world terrorist. According to George Kassimeris,

> What we have now is a series of loose mutually reinforcing and quite separate international networks, whose followers combine medieval religious beliefs with modern weaponry and a level of fanaticism that expresses itself primarily in suicide bombings and a willingness to use indiscriminate violence on large scale. (Kassimeris, 2007: 5)

The desire to cause distress further materializes in the Joker's execution videos, which simulate those of the Taliban and al-Qaeda that were displayed by the media after 9/11. In line with Baudrillard's analysis of terrorism, these scenes illustrate the media's role in the dissemination of terror, both within the film and in relation to 9/11. Indeed, the flashing of press cameras pervades the film, the media context of terrorist activity in *The Dark Knight* thus clearly paralleling the attacks of 2001. Moreover, the film's televised bulletins conform to an analogy of theatre that some scholars ascribe to terrorism. For example, Whittaker describes how "actors play roles, and they manage scenes with their victims. The action is carefully staged in time and place, and the highpoint of the drama will be reached when players engage with a fascinated audience" (2004: 95). This performance is dependent on the media, which control terrorist information reaching the public, and which terrorists exploit to gain publicity (Hewitt, 2003: 110). Brigitte Nacos observes that bin Laden successfully exploited mass media by giving interviews and supplying them with videotaped messages and films (2007: 101). Similarly, the Joker constantly performs—not only is he visually theatrical, his appearance tending toward the spectacular, but he also plays to videos and television bulletins. The Joker directs this performance toward the media, because, like the real-world terrorist, he depends on media images to spread his message.

Thus, despite his disfigured face and grotesque nature, the Joker is compelling, creating an aura both of fascination and of repulsion. In part, he generates excitement through the extreme measures he takes in creating

complex strategies and spectacular modes of death for his victims, which depend on exact timing. One example of this is the attempted murder of Rachel and Dent, whom he connects to devices set to explode simultaneously. This detail is important in the narrative because Batman only has enough time to save one of them. Another example of potential spectacular modes of death connected to simultaneous timings occurs in the ferry scene. Here, the Joker instructs the passengers of two ferries, one carrying convicted felons and the other carrying civilians, to detonate explosive devices aboard the other vessel at a specific time to save their own lives. Clearly, this attention to spectacle and timing derives from the nature of the plane hijackings of 9/11 and the intended coordinated destruction of their targets. Indeed, the ferries, like the planes, are a mode of transport. Moreover, the convicted felons wear bright orange prison uniforms, alluding to the Guantánamo Bay detainees.

Fascination with the Joker also undoubtedly arises because of the death of Heath Ledger shortly before the film's release. Ledger's death not only heightens the Joker's spectral qualities but also reinforces his sense of obscurity. Indeed, when in prison, the police officers are unable to confirm any aspect of his identity. "He has no matches on prints, DNA, dental...no name...no other aliases," Commissioner Gordon tells us. Indeed, the film's entire narrative revolves around ambiguous identity. Questions relating to the respective real identities, both of the Joker and of Batman, underpin the film, signifying anxieties about the nature of terrorism, specifically the anonymity of the individual terrorist. The use of masks further indicates this to be a pervasive theme. For example, at the film's outset, there is a zoom to close-up of a hand holding a mask without any revelation of the character's identity. As Baudrillard asks, "Might not any inoffensive person be a potential terrorist?" (2003: 20).

SPECTACLE AND TRAUMATIC MEMORY

As well as the fanatical action of the Joker, *The Dark Knight* mediates terrorism and trauma through scenes of spectacular destruction, deploying the "impact aesthetic" as described by King (2000: 91–116). For example, in the opening scene, fireballs billow out toward the spectator, followed by an explosion in which glass shatters outward toward the screen. King describes such outward motion as an "impact aesthetic." According to King, the fireball functions particularly effectively as spectacle because "[it] is all the force and intensity of the ideal action sequence compressed and made visibly manifest" (2000: 102). A similar spectacular effect surfaced in documentary images of 9/11 with Baudrillard describing how the authenticity of these images added a further dimension of fascination. He concludes, "Rather

than the violence of the real being there first, and the *frisson* of the image being added to it, the image is there first, and the *frisson* of the real is added" (2003: 29).

Similarly, in *The Dark Knight*, the Gotham Hospital explosion scene stimulates flashbulb memory and thus becomes more potent. Here, the Joker, dressed as a nurse, leaves Harvey Dent's hospital bed and approaches the camera. Behind him explosions occur sequentially, fragments of debris flying toward the spectator. Subsequently, we see him center-framed against the backdrop of the hospital, which begins to collapse. The windows blow outward, with a low-level camera angle revealing the scene from a different perspective. Fragments of paper shower from the falling building, resembling one of the most memorable images of the Twin Towers' destruction. The Joker then exits the scene to leave the spectator contemplating the pyrotechnic display. An overhead shot then recaptures the sequence of explosions and fireballs, providing an example of the spectacle that Baudrillard claims persistently enthrall us. A further overhead shot of the site shows the buildings burned to the ground, another allusion to Ground Zero. The truncated sequences of explosion, fireball, and smoldering remains create a montage effect of "arresting images" (Klinger, 2006) that simulates traumatic memory. This spectacle replays once more on a news bulletin, much in the way that 9/11 was repeatedly replayed. As noted in the introduction, King describes a similar repetitive effect in spectacular narratives whereby we see an initial impact shot that then replays from different angles to suggest that it is happening more than once (2000: 94–95).

This technique is especially apparent in the Harvey Dent chase scene, which features a continuously unfolding sequence of spectacular destruction. Beginning with an overhead tracking shot, we see a convoy of vehicles, which is escorting Dent, divert to avoid a blazing fire engine. As the Joker suddenly appears alongside the convoy, his truck ramming various police escort vehicles, the pace of cinematography escalates to feature a combination of rapid edits, low-angle shots, fast pans, and backward tracking shots. The Joker forces another van into the river, and water sprays outward toward the camera, which then executes a semicircular zoom in from long shot, the kinetic motion of the truck and camera combining to spectacular effect.

The Joker subsequently attacks the convoy with several bazookas, the first exploding center frame toward the spectator. The second causes a police car to catapult onto its end, the camera pulling back as the car travels toward it. A further spectacular explosion arises as the Joker's team position a high-rise trip wire to sabotage a helicopter escort. As it hits the trip wire, seen in close-up and sharp focus to emphasize its lethality, we see the helicopter, also in close-up, spinning toward the spectator. The explosion scene replays several times from different perspectives and in increasing close-up, again

exploding toward the spectator, before the helicopter crash-lands and slides laterally across the frame. The sequence's final explosion occurs as Batman upends the Joker's vehicle, which then topples over before sliding toward the camera while the camera simultaneously accelerates toward it in a rapid zoom. Such effects, together with the Joker's erratic figure behavior and the specific resemblances to 9/11 footage, may be relevant to audiences undergoing emotional disturbance and trauma following the attacks. Arguably, the Joker's frenetic movements in the videotaped executions, and his extreme lateral swaying movements when he escapes from Gotham jail in a police car, with moments of spectacle tending to feature both lateral figure and camera movement, have potential to address traumatic memory through the process of Eye Movement Desensitization and Reprocessing.

Spectacle relates to terrorism not only through "impact aesthetics" but also through shock value. Three scenes specifically highlight shocking violence. The first occurs in a "magic trick," the Joker making a pencil disappear in the presence of rival gangsters. Placing the pencil upright on a table, he then forces one gang member's face onto its point. Rapid editing disguises the gruesome detail of this action, but its speed paradoxically serves to heighten its shock value, as the pencil does indeed disappear. Further suggestions of terrorism through shocking imagery arise in the spectacle of Dent's burning body, which implicitly references those trapped in the Twin Towers, while another occurs when Dent and Garcia converse about the mass convictions. The office scene where they stand serves as a banal backdrop until one of the Joker's victims, dressed as Batman, thuds against the window. Subsequently, we see the Joker kill his victim in a televised bulletin, the frenzied and kinetic home cinematography highlighting his irrational and terrifying nature.

Other aspects of the mise-en-scène remind the viewer of 9/11. One indication is the light beam, directed skyward, that the Commissioner uses to summon Batman's help. While the "Batsignal" is iconic of Batman movies, here it has special significance. Although the huge lamp that radiates the light lies at an angle, the first light shaft seen to project skyward is actually vertical, like the twin beams of *The Tribute in Light* that radiated into the sky to mark the sight of the Twin Towers after their destruction.

The film's most distinctive reminder of 9/11 occurs in scenes where Batman dives off high buildings, and, although typical of the genre, these closely resemble 9/11 footage. For example, in several sequences, Batman dives from a skyscraper with the camera revealing his point of view of the drop below before cutting to frame him in long shot, much in the same way that we saw bodies falling from the Twin Towers. In another instance, Batman seizes Lau (Chin Han) from the upper floors of a skyscraper in Hong Kong, before attaching himself onto a low-flying aircraft. The low-angle

shot of the airplane highlights its close proximity, clearly echoing 9/11, while the subsequent reaction shot of one of Lau's colleagues shows his disbelief, mirroring onlookers' similar reactions when the Towers were attacked.

In addition to its 9/11 imagery, *The Dark Knight* also offers perspectives that invoke fresh horrors, with elements of the film's cinematography potentially contributing to traumatic memory. Following the opening sequence of full-frame fireballs, the camera then tracks towards a skyscraper, its motion simulating the flight path of the planes that flew into the Twin Towers. When almost at point of impact, a window explodes outward. The ensuing sequence continues to reflect 9/11 as two masked men emerge from the broken window to rig a wire across to an adjacent building and then traverse the two by abseiling across. As they set up the wire, the camera, positioned within the building, rapidly tracks toward the open window and then tilts down to reveal a high-angle shot of the street below, creating a lurching effect for the spectator, which gives the sensation of falling or jumping from the window.

Allusions to terrorism further materialize in the film's thematic aspects. The central theme is one of good versus evil, with some ambiguity between them. Reflecting Baudrillard's assertion that "no one seems to have understood that Good and Evil advance together, as part of the same movement [...] they are at once both irreducible to each other and inextricably interrelated" (2003: 13), *The Dark Knight* persistently explores the relationship between the two. The blurring of the boundary between good and evil is apparent in certain similarities between the Joker and Batman, and by Harvey Dent's degeneration into vigilantism. His turning to evil follows Rachel's murder in the explosion, triggered by the Joker, that partly destroys Dent's face and compromises his identity both physically and morally. Dent's nickname of "Harvey Two Face" calls attention to this duality and perhaps points to the radicalization of individuals. As Whittaker notes, "Terrorists, in general, are normal people, neither psychopaths nor mentally deranged" (2004: 60), even as Dent's literal "two-faced" appearance also points to my earlier quote from Dick Cheney regarding "the dark side."

In addition, Batman's coercive "interrogation" of the Joker, while in custody, evokes scenes of Guantánamo, Bagram, and Abu Ghraib and perhaps condemns the methods used there, which "amounted to torture" (Simpson, 2006: 217), though in many ways, the film seems to justify illegal, immoral, or subversive responses to extreme provocation. This is not only evident in Commissioner Gordon's tacit approval of Batman's torture of the Joker but is further apparent in Batman's unethical surveillance of Gotham City. Despite Lucius Fox's (Morgan Freeman) disapproval of Batman's methods, he complies with the surveillance to capture the Joker.

The relationship between the Joker and Batman is thematically relevant to a film about terrorism. They are opposites in almost every sense, Batman symbolizing Western values as a wealthy capitalist in scenes that see him arrive by private helicopter, or sail aboard a private yacht. In contrast, the Joker signifies the abject other, who cares little for money. However, they have similarities in that both have dual identities and operate on the fringes of society in subversive ways. Like Baudrillard's claim that "perhaps that is the terrorist's dream: the immortal enemy. For, if the enemy no longer exists, it becomes difficult to destroy it" (2003: 55–56), the Joker's words to Batman, "What would I do without you. You complete me. To them, you're just a freak, just like me" imply that Batman is his *raison d'être*. The implication in *The Dark Knight* is that terrorism exists merely because of the war waged against it, with the film making much of the consequences, namely, the deaths of innocent civilians. As Kassimeris notes,

> The invasion of Iraq, the images of torture and the widely documented abuse of prisoners at Guantánamo [...] has left the US reviled not only in the Arab world but throughout the West, under-cutting the moral authority which is vital for any liberal democracy in dealing effectively with persistent terrorist violence. (Kassimeris, 2007: 11)

Though Batman's flight into the shadows at the film's finale again suggests a need to act subversively, thus justifying his actions (and those of the Bush Administration), the film seems inconclusive. Narratively, it does not offer closure and resists the temptation of a "happy ending," recognizing that 9/11 at that time, was still an open wound.

CONCLUSION

In addition to inflections that suggest support for subversive practices in response to extreme events, *The Dark Knight* draws directly on 9/11 imagery, indicating how fantasy film may contribute to the mediation of traumatic memory for some viewers. However, in *The Dark Knight,* these images remain visually discrete from the film's storyline and are thereby potent stimuli to traumatic memory. In part, this stems from the generic attributes of the fantasy film that allow it to maximize both the spectacular effects of film and the spectacular possibilities of terrorism. Thus, although fantasy films, such as *The Dark Knight,* seem distant from the realities of terrorism, they are able to address traumatic aspects of 9/11 in different ways to more realistic depictions. Utilizing Baudrillard's account of terrorism, this chapter has illustrated how *The Dark Knight* mediates 9/11 and terrorism through

the characterization of the Joker and has suggested that the film's spectacu-
lar visuals may activate unconscious recollections of the event. Although
the film's imagery is unlikely to traumatize or even emotionally affect the
spectator directly, it may still operate within a continuum of memory that
concerns 9/11. This may emerge either through "flashbulb" memory, the
"arresting image," or through traumatic memory, perhaps enabling a work-
ing through of traumatic events for some, and thereby explaining in part
the success of the fantasy film since 2001. For others, viewing images that
simulate those of 9/11 ironically reflects Baudrillard's claim of the West's
fascination with its own destruction.

WOUNDING, MORALITY, AND TORTURE: REFLECTIONS OF THE WAR ON TERROR IN *IRON MAN* AND *IRON MAN 2*

THE *IRON MAN* FILMS ARE ONE OF A SERIES OF MARVEL COMICS adaptations that include *Spiderman*, *Hulk* (Lee, 2003), *X-Men* (Singer, 2000), and *Marvel's The Avengers* (Whedon, 2012), along with their respective sequels. The first *Iron Man* film (Favreau, 2008), which tells the story of Tony Stark (Robert Downey Junior), a wealthy industrial entrepreneur and weapons designer, performed well at box office, having the third-highest grossing opening weekend of 2008 behind *Indiana Jones and the Crystal Skull* and *The Dark Knight*, and the twenty-third highest opening weekend of all time.[1] Its sequel was released in 2010 with a third planned for 2013, and the character of Iron Man also features in *Marvel's The Avengers,* which currently ranks third in all-time worldwide grossing box office as of July 2012.[2] *Iron Man* achieved critical acclaim as well as commercial success, whereas *Iron Man 2* (Favreau, 2010) outperformed the first film, becoming the fourth-highest grossing film of 2010, and fifth in the highest grossing weekends of all time.[3] It currently ranks at position sixty-three in all-time highest grossing worldwide box office.

The success of the *Iron Man* franchise reflects the generalized box-office dominance of fantasy film superheroes in the new millennium. As evident in *Spiderman*, *The Dark Knight,* and *The Kingdom of the Crystal Skull*, superhero characters have become increasingly popular during the post-9/11 period, offering escapism and reassurance to audiences in vulnerable times.

As Alex Harvey notes, "After the fall of the Towers, the superhero became a figure of some focus for those seeking to express their grief, anger and fear in the wake of the attacks" (2010: 120). Combining fantasy elements with a science-fiction iconography, and in line with many of their superhero contemporaries, the *Iron Man* films draw on the war on terror for their contexts and imagery. The first film is set in Afghanistan and references themes of wounding, torture, and corruption in connection to the war on terror, its visuals reminding spectators of photographs of abuse at terrorist detainee camps (see Danner, 2004). *Iron Man 2* consistently recalls images from media footage too, namely the destruction of landmark buildings in New York on 9/11 and the associated effects of shattering glass and falling bodies. Indeed, according to Marc DiPaulo, "Jon Favreau [...] speculated that 9/11 set the stage for the current superhero craze" (in DiPaulo, 2011: 18) (although the rise of the superhero film pre-dates 9/11, it has proved more commercially successful since 2001). DiPaulo also states that according to Favreau, "as deceptively simple and provocative as those films were in their iconography, they still featured tortured heroes wrestling with issues of power and responsibility that helped audiences work out their own feelings about the current state of the world without directly speaking to those fears" (in DiPaulo, 2011: 19). DiPaulo's account therefore offers some convergence with this book's claims in respect of *Iron Man*. In addition, although Iron Man is a superhero, the premise upon which the narrative's subtext hinges is that of a "weaponized suit" as a metaphor for weapons of mass destruction. This analogy not only emerges in the films' allusions to the war on terror but also in references to Stark's toxic palladium-powered arc reactor, which invoke nuclear associations and thereby mobilize related traumatic histories of nuclear holocaust. The preoccupation with weaponry further reflects US defense budget cuts announced by Barack Obama in 2009 as a counterrecessionary measure, and there are distinct connections forged between weaponry and masculinity (MacAskill, 2009). At the same time, the films signal contemporary concerns with North Korea and Iran's nuclear programs.

Moreover, despite Stark attaining superhero status as Iron Man, the implanted arc reactor ostensibly renders him a wounded hero. The wounding of post-9/11 cinematic heroes has become increasingly commonplace, doubtless reflecting the physical and psychological damage inflicted on the United States by 9/11 and here further commenting on perceived vulnerabilities regarding its defense program. Furthermore, the films' attention to a reformed morality as a redeeming and, indeed, central quality of Stark, echoes the questioning of US political ethics after the events of 2001. Certainly, issues of morality repeatedly surface in post-9/11 cinematic superheroes—to be a real hero in post-9/11 cinema requires moral integrity rather

than merely a weaponized hard body. Thus, the post-9/11 superhero, one of the traditional cultural icons of US invincibility, often displays vulnerability and moral equivocation, demonstrated here by the protagonist who manufactures weapons of mass destruction. Ultimately, although these cinematic heroes may act subversively, the end of the film often justifies a need (as is evident in *The Dark Knight*).

These tropes of damaged masculinity and ambiguous morality are not restricted to the superhero genre but surface in other post-2001 films too, including, as already noted, *The Dark Knight*, the latter films of the *Harry Potter* series, *The Lord of the Rings* trilogy, and *Avatar*. However, even though cinema has witnessed a growing vulnerability in its male heroes, they tend to overcome threats to their masculinity, the portrayal of a recovered and heroic masculinity arguably reflecting a retaliatory American psyche following 9/11. As well as addressing issues concerning the invasion of Iraq, *Iron Man 2* also expresses anxieties about energy resources that are relevant to a new millennial audience. This chapter thus explores the films' visual and thematic references to the war on terror and other post-9/11 concerns and the ways in which such imagery may be meaningful for viewers.

PLOT

Iron Man reveals weapons development expert Tony Stark promoting a new missile called "the Jericho" in Afghanistan when his team come under attack from a group of insurgents who injure him with one of his own explosive devices. He regains consciousness and finds himself in a cave with a device embedded in his chest to repel shrapnel from his heart. The insurgents demand that he recreate the Jericho missile for them and provide him with the materials to do so. With the aid of Dr Yinsen (Shaun Toub), who has implanted the arc reactor into his chest and saved his life, he constructs a weaponized suit and uses it to blast his way out of the cave. His army friend, Lieutenant Colonel Rhodes (Terence Howard), thereafter rescues Stark, who returns to the United States and perfects the Iron Man design but abandons the weapons program. In the meantime, he discovers that his work colleague, Obadiah Stane (Jeff Bridges) is still secretly supplying Stark weapons to the insurgents and has conspired with them to assassinate him. After Stark's escape, the insurgents discover the remnants of his prototype armor, and Stane attempts to replicate it on a much larger scale but is unable to recreate the arc reactor to power his version of the suit. He eventually attacks Stark, paralyses him (again, ironically, with a device designed by the latter), and steals the arc reactor from his chest. Stark survives by replacing it with the original prototype device and, then, wearing the upgraded Iron Man armor, attacking and killing Stane with the assistance of Pepper Potts

(Gwyneth Paltrow), his secretary. *Iron Man 2* begins where *Iron Man* ends, with Stark now being slowly poisoned by the palladium that powers the arc reactor in his chest. Eventually, he succeeds in synthesizing an artificial variant of the element, recovers, and fights off an army of Iron Man drones, created by weapons competitor Justin Hammer (Sam Rockwell) and led by rival Russian scientist Ivan Vanko (Mickey Rourke).

TORTURE, WOUNDING, AND THE WAR ON TERROR

This book's premise is that fantasy films enable audiences to unconsciously address anxieties arising from 9/11 and the war on terror as well as other new millennial concerns, albeit in ameliorated form. Here, the *Iron Man* films directly confront the viewer with such issues, which include the implication of the United States providing arms to Iraq and Afghanistan, the justification for invading Iraq, and the use of torture at US detention camps. Together with *Pan's Labyrinth*, the *Iron Man* series therefore paradoxically brings the viewer closest to what Slavoj Žižek (2002) terms "the Real," through the intrusion of real violence into the artificial "reality" that surrounds Stark (where robotics and technology orchestrate his everyday life). The films further interrogate concerns about collateral damage in the recent Iraq and Afghanistan wars, suicide bombers, and claims of inadequately equipped solders in the real world. Predominantly, they achieve this through images that conjure specific memories by intertextual reference to media footage and photographs of the terrorist detainee camps. There is also distinct celebration of technology, the films insinuating that it is a universal panacea. The implication is that the absence of adequate technology leads to a compromised masculinity, evident in the physical weakness and moral flaws of its male characters. The reference to crashed fighter jets specifically gestures toward real-world announcements of budget cuts to the F-22 fighter plane, which promoted fears of US vulnerability (MacAskill, 2009). In addition, the films frequently deploy "impact aesthetics," presenting scenes of warfare and terrorism as spectacular destruction and rendering them as arresting images through slow motion and repetition. Corresponding with other fantasy films post-9/11, there is also an emphasis on the mastery of flight and survival from falls.

However, *Iron Man's* opening departs from that of other films considered here in its realistic effects and semblance to a war movie, mediated through handheld camera and a mise-en-scène of military vehicles and US army personnel set against a backdrop of Afghanistan. These aspects immediately immerse the viewer in the war on terror, while the diegetic sound of loud rock music alludes to its characters' macho sensibilities. The opening scene then confounds this reassurance by killing most of the army personnel in

WOUNDING, MORALITY, AND TORTURE

a roadside explosion. Kinetic, unsteady cinematography with rapid editing and sounds of gunfire set against imagery of fireballs and explosions continue to enforce its realism. Stark, the sole survivor, escapes from his vehicle to see a missile land close by. The camera rapidly zooms in to a close-up of the device, focusing on the words "Stark Industries" etched on its side, before it detonates and fires shrapnel at him. The close-up, emphasizing the irony of being wounded with one's own weapons, inevitably acknowledges general perceptions of Western complicity in arming Iraq and Afghanistan (see Phythian, 1997). There are conflicting opinions about such involvement, with Michel Chossudovsky outlining clear connections between the US Administration and al-Qaeda (2005: xiii). Conversely, in his study of 9/11, David Holloway (2008: 17) argues that claims of complicity do not fully appreciate the complex historical and cultural factors involved. In discussing the supply of arms to Afghanistan to wage war against the Soviets in the 1980s, he explains that "the claim that the US had created bin Laden [...] missed vital truths about the anti-Soviet *jihad*" (Holloway, 2008: 20). Holloway concludes, "Overwhelmingly, the Afghan *jihad* was a story of Islamist and Soviet agencies, not American ones" (2008: 20). Whether intending to be reflective of political truths or not, the narrative of *Iron Man* pursues a theme of illegal arms sales through US double-dealing between the insurgents and Stane, Stark's corrupt second in command.

Following the missile detonation, an overhead camera perspective pulls upward as Stark opens his shirt and blood begins to seep through. He touches the blood, as if to test its realness, the scene exemplifying Žižek's notion of "the direct experience of the Real as opposed to everyday social reality—the Real in its extreme violence as the price to be paid for peeling off the deceptive layers of reality" (2002: 6). As the screen cuts to white, the distant muffled sound of foreign voices is heard, indicating that Stark has lost consciousness. Slowly coming into focus, presumably from Stark's point of view, we see a backlit textured cloth, followed by a cut to close-up of Stark, revealing it to be a hood covering his head (also alluding to the hooding of Guantánamo detainees). The camera reverts to Stark's perspective, disclosing figures that are indistinct in the darkness, before it pulls back to observe him surrounded by insurgents wearing scarves around their faces and directing their rifles at him. The film has attracted criticism in respect of its representation of the insurgents (among other aspects), with claims that it invokes Middle-Eastern stereotypes (Catalan, 2008). Certainly, as Richard Jackson explains, and as already observed within preceding chapters, terrorism discourse draws on a "ready-made set of cultural tropes and narratives about the threatening and alien other" (2007: 189).

The film then rewinds to Las Vegas 36 hours earlier, where a montage video sequence discloses Stark's meteoric rise to success, appropriating a

style of exaggerated excessiveness that parodies showtime celebrity culture and informing the spectator that "Tony Stark has changed the face of the weapons industry by ensuring freedom and protecting America and her interests around the globe." This style of deliberate excess is later relevant to the film's critique of the way in which the war on terror was vindicated. A similar "showtime" aesthetic emerges when Stark subsequently flies out to Bagram (significant as a site of one of the terrorist detention camps) to demonstrate his new weapon, "the Jericho." As he begins his presentation of the weapon to the troops, he comments, "I prefer the weapon you only have to fire once. That's how dad did it. That's how America does it.... Find an excuse to let one of these off the chain and I personally guarantee you the bad guys won't even want to come out of their caves." Clearly, the single-use weapon to which he refers alludes to the dropping of the atom bombs on Hiroshima and Nagasaki and thus overlays the war on terror with the earlier traumatic events. The camera then cuts to a close-up of the soldiers as they turn their heads in unison to watch the weapon's performance. The rocket launcher rises up and a low camera angle looks upward at the missiles as they launch. The sequence thus builds a sense of anticipation, priming the spectator for a spectacular event. An edit to the distant mountains reveals the weapon disseminating multiple smaller missiles in a cascading effect. As the camera then cuts back to Stark, the missiles still travelling midair, he announces dramatically, "For your consideration, the Jericho," and spreads his arms in a cruciform shape just as the weapons crash behind him in the mountains. A wall of black smoke billows up and a series of blasts are visible in the background before another series of larger, slow-motion explosions and blast waves surge toward the viewer, engulfing Stark in dust. The camera then cuts to the onlooking military personnel, whose caps are swept off by the blast's shockwave (the resultant dust clouds reminding viewers of media footage as the Twin Towers collapsed). Stark's outstretched arms have a religious connotation and also infer US firepower superiority emphasizing the impressive display of weapons, both within the diegesis and for the spectator.

The ensuing scene subsequently reverts to the present, as Stark experiences flashbacks and intermittent consciousness in a disturbing and surreal sequence. A montage of dark shadowy images of a wounded Stark, seen from directly overhead, includes close-ups of bloody wounds, "double-vision" images, bright lights, and deliberately out-of-focus, unsteady camerawork accompanied by screaming and other distorted sounds. The images are fleeting and conjured as traumatic memory but, given the context, allude to the interrogation of al-Qaeda suspects (see Danner, 2004; Tran, 2008) and engage spectator attention through their framing as surreal arresting images. Moreover, when Stark regains consciousness he discovers that an

electromagnet has been inserted into his chest and that he is wired to a car battery. Initially, the spectator is led to believe that this is a form of torture, although it transpires that the electromagnet has saved his life. This familiar imagery also evokes the photographs of Abu Ghraib that came into world-wide circulation in 2004, which showed detainees made to stand, arms out-stretched, attached by wires to fake electrocution devices, believing they would be electrocuted if they moved (see Danner, 2004).

Moreover, when Stark refuses to build the Jericho missile, the insur-gents subjected him to waterboarding, which again echoes the interrogation techniques deployed at US terrorist detention camps. These sequences are also surreal, with low-key illuminated underwater shots, directed upward at Stark's submerged face, intercutting rapidly with close-ups of the spark-ing electromagnet in his chest and Stark gasping for breath. Although such imagery was absent from the detainee-abuse photographs that emerged from Abu Ghraib, the viewer immediately associates it with mistreatment at the detention camps since the procedure attained widespread notoriety regard-ing its questionable legitimacy in interrogation. Whereas many considered it torture (see Chossudovsky, 2005; Simpson, 2006) an October 2002 Department of Defense memorandum regarding terrorist suspects recom-mended the following: "The use of a wet towel to induce the mispercep-tion of suffocation would also be permissible if not done with the specific intent to cause prolonged mental harm" (in Danner, 2004: 176). Heated public debate followed the revelation of such methods at Guantánamo. In this sequence, its infliction on a US citizen perhaps serves to address such unease whereas its reframing within a superhero narrative simultaneously ameliorates the event.

In its clearest allusion to the war on terror, the early scenes of *Iron Man 2* take place in a court of law, which essentially parodies the justification for the invasion of Iraq. Here, Senator Stern (Garry Shandling) demands that Stark hand over his Iron-Man technology on the strength of a sin-gle sentence taken from Lieutenant Rhodes's report. The sentence states, "Iron Man presents a potential threat to the security of the nation and her interests" (Rhodes, *Iron Man 2*) but within the report precedes a recom-mendation that Stark be employed by the military. Clearly, such decontex-tualization, as Rhodes tries to explain, is misleading, the scene alluding to the way in which satellite images were also misinterpreted by Colin Powell and his advisors before invading Iraq.[4] In fact, similar satellite images are presented to the spectator here, accompanied by Rhodes's authoritative voiceover, which says, "Intelligence suggests that the devices seen in these photos are in fact attempts at making copies of Mr. Stark's suit." The film thus parodies the Colin Powell interview, in which he stated, "The photos that I am about to show you are sometimes hard for the average person to

interpret, hard for me,"[5] since the diegetic satellite photos are vague and ambiguous and give no indication that the Iron-Man suits have been copied. The Senator also summons "weapons expert" Justin Hammer (Sam Rockwell) to give evidence; the latter immediately disclaims, "I am no expert." Later in the film, Hammer's weapons prove to be ineffectual and useless, his obvious lack of knowledge providing further negative commentary on the justification for invading Iraq. The sense of irony is heightened by the official subtitles "Senate Armed Services Committee—Weaponized Suit Defense Hearings" that accompany the satellite images. The juxtaposition between these titling conventions, the seriousness with which the court examines the images, and the improbability of a weaponized suit as a threat to national security compounds the implied criticism of the invasion of Iraq. The parody of celebrity culture in the excessive "playboy" characterization of Stark amplifies the sardonic aspects even more, especially as the audience knows that Stark is acting in the interests of the United States. The film's political commentary further surfaces as Stark sabotages their presentation, instead summoning up images of destruction, caused by malfunctioning Iron-Man copies in North Korea and Iran, and pointing out to the senator their obviously greater threat, this having real-world significance for the spectator. (As Leonard Weinberg and William Eubank (2007: 166) note, North Korea and Iran are also identified as rogue states by the National Security Council in a document published by the White House in 2002.)

ACTION SPECTACLE AND COLD-WAR AESTHETICS

In addition to their arresting images of torture and their references to the war on terror, the films feature spectacular scenes of destruction, which include fireballs, shattering glass, and images of flight. Often, such scenes involve illustrations of superior US technology. An early opportunity for this display occurs in Stark's escape from the terrorists in *Iron Man*. Instead of constructing "the Jericho," as instructed by their captors, Stark and Yinsen build an armored suit fuelled by a palladium arc reactor and use it to attack them. As Stark stands at the entrance of the cave to effect his escape, a low-angle shot from the insurgents' point of view looks up toward him as their bullets ineffectually strike his armor (further implying US firepower superiority). The camera then reverts to Stark's viewpoint as looks down on them. "My turn," he says, as a wall of fire issues from his weaponized gauntlets and fills the frame with fireballs, the blazing bodies of his captors reminding the viewer of those trapped within the Twin Towers. Now surrounded by the flames, Stark launches himself, using the jet propulsion of his armored suit, and escapes the spectacular sequence of explosions, which

are viewed in a consecutive sequence of long shot, close-up, extreme long shot, and slow motion as the ball of flames mushrooms upward, thereby generating an "impact aesthetic." A final edit to a panoramic viewpoint then sees Stark, as Iron Man, accelerate from the fireball's center and fly skyward. Indeed, throughout the film, there is an emphasis on the control of flight as a means of escape or as a way to save others.

In the same vein as *The Kingdom of the Crystal Skull*, this "mushroom cloud" imagery not only recalls 9/11 but simultaneously conveys resemblances to the atomic bomb. The fact that Stane later succeeds in illicitly removing the arc reactor from Stark's chest may also be a commentary on the dangers of nuclear weapons in the wrong hands, indicated as he comments to the now paralyzed Stark, "Your father, he helped give us the atomic bomb. A new generation of weapons with this at its heart. Weapons that will help steer the world back on course, put the balance of power in our hands." *Iron Man 2* mediates the Cold-War analogy still further, its terrorist other on this occasion being Russian scientist Ivan Vanko, and implicating nuclear threat in its dialogue and mise-en-scène. For example, Stark states at the court hearing "I'm your nuclear deterrent.... It's working. We're safe. America is secure," thereby attempting to reassure audiences within the diegesis as well as audiences of the film, perhaps in response to recent US defense spending cuts (MacAskill, 2009). *Iron Man 2* also repeatedly references the toxicity of the palladium as a central narrative strand, with Jarvis, Stark's robotic butler telling him, "The device that is keeping you alive is also killing you."

Technology consistently provides a source of spectacle, further arising as Stark works on a revised model of the Iron Man suit (*Iron Man*) on his return to the United States. Here, Stark's futuristic design equipment, with which he is able to construct virtual holographic models of the suit, appears sophisticated and almost otherworldly in contrast with the primitive methods of the Afghani fighters, who literally piece together the remnants of Stark's earlier hand-built prototype. A similar spectacular sequence arises in Stark's quest to discover a new chemical element to power his arc reactor. On this occasion, realizing that his father has left him a clue to the element's structure in the blueprint of an old exhibition plan, he replicates the chart in the form of a hologram and thereby discovers the substance's molecular layout. He manipulates the virtual structure midair to reveal the new element, the procedure producing surreal, magical effects. He then uses this template to construct its physical form in a process that is partly suggested as industrial (construed by the use of welding goggles). However, the equipment (an extremely long cylinder) is also recognisable to audiences through media coverage of recent subatomic particle research using the Hadron Collider. Alongside the satellite imagery of inferior North Korean

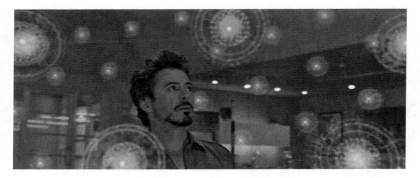

Figure 13 Holographic technology in *Iron Man 2*.

and Iranian Iron Man "prototypes," these visuals of superior US technol-
ogy (also evident in the vast array of equipment throughout his home) may
thus be indirectly reassuring for audiences. Moreover, as he refines the
Iron-Man suit, there are workshop sequences that show him perfecting and
controlling flight, culminating in supersonic speeds whereby he is able to
outrun fighter jets. Even when an early version of the suit suffers from a
buildup of ice and causes him to freefall temporarily, he regains control of
flight.

Stark uses the upgraded Iron-Man armor to return to Afghanistan to
attack the Ten Rings, the group of fighters who had captured him and who
are now terrorizing villagers in Gulmira (the village where Yinsen's family
lives) in scenes of slaughter resembling war on terror media footage or recent
Iraq combat films. Iron Man saves the villagers and incinerates the weapons
depots in spectacular fireballs (and thereby reverses real histories of civilian
deaths, for example, the killings of Iraqi civilians at Haditha in 2005). As
DiPaulo comments, "The scene is powerful partly because many audience
members wished that US forces would be able to avoid collateral damage
in the real world as well" (2011: 57). The use of torture is also intimated
here when Iron Man leaves one of the insurgents to the villagers, telling
them, "He's all yours," implicitly suggesting that they will kill him slowly
and painfully. Meanwhile, military monitors detect him and immediately
deploy armed fighter jets, in contrast to the real-world aircraft attacks on
9/11 when US military response was delayed. A missile launch by one of the
jets causes Iron Man to activate flares, leading to a midair fireball and the
crash of one of the jets, providing further "impact aesthetic" visuals. "Now
what am I supposed to tell the press?" Rhodes asks Stark when he discovers
that Stark had indirectly caused the jet crash. "Training exercise. Isn't that
the usual BS," responds Stark, referring to the misinformation surrounding

the invasion of Iraq and the suppressed reports of collateral damage that unfolded there (see Chossudovsky, 2005: 149). This analogy is corroborated by Rhodes's appearance on television to officially announce, "An unfortunate training exercise involving an F-22 Raptor occurred yesterday. As for the unexpected turn of events in Gulmira, it is still unclear who or what intervened but I can assure you that the United States government was not involved."

There is further reference to collateral damage in *Iron Man* when Stane and Stark go into conflict in their respective Iron-Man armories. With his amplified size, Stane becomes increasingly aggressive, demonstrating his newfound power by picking up a car containing civilians. "Put them down," shouts Stark, to which Stane responds, "Collateral damage, Tony." Their conflict culminates in more spectacular destruction as Potts activates a huge electrical surge through the arc reactor and thereby electrocutes Stane, the power channeling upward into the sky in a vertical column of light. The column is similar to the *Tribute in Light* that was also suggested in *The Dark Knight* and also resembles an identical effect in *The Lord of the Rings: The Return of the King*, perhaps alluding to divine intervention. As Stane crashes down onto the reactor, a massive explosion occurs with fireballs billowing out toward the screen.

Iron Man 2 continues with these explosive effects and fireball imagery, which usually involve shattering windows and spectacular destruction. Here, events unfold in New York and therefore likely resonate more profoundly with audiences in respect of the 9/11 attacks, the next one occurring as Iron Man and his friend, Rhodes, descend toward a weapons exposition where Hammer is demonstrating an army of drones. These first fire up at him and then shoot out the circular glass domed roof of the exposition, which splinters down in slow motion. The scene of destruction continues, but it is now visible from Rhodes's overhead perspective as he flies in toward the towers of the exposition before a cut to its interior reveals the drones streaking downward. As they fire again, the side windows now implode toward the characters (and the spectator) and plates of glass shatter and slide downward, further replicating the imagery of the Twin Towers' collapse. The camera also often immerses the viewer in the screaming crowds, creating effects akin to those shown in media footage of fleeing New Yorkers on September 11.

As well as the motif of shattering glass, a further distinctive feature of the New York scenes is the continued use of fireballs, the first typifying King's description of the "impact aesthetic." During the drone attack on Stark and Rhodes, fireballs streak across the screen from left to right as the camera tracks diagonally across the screen before cutting to close-up as fireballs fill

the frame and cars upend, toppling toward the spectator. This scenario is then repeated from a slightly higher perspective as the fireballs now move directly toward the spectator. The second example unfolds as the drones attack the replica earth structure on top of the exposition, causing a series of explosions that are visible in long shot before the camera cuts to extreme long shot. The circling camera now surveys the scene from a distance, replicating helicopter images of the burning Twin Towers.

A final way in which the film may be significant to post-9/11 audiences in terms of spectacle lies in the drones themselves. In justifying their use, Hammer tells the exposition audience, "For far too long this country had to place its brave men and women in harm's way," acknowledging those lives lost in the war on terror. Indeed, the film draws on the widespread investment in, and deployment of, robotics technology after 9/11 in its various robotic manifestations (Singer, 2009: 35). The inclusion of the drones may also reference Colin Powell's public case for the invasion of Iraq, when he revealed that unmanned experimental drones had the capacity to deliver biological weapons.[6] The humanoid form of the drones, in the case of *Iron Man 2*, engages a common trope of representing the other in fantasy and science fiction—one where the enemy appears human but is not. It calls attention to terrorists as suicide bombers too, as toward the end of the film, Stark and Rhodes notice that the drones have flashing red lights on their chests in place of the arc reactors. Vanko then tells them, "All these drones are rigged to blow." Moreover, the utilization of drones as terrorists and suicide bombers avoids the Eastern stereotypes that Favreau was accused of deploying in his first film.

MORALITY AND MASCULINITY

Further to the images and themes that relate to the war on terror, the *Iron Man* films also reflect on the failure of US morality as well as on its symbolic impotency, which was widely acknowledged during the September 11 attacks. Returning to the United States after his escape in the first film, Stark states, at an informally convened press conference, "I saw young Americans killed by the very weapons I created to defend and protect them and I saw that I had become part of a system that is comfortable with zero accountability." Stark's moral epiphany is further evident when he tells Potts, "I just finally know what I have to do," meaning that he intends to destroy all the weapons that he has manufactured.

His more sober persona thus reflects a newfound moral sensibility, first indicated by the fact that he shuts down Stark Industries' weapons

manufacturing division. Stane's immediate reaction is concern with a potential stock drop and, therefore, as in *Pirates of the Caribbean*, the film alludes to the profiteering of companies, connected to the Bush-Cheney Administration (see Kellner, 2010: 61). Stane's public justification for Stark's decision to close the weapons division is that the latter is suffering from Posttraumatic Stress Disorder (PTSD). Rhodes also tells Stark, "What you need is time to get your mind right," further attributing Stark's decision to psychological deterioration (although we know this to be incorrect, the reference to PTSD is inevitably meaningful for audiences in its widespread recognition as a consequence of 9/11 and the war on terror).

Although Stark is psychologically unaffected by his three months in captivity, his physical vulnerability becomes apparent when he asks Potts to assist him with replacing the original arc reactor with a more sophisticated version. Potts has to remove the wire from inside the reactor shell within a cavity in Stark's chest but accidentally touches the sides, triggering an electric shock. She then mistakenly takes out the magnet, causing Stark's heart to dysfunction. Further compounding the sense of bodily wounding and corporeality, she comments on the smell and sound of the device as she removes it. "That's the sound of plasmic discharge," Stark reassures her, and as she inserts the replacement reactor, Stark jumps up, appearing fully restored, and the arc burns brightly. This wounding scenario recurs toward the end of *Iron Man* when Stane also removes the arc reactor from Stark's chest, temporarily incapacitating him. In each of these experiences, Stark is at the point of death but endures and makes a complete recovery.

Julie Drew makes some claims that are relevant to this combination of wounded but hard-bodied masculinities in post-9/11 cinema in her analysis of public discourse following 2001. Here, she identifies a movement toward a gendered national identity. Examining extracts from the *New York Times*, Drew concludes that such gendered identity was polarized,

> highlighting physical strength and violently punitive responses to conflict as both desirable and necessary, as well as paternalistic attitudes towards injury and trauma, both of which are assumed to be predicated on weakness, and which are read as feminine. What is particularly interesting about post-9/11 public discourse is not that the U.S. argues that it is masculine, but that the U.S. is far too feminine, and thus must work to become more masculine in order to be safer. (Drew, 2004: 71)

Ostensibly, Drew argues that various forms of public discourse, including "presidential crisis rhetoric" (2004: 71), produced a "deliberate and public reconstruction of [U.S.] national identity as aggressive, stoically masculine,

and paternalistic" (2004: 71) in contrast to the language invoked by media accounts of US citizens that rendered them as feminized. In sum, Drew outlines a media rhetoric that gendered ordinary citizens as feminized and that engaged President Bush as part of an enterprise to construct "an explicitly masculine national identity" (2004: 73). Related to this is Susan Faludi's discussion of fire-fighters' responses to 9/11: "Philip Weiss described, more honestly than most, the humiliation—and hence, the hollow bravado—that witnessing the World Trade Center's collapse had spawned in him and male colleagues" (Faludi, 2007: 154). It is possible to interpret Stark's wounded and hard-bodied masculinity as mediating this scenario, with the construction of hard-bodiedness akin to the masculinized image conveyed by Bush. Conversely, the films portray other men as symbolically impotent in contrast to strong women. Whereas in *Iron Man*, Stark's next-in-command is Obadiah Stone, the sequel sees him promote his secretary, Pepper Potts, to chief executive officer. She proves to be far more efficient at organizing the company than Stark and ultimately saves his life twice. As replacement secretary for Potts, Stark employs Natalie Rushman (Scarlett Johanssen) who is, in fact, a secret intelligence agent sent to protect Stark, and who proves an expert in self-defense. When she breaks into Hammer Industries to challenge Vanko (the Russian scientist who is assisting Rockwell in creating the drones), she overwhelms several men while her male colleague struggles to defeat one. As he announces proudly, "I got him!" he looks up to see the trail of bodies she has left. While responding to criticism of the misogyny of *Iron Man*, such displays of physical strength in Rushman's character—and corporate expertise in Potts's—undoubtedly prove empowering to female audiences. Attracting female audiences is important since, in a discussion of gender and the blockbuster, Barbara Klinger states, "[Women] are repelled by the inhuman, overly technological universe offered by the typical blockbuster to the typical audience of adolescent boys" (2008: 69). In a further signification of male ineffectuality, Justin Hammer, weapons expert, sells weapons to Rhodes, including one that is referred to as "the ex-wife," which is "capable of reducing the population of any standing structure to zero" (Hammer, *Iron Man 2*). Later in the film, Rhodes deploys the "ex-wife" in an attack on Vanko, only to find that it merely fizzles like a small firework and falls feebly to the ground, providing a further commentary on Hammer's, and by extension, the United States' masculine identity. As in the films' other examples of masculinity being compromised by inadequate technology, this too reflects on US defense cuts in military spending.

Stark's ethical development is also relevant to the post-9/11 film in the way that morality has influenced concepts of US identity since 2001. As

discussed in Chapter 1 of this book, Cynthia Weber identifies a connection between cinema and morality in post-9/11 film, noting a questioning of moralities that confounds US identity (2006: 4). The close attention to morality within *Iron Man* chimes with Weber's claim regarding American identity, thus reframing Western masculinity through morality as well as through hard-bodiedness and wounding. This is relevant in connection to the films' interrogation of US morality and the equivocal tactics of the Bush Administration, both in invading Iraq and in the revelations concerning Guantánamo Bay, Abu Ghraib, and Bagram. Resolution and a restoration of morality come with the protagonist's transformation of personality and change of mind about weapon development plans.

CONSUMERISM AND ENVIRONMENTALISM

Whereas the *Iron Man* films center on the war on terror, there are obvious commentaries on Stark's extravagant lifestyle and its comparison to the poverty both of the Afghan villagers and of Ivan Vanko. Continuing Stark's moral reformation in *Iron Man*, *Iron Man 2* sees him, now facing imminent death, give away his entire art collection and hand over the company to his secretary. There is therefore a rejection of materialism and corporate avarice and a reevaluation of what is important, in line with the depressed economic backdrop to the film's release. Moreover, although the images of landscape destruction that figure prominently in other new millennial fantasies such as *Avatar*, *The Kingdom of the Crystal Skull*, and *Lord of the Rings* are absent here, there are several references to the energy crisis, with Pepper Potts telling Stark, "We have already awarded contracts to the wind farm people." Also, in *Iron Man 2*, Nick Fury (Samuel L. Jackson) tells Stark that "[his father] was about to kick off an energy race that was gonna dwarf the arms race—he was on to something so big it was gonna make the nuclear reactor look like a triple A battery." The energy crisis analogy becomes further evident in Stark's search for an energy source that is not toxic, corresponding with the pursuit for alternatives to nuclear energy and its attendant risks.

CONCLUSION

The *Iron Man* films continually offer visual parallels with the war on terror, implicitly critiquing US involvement in Iraq and the measures undertaken at the terrorist detention camps. Some reviews of the first film are negative, condemning its stereotypical portrayals of Middle Eastern characters as well as its objectification of women. Thomas Schatz also

notes that "an indifferent response to *Iron Man*'s politics may have been due to its comic book tone and playful take on the superhero genre [...] although its jingoistic Americanism [...] probably contributed to its relatively subpar performance overseas" (2012: 202). *Iron Man 2* addresses these issues of representation, reconfiguring the terrorist other as the army of suicide bomber drones that were created by Vanko, and portraying women as intellectually and physically superior to men. Overall, the films display a development in Stark's character whereby he destroys his luxurious Malibu home (signifying a rejection of materialism and technology) and realigns his moral compass. However, Matthew Alford notes that "several reviewers fell for this conceit" (2010: 111) and goes on to argue that "these readings of the film ignore the blatant fact that Stark actually continues to build weapons [...] and this is shown to be great news as long as such capabilities remain only in American hands" (2010: 111). Nonetheless, though there is undoubtedly a celebration of US firepower, spectacular destruction is inflicted upon both the insurgents and upon Stark (Rhodes, Stane, and the US government fighter jets all attack him). The most disturbing sequences of the two films, namely, the flame-throwing Iron-Man prototype and resultant burning bodies, the attack on the exposition in New York, and Stark's torture, comprise visuals that generate flashbulb memories. Some reviewers found such imagery distasteful, David Denby commenting, "The freelance fanatics [...] waterboard Tony Stark, which, considering what some American interrogators and their surrogates have done to suspects recently, is enraging to watch" (2008). Other less significant alignments with 9/11 contribute toward the films' meaningfulness for spectators. For example, in attempting to trace Vanko's telephone call in *Iron Man 2*, we see a map onscreen progressively closing in on Manhattan as its epicenter. Vanko's easy hacking of the computers systems, when he "blasted through the firewall" (Hammer, *Iron Man 2*) highlights the vulnerability of US security and he further manages to sabotage the telephone lines, these small details revealing parallels with 9/11 in that phone lines were overwhelmed and not operational. In recognizing a failure of morality (in respect of Iraq and the detainee camps) and damage to the US psyche, the film portrays a beleaguered masculinity, specifically through Stark's wounded body. However, Stark's recovery from near-death experiences converges with that of other fantasy heroes in signifying US resilience. At the same time, the films also promote audience pleasure through excessiveness: first, in experiencing Stark's indulgent lifestyle and its display of wealth and materialism and, second, through inviting audiences to recognize a parodic element in his excessiveness. Thirdly, the films fetishize warfare and technology as spectacle but

in contrast to criticisms leveled at Favreau, arguably condemn American military jingoism and strategy in relation to the war on terror through such excesses. The films thus simultaneously address the negative aspects of the war on terror but may enable audiences to work through these by their reframing within a superhero narrative.

CHAPTER 9

SHOCK AND AWE: TERROR, TECHNOLOGY, AND THE SUBLIME NATURE OF CAMERON'S *AVATAR*

IN 2009, THE FILM AVATAR BECAME THE HIGHEST GROSSING FILM OF ALL time, its success partly deriving from an intensive marketing campaign centered on recent technological innovations that enabled its director, James Cameron, to conjure a beguiling visual imagery that had been previously unachievable on screen. Currently still topping box-office charts, *Avatar*'s otherworldly depiction of life on the fictionalized planet of Pandora includes scenes of seemingly impossible floating mountains, vast, surreal landscapes, and a luminescent strangeness of flora and fauna. Closely connected to these natural forms are allegorical depictions of terror, while a sublime aesthetic also dominates the film's technological spectacles. Indeed, the destruction of nature by military technology indicates the cultural gulf between the US army and Pandora's indigenous population, the Na'vi. The attempted domination of the Na'vi, seen by some scholars as analogous to the treatment and representation of Native Americans, inevitably conjures parallels with the war on terror. The film's allusions to 9/11 and the war on terror, particularly the Iraq War, cannot be in doubt, since in discussion about *Avatar*, Cameron commented, "We went down a path that cost several hundreds of thousands of Iraqi lives. I don't think the American people even know why it was done. So it's all about opening your eyes" (in Hoyle, 2009). The juxtaposition of technology and nature thus not only provides examples of sublime spectacle

as commentaries on current environmental crises but also renders the entire narrative indistinguishable from its 9/11 contexts.

Several studies have already determined connections between war, landscape, and sublime imagery. For example, Hockenhull (2008) locates a neoromantic sublime in the landscapes of the wartime films of Michael Powell and Emeric Pressburger, whereas Maurizio Natali (2006: 93) and Holloway (2008: 93) identify sublime effects related to 9/11 in American cinema. Similar features are discernible in *Avatar*, the film activating spectator emotion concerning contemporary issues through its sublime aesthetics. Specifically, it highlights environmental concerns through the wanton destruction of nature. In less obvious ways, the film's themes and visual juxtapositions unconsciously initiate associations with 9/11 and the war on terror in their allusions to documentary footage of those events (and intertextually, through other fictional films). Such associations might derive from photographs and news reports of those who jumped or fell from the Twin Towers, footage of the attack on the Towers, the injuries sustained by US military personnel during the conflicts in Iraq and Afghanistan, and accounts of unmotivated US attacks on Iraqi civilians, for example, at Haditha (see Goldenberg, 2006). Essentially, *Avatar*'s fantastic nature, which is seemingly remote from the realities of terrorism, enables it to marshal contemporary anxieties in more subtle ways than realistic depictions, allowing the viewer to work through traumatic issues unconsciously in a way that a realist film could not do.

As noted earlier, films often achieve this by the deployment of stock emotional paradigms, such as survival in the face of threat (Plantinga, 2009: 75). In this case, *Avatar*'s fantasy narrative entails a paradigm of good (the Na'vi and their natural way of life) overcoming evil (the US military). In the way that Plantinga argues that the narrative film's reframing of negative emotions to produce pleasure enables a "working through" (2009: 179), *Avatar* reframes 9/11 in scenes of sublime spectacle, which often display the characteristics of Klinger's arresting image (2006: 24). Klinger's notion of the arresting image resembles Edmund Burke's analysis of the sublime in the way that he too discusses the activation of emotions through "associations" and "memories" (1998: 118). Burke explains that "besides such things as affect us in various manners according to their natural powers, there are associations made [...] which we find it very hard afterwards to distinguish from natural effects" (1998: 118). He suggests that these associations may stem from "conclusions from experience" (1998: 118), an argument that corresponds with Klinger's notion of the arresting image and Plantinga's claim for a reframing of negative emotions. Whereas Burke's theory of the sublime is germane to *Avatar*'s sublime characteristics, Klinger's perspective is also relevant here in her more detailed discussion of cinematic composition,

temporal distortion, and surreal and juxtaposed elements that constitute arresting imagery.

Such elements are evident in the visual and symbolic oppositions of *Avatar*, emerging predominantly in the incongruities between nature and technology. As in Klinger's thesis, temporal distortion through slow motion may accompany such scenes, though more so toward the end of the film when arresting imagery occurs more frequently. In sum, this chapter first identifies the Burkean sublime in *Avatar* through various aspects of nature and technology (e.g., in relation to dimension, limitlessness, and verticality) as ways to highlight environment issues and 9/11 connections. Second, it locates instances where the combination of these two sublime aspects intensifies viewer involvement through the production of spectacles that do not merely reframe negative emotions but generate specific associations with 9/11 and the war on terror through Klinger's concept of the "arresting image" (2006: 24). The mounting frequency with which arresting images occur as the film progresses correlates with the film's narrative trajectory of good eventually overcoming evil. Additionally, these arresting images become increasingly recognizable as pertaining to 9/11. Thus, the entire narrative and visual momentum of the film encourages catharsis as its finale approaches.

The narrativizing of traumatic events in this way has parallels with psychological interventions for trauma, which I outlined in the introduction as including controlled reexposure to the original trauma through regression analysis, cognitive behavior therapy, or narrative exposure therapy. Taking into account Klinger's contention for the arresting image, in conjunction with the Burkean sublime, the spectacular nature of *Avatar* and its contemporary inferences may thus enable the emotional energy surrounding these issues to be released, especially given Plantinga's claim that eliciting emotional effect is an overriding intention of narrative film in general.

AVATAR AND THE TECHNOLOGICAL SUBLIME

Avatar's plot centers around protagonist Jake Sully, a paraplegic ex marine, whose mission is to infiltrate the Na'vi (a humanoid species inhabiting Pandora) by assuming an avatar identity. The avatars contain both human and Na'vi DNA, Sully replacing his deceased twin brother because he has identical DNA and is therefore an ideal match for the avatar. The motivation for the avatar mission is twofold: first, a scientific exploration of the neurobiological network that exists on Pandora, and second, a military intervention to procure a valuable mineral (unobtainium) that underlies the Hometree, the home of the Na'vi. Increasingly, however, Sully embraces the Na'vi way of life and opposes the military's intention to attack them. When the military devastate the Hometree, he resists their attack, fighting

alongside the Na'vi. Ultimately, Sully rejects his former life and permanently assumes his avatar identity.

Avatar affords multiple opportunities to examine the technological sublime in the military's equipment, which, like Pandora's landscape, has hyperbolic qualities. This imagery evokes sensations of incredulity, especially that pertaining to the destructive capacity of military technology. The ability to provoke such responses corresponds closely with Burke's theory of the sublime, which describes paradoxical sensations of pleasure and pain and constitutes "whatever is in any sort terrible, or is conversant about terrible objects, or operates in a manner analogous to terror" (1998: 36). Burke locates the sublime in qualities of power, infinity, magnificence, darkness, suddenness, vastness, obscurity, and extremes of dimension. Although aesthetic discourse often aligns these aspects with nature, according to Philip Shaw, "Burke shifts the origin of the sublime away from physical things and towards mental states" (2006: 49). For Burke describes an "astonishment" associated with the sublime, an "emotion in the mind" arising from images of greatness that have "terror for [their] basis" (1998: 145).

Avatar's utilization of acute camera angles and extreme perspectives is important in this respect since these often enhance the film's sublime attributes. Alternatively, extreme long shots or panoramic shots also contribute to feelings of awe in exaggerating the vastness of objects or landscapes. The spectator thus oscillates between the "astonishment" (Burke, 1998: 54) arising from extreme, close-hand visual experiences and more distant contemplations of grandeur. The appearance of technology and nature, together, within the same frame provides antithetical characteristics that generally reemerge in the film's other binary oppositions (these include, for example: civilized/primitive; US military/Na'vi; human/animal; violence/peace; material/spiritual; and masculine/feminine) and correspond with the juxtapositions of Klinger's "arresting image" (2006: 24).

The first sublime image occurs at the film's outset when it invites the viewer to contemplate an image of a spaceship surrounded by a void, encapsulating Burke's references to vastness, infinity, and the universe without end (1998: 71). A slow tracking shot that runs down the entirety of the ship emphasizes its colossal size too. The camera subsequently cuts to an extreme long shot that shows the spaceship, now dwarfed by Pandora, a slow pullout revealing these set against an even larger planet, whose edges mostly exceed the frame. The scene thus engages concepts of the sublime through extremes of dimension in its juxtaposition of technology (the space ship) and nature (Pandora). It also reflects *Avatar*'s underpinning articulations of the sublime in its themes of limitlessness and finitude (these ultimately commenting on immortality and death).

Concurrently, Sully's voiceover informs us both of his injuries and of his dreams of flying. The camera cuts from his fantasy of flight to a claustrophobically framed close-up of his open eye, signaling his return to consciousness. The close-up of his eyes is a recurrent visual device, indicating not only rapid eye movement (and therefore that his brain is active either in dreams or in his avatar body), but also signifying the limitations imposed by his return to human form. The sense of limitlessness conveyed by the earlier image of outer space, and Sully's dreams of flying (where a rapid overhead tracking shot over vast green forests conjures his imaginary flight) further contrasts with the restrictions of his physical incapacity indicated thereafter. Here, the viewer learns that Sully is unable to walk because of injuries sustained during combat. His combat gear and wheelchair may be familiar to viewers, reminding them of recent images of amputees and injured combatants returning from the wars in Iraq and Afghanistan. In addition, the constraints imposed by his disability convey a stasis and powerlessness, arguably reflecting the "impotence" felt by the United States immediately following the 9/11 attacks (Faludi, 2007: 53). Certainly, the film continually emphasizes the fact that Sully is a paraplegic, both through the derogatory comments of his army colleagues and through his repeated, exaggerated action of physically picking up his legs to move them. Indeed, congruencies with 9/11 and the war on terror become increasingly discernible as the film progresses.

Sully's voiceover, privileging his perspective, is important in persuading the audience of the film's antiwar stance, his injuries a direct reminder of the negative aspects of warfare. Also reflecting losses in Iraq and Afghanistan, the film suggests that one soldier is easily replaceable with another. For example, government officials tell Sully, whose deceased twin brother was initially intended for the avatar program, "Your brother represented a significant investment...you can step into his shoes." Implicitly, Sully is dehumanised by this comment and only becomes operationally useful when integrated with some form of technology (his wheelchair or avatar body). His brother's coffin is bar-coded with a six-digit number, alluding to the high number of casualties in the Iraq war while reducing that loss to a mere numerical value.

Sully's contemplation of his brother's body intercuts with details of his transfer to Pandora and his brother's subsequent cremation. The screaming of an engine follows as the camera cuts to an extreme long shot of a jet entering the atmosphere of Pandora, providing the film's first sublime "arresting image." The sound effects here reflect Burke's description of suddenness. For Burke explains that certain sounds also arouse the sublime. These include "[a] sudden beginning or sudden cessation of sound of any

considerable force" (1998: 76). As the jet rapidly diminishes to a minute fleck against a backdrop of enormous dark clouds, it sustains sublime visual effects through the magnitude of the clouds and establishes a connection to 9/11—for one of its most memorable images was the black smoke billowing from the Twin Towers. This sequence thus essentially reframes negative emotions to elicit pleasure through the construction of sublime imagery, subtly introducing the spectator to scenes alluding to the attack.

A deep crater scarring Pandora's surface becomes visible as the jet powers down toward a vast industrial complex. Low camera angles reveal a number of trucks that appear miniaturized against another gigantic vehicle, while human figures are barely perceptible. A cut to close-up shows the wheels of the one vehicle turn anticlockwise while the truck's wheels turn clockwise. The combined effect is of a huge mechanism, conflating the military with technology, industry, and landscape destruction through sublime effects based on vastness and further implying the dehumanization of the military. As the aircraft touches down, the size of the craft, now seen in close-up, exceeds the edges of the frame. The marines run out from the aircraft, leaving Sully behind as he swings his defunct legs over into a wheelchair (thereby highlighting his helplessness). A low-angle shot reveals the contrastingly vast metallic legs of an enormous robot striding effortlessly toward Sully, who appears small and vulnerable in comparison. Thereafter, another truck closes in, rendered from an extreme low angle below Sully, who also looks upward at it, the spectator's lower perspective amplifying the truck's enormity. The camera then zooms in as the truck rolls by, each wheel now filling the frame. Such scenes of gigantism illustrate how, as Scott Bukatman notes, "the might of technology, supposedly our own creation, is mastered through a powerful display that reveals anxiety but re-contains it within the field of spectatorial power" (2000: 219). At the same time, they accentuate Sully's disability.

Images of terror and awe thus permeate the early sequences as a technological sublime, this generally corresponding with the masculine identity of the US military. In contrast, the film signifies Sully as other. In fact, the other characters humiliate Sully because of his disability, one describing him as "meals on wheels," further suggesting the dehumanisation that was earlier implied. Despite these negative connotations, Sully's voiceover encourages the spectator to identify with him, persuading us that the military's strategy is flawed, and we mostly see events unfolding from his perspective, initially through low-angle shots. When scientist Grace Augustine (Sigourney Weaver), who is leading the avatar team, finds out that Sully is joining the group, she further suggests a condemnation of US military action, commenting, "The last thing I need is another trigger happy moron out there." In its diegetic disparagement of military action, the film is thus

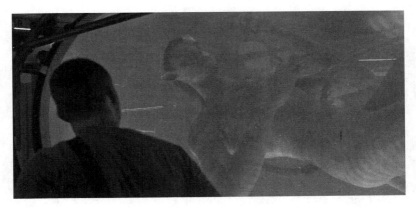

Figure 14 Jake Sully's (Sam Worthington) avatar in *Avatar*.

clearly critical of the Iraq War. "She likes plants better than people," says one character, consolidating another of the film's distinctive features—its affinities between the feminine and the natural.

Certainly, the avatar program, overseen by Grace, is presented as a maternal enterprise comprising imagery that is suggestive of gestation, birth, and motherhood, though whereas the gestation of Sully's avatar resembles a "natural" process, we witness another variant of the technological sublime in the avatar's activation. Floating in an enormous uterine-like container, its involuntary movements mimic those of a human fetus, while its larger-than-life size instills a sense of awe in the viewer. The avatar has Sully's facial characteristics, and since we have been encouraged to identify with him, this visual element provides an added fascination. Sully's first awareness as an avatar is presented on screen as a visual blurring and auditory muffling, as if he is just awakening. The viewer continues to see and hear from his perspective as he regains sensory clarity, revealing a medical setting for the avatars' activation (the film's medicalization of the avatar program pointing toward advancements in the field of bionics, transplant surgery, and cloning).

When Sully first assumes his avatar identity, he exhibits both infantile and animalistic tendencies. Not only do his ears twitch involuntarily and his tail sweep from side to side, but we see a close-up of his huge toes as he wriggles them and attempts to walk, this attention to mobility drawing on the film's broader theme of aspirations to limitlessness. The camera position still assumes his point of view, but it now moves to his newly elevated perspective. The viewer also consequently looks down on the avatar personnel. Because of this, the film endows the viewer with a similar sensation of power, which in the film's overall context of 9/11, may temporarily reverse any feelings of impotence following those events. Moreover, Sully experiences a newfound

sense of freedom as he psychologically escapes from his former identity and physically breaks free of the various monitors and wires. Sully's liberation as an avatar contrasts with his sense of confinement and incapacitation when he returns to his human form, signaling conflict between the two states and reiterating the opposition of limitlessness and finitude that underpins the narrative. There is also a concurrent juxtaposition between human figures and the avatars, long shots highlighting disparities in their respective heights and providing opportunities for spectator contemplation of sublime beings. Since the film consistently encourages alignment between the spectator and the avatars/Na'vi (through subjective camera and voice-over), viewers are continually granted a sense of power (through their physical potential) as well as a sense of morality (in their spiritualism and respect for life). This is significant in respect of the film's capacity to alleviate viewer anxiety concerning 9/11, since US morality was compromised through the invasion of Iraq (both when Weapons of Mass Destruction failed to materialize and in the death of innocent civilians).

A further variant of the technological sublime emerges in the oversized cyborgs and other robotic equipment that the military utilize against the Na'vi. In visualizing these phenomena, Cameron again deploys extreme low-angle shots to emphasize their overwhelming nature. These machines enhance human performance and thus confer posthumanistic qualities. Indeed, like the avatar program, the attempt to become more than human through cybernetic enhancement demonstrates a striving for the sublime (in this case, the posthuman sublime) through an increase in size and strength. Like Sully's desire to inhabit a taller, more able-bodied form, the military equivalent is a readiness to integrate with technology. For example, in the sequence where Sully first meets Quaritch, we see the latter climb inside a colossal robotic machine that serves to amplify his size and strength and to display his aggressive tendencies, which occurs when he punches his massive cybernetic-enhanced fists into the air. The framing ostensibly sets up both Quaritch and Sully as cyborgs, with Quaritch to the left of the frame within his cyborg suit (represented as a violent Western power), and the debilitated Sully to the right in his wheelchair (as disempowered other). Sully is motivated to become an avatar, however, not only by a desire for improved physical capacity but also for homology with the Na'vi (and their spiritual, ethical way of life), whereas the military merely aspire to increased destructive capacity motivated by corporate greed.

In sum, Avatar's depiction of the technological sublime, which is often juxtaposed against the natural sublime, initiates associations with 9/11 and the war on terror through allusions to such imagery. The technological sublime has diverse representations but generally encapsulates a desire for

limitlessness and immortality. It generates secondary associations through the related binary oppositions that reflect the polarities between nature and technology (such as east/west and feminine/masculine). The technological sublime manifests in scenes of posthuman enhancement, including the avatars, the cyborgian military equipment, and the references to Sully's "new legs." Indeed, the theme of prosthetic limbs and body parts is a recurrent motif of the film, the Colonel promising Sully "new legs" if he succeeds on the avatar mission. Exemplifying the vulnerability of the embodied human form, power is therefore mobilized by disembodiment (as an avatar) or posthuman enhancements (in the military equipment). For the viewer who is unconsciously forming associations with the real world, such enhancements most obviously relate to limb replacement that follow warfare as well as to 9/11 reports of the recovery of body parts rather than intact bodies (Simpson, 2006b: 28).

AVATAR AND THE NATURAL SUBLIME

If a technological sublime defines the US army, then a natural sublime characterizes life on Pandora. On Sully's first outing there, sweeping pans reveal it to be a lush green place with exotic wildlife and luminescent plants that have their own energy. Military equipment does not always work there because of a flux vortex—it is thus antitechnological and illustrates the recurrently signified incompatibility of nature and technology. Sully's affinity for Pandora perhaps arises from his disability, which renders him closer to nature by experiencing the rigors of embodiment. Within the vortex, the floating mountains of Pandora epitomize Burke's notion of the sublime. Extreme low-angle shots show the mountains suddenly emerging from the mist and coming into view. We then see the science crews' expressions of awe and exclamations of "oh my god" through reaction shots as their aircraft flies between them, the latter rendered minute in comparison to the mountains. In their vast unanchored state, the mountains thus provoke wonderment both for the characters and for the spectators. This sequence is important in illustrating that "the landscape sublime is rooted in an activity of contemplation, in the attempt to grasp what, fundamentally, cannot be grasped" (Bukatman, 2000: 214). While the strangeness of their appearance elicits fascination in the viewer, the mountains thus seem to exert a transcendent effect that goes beyond earthly concerns for the characters. The deployment of low-angle shots attenuates their heavenward connotations, while a subsequent narrative arc (to access the Banshees) requires a seemingly infinite physical ascent to reach their "summit." Both aspects point toward the divine implications of the mountains, and therefore a seemingly

inherent sublimity. However, the perception of transcendent sublimity for the viewer primarily rests upon the reactions of the characters, and while the mountains *are* strange and awe-inspiring, the nature of their sublimity is thus relational rather than inherent.

Sublime effects further emerge in relation to Sully's final initiation into the Na'vi, a task that involves bonding with a Banshee. To locate the Banshees, Sully and Neytiri (Zoe Saldana), one of the Na'vi, climb upward through the floating mountains, crossing a bridge of entwined tree roots to access the highest precipice. Their journey is fraught with the danger of falling, indicated by the acute vertical drops and seemingly infinite expanses of space surrounding the mountains. Burke highlights the vertical drop as a source of the sublime, noting, "We are more struck looking down a precipice than at looking up at an object of similar height" (1988: 66). Clearly, the perpendicular features here cohere with such observation.

Extreme low-angle shots lead the eye up through the mountains, each mountain attached to the one above it by tree roots. Framing also enhances their upward extension as well as conveys a sense of infinity. Subsequently, an extreme high-angle shot shows Sully ascending toward increasingly ver-tiginous ledges that appear unstable and terrifying and climbing a twine rope that seems to have a bottomless drop beneath it. An extreme long shot then displays the group as diminutive figures crossing the twine bridge set against a blue sky punctuated by huge clouds and the floating mountains. The con-templation associated with the vastness and strangeness of the mountains thus continues to exert a sublime effect, the sequence providing examples of arresting visuals in their surreal elements and, for some viewers, resurrecting memories of the falling bodies during the Twin Towers' attacks.

Sully eventually tames his Banshee, suggesting a mastery of nature akin to the military's assault on Pandora. Here, however, the control of the Banshee depends on the formation of a psychic bond that involves mutual trust, which reflects the Na'vi's close connection with their environment. Initially, close-ups of the Banshee's aggressive behavior and reaction shots of an apprehensive Sully suggest its terrifying nature, and, as Sully mounts the Banshee, rapid panning and tracking shots from multiple angles accen-tuate the power and terror of its flight. An accelerating bank down in a vertical pan blurs to indicate the speed of their descent and again resonates with the Burkean sublime in its deployment of extreme camera angles and movements, descending tracking shots, and rapid overhead zooms that cut to low-angle perspectives, thus exaggerating its vertical characteristics (Burke, 1998: 66). An apparent spatiotemporal distortion arises from the kinetic cinematography and contributes to the sequence's arresting imagery. Sully's taming of the Banshee focuses on their close bond thereafter rather

than its former terrifying nature, and the scene thus exhibits qualities of the relational sublime. As Shaw explains, "Objects of this world [...] are subject to time and change; the nature of such objects is therefore relational or comparative: a physical object may be pleasing or terrifying depending on the way it is considered, the way in which it is represented" (2006: 20). The notion of psychic bonding also calls to mind Campbell's claim for an Easternization of the West (2010). In the context of 9/11, the scenes of rapid, uncontrollable descent and the command subsequently exercised over this motion may unconsciously alleviate unpleasant associative memories (of falling bodies) for the viewer.

As noted earlier, an affinity with nature is fundamental to the Na'vi way of life, and Sully's perspective reveals them as a caring, highly sensitive group that has spiritual beliefs. This emerges in discussions about the flow of energy and bonding with animals—for example, Neytiri tells Sully when mounting a horse-like creature to "feel her heartbeat, feel her breath." Although they kill other animals, they are humane, unlike the military, which does not seem to have any respect for human life. Discussing the attack on the Na'vi, Quaritch says to Parker Selfridge (Giovanni Ribisi), who is in charge of mining the unobtainium, "We'll drop them out with gas first—it'll be more humane [...] *more or less*" [original emphasis]. He also talks of "pre-emptive attack," saying, "Our only security is in pre-emptive attack...we will fight terror with terror," the film clearly alluding to the preemptive invasion of Iraq.

The sublime further emerges in certain aspects of Pandora's wildlife, and the Hometree generates particular feelings of awe and terror. When the avatar team first flies out toward it, an extreme long shot reveals their aircraft as miniscule in comparison, the narrative slowing down and enabling the viewer to contemplate the composition. The scene offers an uncanny repetition of 9/11 in the discordance between the aircraft and the enormous tree, igniting associations with the hijacked planes crashing into the Twin Towers. The scale of the imagery and the juxtaposition of its elements further exemplifies Klinger's concept of the arresting image and illustrates Burke's notion of vastness as sublime affect.

On landing, further extreme camera angles, this time from a low perspective, show Sully's point of view as he looks upward at the vegetation. A shift in camera perspective from a low-level shot of a seemingly normal-sized tree trunk to an overhead position suddenly renders the tree as colossal, revealing the minute flecks at its base to be the avatar team. Whereas the colors of Pandora's flora and fauna often cohere to aesthetic notions of beauty in their exotic palette and form, sometimes their size and luminescent qualities tend toward the sublime. Certainly, many of the creatures, in

their enormity, terrifying nature, dark coloring, and capacity for "sudden-
ness," are sublime (Burke, 1998: 76). These attributes surface when Sully
comes under attack from a huge rhinoceros-like creature. Seen from a low
angle, it charges toward the camera, while behind Sully appears another
aggressive-looking beast, dominating the frame. The continuous accelera-
tion out of the frame emphasizes the creature's terrifying aspects, especially
as its open, snapping jaws continually seem to threaten not only Sully but
also the spectator. To escape, Sully jumps over the edge of the waterfall, its
verticality relayed as sublime spectacle through an extreme overhead camera
angle. Sully thus appears miniaturized as he leaps over its edge, accentuat-
ing nature as a source both of awe and of terror, and at the same time, his
fall, which is seen in slow motion, generates distinct associations with those
who jumped from the Twin Towers. Muffled sounds, consistent with sub-
mergence underwater, replace extradiegetic sound effects, Sully's survival of
the fall providing another instance where associations with 9/11 may offer
some relief to viewers.

Because Sully is lost on Pandora, the avatar team temporarily abandons
him. This allows the sequence to draw on another typical source of the
sublime—the universe without end—the night sky of Pandora revealing an
enormous blue orb in close proximity with minor planets dotted around it.
Burke describes how the "starry heaven [...] never fails to excite an idea
of grandeur [...] the stars lye [sic] in such apparent confusion, as makes
it impossible on ordinary occasions to reckon them. This gives them the
advantage of a sort of infinity" (1998: 71). Again, the narrative slows down,
enabling a contemplation of the image and extending the film's subtext of
infinity through the stars and the universe. Its limitlessness perhaps reflects
the immortality implied in the cycle of life and death on Pandora and may
therefore unconsciously reassure audiences bereaved by 9/11 and the war on
terror.

This recycling of energy and its implications for an afterlife become
apparent in the subsequent scene where Sully remains lost on Pandora.
Sudden animal sounds alarm Sully; the creatures are almost impercepti-
ble in the darkness, again presenting nature as terrifying and fascinating.
Multiple black hound-like creatures threaten him, slow motion heightening
their terrifying nature, while lighting enhances the glisten of their teeth. As
Burke notes "[The sublime] comes upon us in the gloomy forest, and in the
howling wilderness" (1998: 60). He further comments, "The angry tones of
wild beasts are equally capable of causing a great and aweful [sic] sensation"
(1998: 77). Sully kills the hounds in self-defense, but Neytiri, who comes to
his aid, apprehends him, explaining that the Na'vi believe in humane killing
as well as in the renewal of life.

9/11, THE SUBLIME, AND THE WAR ON TERROR

The convergence of technology and nature occurs more frequently and obviously in the film's latter scenes, when allusions to 9/11 and the war on terror are unmistakable. Temporal distortion figures prominently and imagery directly provokes memories of 9/11. Moreover, editing techniques further heighten the emotional intensity of arresting imagery through the use of the "impact aesthetic" (King, 2000: 94), typically found in the action film. Such techniques manifest in the latter scenes of *Avatar*, further escalating its sublime effects.

The clearest correlation with 9/11 lies in the resemblance of the Hometree to the Twin Towers, both in its doubling (there is a second adjacent tree of identical proportions) and in its height. Yet, it is antithetical to them, the former signifying the natural, feminine, and spiritual, the latter signifying the technological, phallic, and commercial. When Neytiri first takes Sully to the Hometree, we see it from an extreme low-angle shot, silhouetted against the night sky, with even Pandora's adjacent planets appearing insignificant against it. A cut to an extreme high-angle shot, as Sully and Neytiri enter the base of the tree, reveals them as diminutive specks at its base. There are further analogies with the Twin Towers in the architecture of caverns within its root system. When Sully later reports to his superiors on the interior detail of the Hometree, he notes its outer row of columns, which are "real heavy duty. There's a secondary ring here, an inner ring, and a core structure like a spiral. The secondary ring is also load-bearing." Clearly, this description alludes to a building rather than to a tree, recalling the discussions of building structure in relation to the Twin Towers' collapse.

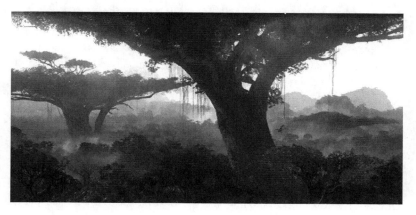

Figure 15 The two trees of *Avatar*.

Several scholars noted the sublime effect of the Twin Towers' destruction, matched here by the equally sublime collapse of the Hometree. Its devastation obviously reflects environmental issues, while also symbolizing the unstable hegemonic position of the United States. Narratively, the tree perhaps seems threatening to the military because of a neurobiological network that connects it to all living entities on Pandora. Such a potential link of self to other challenges US autonomy, a possibility reflected in the film's colonial tropes that form conscious narrative chords. Indeed, Quaritch refers to the Na'vi as "savages" and threatens to "blast a crater in their racial memory." While commenting on America's colonial past, these tropes may reflect concerns about US identity after 9/11. Just as security at US national borders has intensified to prevent further infiltration of the terrorist other, the nature of the neurobiological network on Pandora perhaps also implies the intangibility and pervasiveness both of the war on terror and of the forces of terrorism that François Debrix suggests (2005: 75).

Further congruencies with the war on terror surface in allusions to oil as a motivating factor for attack, the equation between oil and unobtainium reflecting a general perception of the invasion of Iraq as driven by oil. Although Stuart Elden comments, "The aim [of US military strategy] is broader and more subtle than one that can be grasped by the claim that it is 'all about oil'" (2009: xix), Steven Hurst suggests that oil has been fundamental in America's policy toward Iraq (2009: 20). Michel Chossudovsky also agrees that "the War on Terror has been used as a pretext to conquer new economic frontiers and ultimately establish corporate control over Iraq's extensive oil reserves" (2005: xvi). Reference to the war on terror is explicit in discussions concerning the unobtainium. For example, Sully says, "When people are sitting on shit that you want, you make them your enemy, so then you're justified in taking them." The film thus makes clear its opinion on the United States' motivations in the Gulf Wars.

The army proceeds to devastate the home of the Na'vi to procure the unobtainium. Extreme low-angle shots show gigantic, remotely driven bulldozers destroying Pandora's forest, leading Sully to climb on top of one to smash its guiding cameras. A full-scale battle ensues where, once more, we see Sully plummeting downward, again resembling the falling bodies from the Twin Towers, while the deluge of debris and ash recalls footage of the Towers' collapse.

A tracking shot reveals a fleet of aircraft approaching, which is incongruous against the breathtaking backdrop of Pandora. "That is one big damned tree," says Quaritch, looking upward from inside the main craft toward the Hometree, before an extreme high-angle shot from above the edifice reveals the same aircraft, almost imperceptible in comparison to the tree's trunk. As the military attacks the tree, fireballs billow out and debris flies toward the

spectator, shown in slow motion, these aspects entailing both the "arresting image" (Klinger, 2006: 24), and the "impact aesthetic" (King, 2000: 94). The following sequence discloses the aircraft set against the vast tree, smoke issuing from its burning trunk, resembling images of the Twin Towers. Quaritch then tells his men to "bring it down," low-angle shots revealing missiles shooting laterally across the frame, while Sully and the Na'vi run toward the camera. The scene occurs in slow motion, its dynamics and juxtapositions constructing a further "arresting image" and again entailing an "impact aesthetic." Fireballs constantly billow out toward the screen, while missiles discharge across the frame and the fleeing Na'vi are rendered in slow motion. Like the other films discussed in previous chapters, images of the Na'vi looking upward in fear provide additional associations with footage of 9/11, which featured onlookers running away and constantly glancing upward. An extreme low-camera angle also looks upward at the tree as its leaves begin to cascade down, a temporary silence providing an ominous pause before a cut to long shot frames the burning vegetation. A sudden rapid zoom reveals the rupture of the tree's base, which again occurs in slow motion, directly replicating the downward collapse of the Twin Towers. A cut to a low-angle perspective of the tree shows it beginning to fall, and creaking sounds precede its slow-motion toppling toward the spectator, first seen in long shot before the camera cuts between multiple perspectives, as if the collapse is happening more than once (in line with King's analysis of the "impact aesthetic"). These also intercut with close-ups of falling bodies and imagery of the Na'vi running toward the camera, the scene darkening as the collapsed tree excludes daylight. We then see the fallen tree in long shot with the hovering aircraft observing the destruction, before medium close-ups of the Na'vi reveal their anguished faces as they look upward in disbelief. From their base, the avatar team and the mining company, displaying shocked expressions, also raise their gaze toward screens showing the devastation, the spectator too assuming their point of view. This image clearly alludes to the mediated images of 9/11 and the onlookers who were likewise staring upward. Another extreme long shot of the conflict then sees the aircraft exit, leaving the spectator to contemplate the sublime spectacle of the tree's broken trunk silhouetted against the burning forest, its splintered remains echoing the steel structures left standing after the Towers' collapse. As the camera cuts to ground level, signs of loss and grief are pervasive—a close-up of Neytiri shows her distress as she discovers her dying father. These visuals, although neither sublime nor arresting, contribute to the overall reliving of the events of 9/11 since viewers may identify with such scenes of grief. The sequence culminates in an extreme long shot of the Hometree, its burning remains, now in the frame's background, creating an aesthetically pleasing backdrop of vivid color. When Sully later returns to his avatar body on

Pandora, he encounters a contrasting mise-en-scène of grey ash, reiterating post-9/11 imagery at Ground Zero.

The military's final "shock and awe" assault on Pandora incorporates further sublime imagery. First, in extreme long shot, we see an entire fleet of airships, led by one huge craft set incongruously against the floating mountains, illustrating extremes of dimension and flying laterally from left to right. The subsequent frame comprises a group of Na'vi flying on the Banshees, also set against the floating mountains, moving laterally across the frame from right to left. These two consecutive scenes convey the opposing forces of the United States and the Na'vi through images of nature against technology. Extreme overhead camera angles that observe the aircraft emerging from beneath the mountains accentuate the scene's surreal qualities, while high-angle shots from the Na'vi's perspective over sheer precipices provide sublime effects in the form of acute verticals. Fast-tracking, downward camera movements and extreme perspectives that center on these vertical drops further heighten the sublime aspects. Slow motion features regularly, especially in instances of death, while scenes of falling bodies occur frequently. The simultaneous traverse of the military's huge armored cyborgs through Pandora's forest replicates these elements—the ground battle entails numerous instances of arresting imagery, often visible in slow motion (especially scenes of death), and depleted of sound, thus amplifying their spectacular and sublime resonances. One image especially stands out—that of a burning horse running through the flaming forest, the sequence seen in long shot and slow motion, and devoid of sound. The vision undoubtedly forges emotional associations with those trapped in the Towers (as well as generates intertextual links with other war films) but without direct reference to them.

Just as defeat for the Na'vi seems inevitable, the forest retaliates, and the same creatures that had earlier threatened Sully now come to the Na'vi's aid. A roaring sound gives way to hordes of animals, seen from low camera perspectives, their size and abundance overwhelming the military. Crosscutting and lateral motion across the frame and toward the spectator engage an "impact aesthetic," while in the skies above, a similar spectacle unfolds as flying Banshees simultaneously attack the military. Once more, an overhead long shot sees Sully fall and survive, the scene rendered in slow motion. For viewers who have consistently been encouraged to identify with Sully and the Na'vi, there is a sense of triumphalism and moral redemption. In addition, the grief expressed by Neytiri and the Na'vi translates into positive action and in this way may encourage an analogous working through for the viewer.

The film ends with Sully's permanent switch to his avatar identity, indicating his rejection of US values (and reflecting Cameron's critical stance

on the Iraq War). The scene replicates an earlier one of Grace's death at the Tree of Souls, which too entails arresting imagery. Here, blue-toned lighting illuminates the scene as the Na'vi sit, holding hands, appearing to form a single entity. Low and high camera angles intercut, emphasizing the unity of the Na'vi as well as their spirituality, while aural and visual distortions from Grace's perspective convey the moment of her death, whereby she seems to enter another dimension. The Tree of Souls itself exerts sublime effects in its physical size and spiritual features (it accesses the souls of those who have died) while the ceremonial scenes of Grace's and Sully's deaths resemble the candle-lit rituals that occurred after 9/11 (and which are evident in other films considered in this book). Moreover, the suggestions of an afterlife might also enable viewers to work through loss.

Indeed, Sully voluntarily abandons his human form to inhabit his avatar body, his difficulty in sustaining his dual identities signaling the incompatibilities of the Na'vi and the military. This becomes apparent from his video log where his increasing disorientation suggests that he seems to be losing a sense of self. "Everything is backwards now—out there is the true world…and in here is the dream," he comments, his equivocation indicating the moral dilemma of the Iraq/US conflict and uncertainties about US national identity after 9/11.

CONCLUSION

Adam Phillips comments that the sublime is an "odd mixture, revealing, as it can, the overlap between pleasure and pain. Because terror, which is the heart of the Sublime, is a passion, which, Burke writes, 'always produces delight when it does not press too close'" (in Burke, 1998: xxi). In a similar vein, *Avatar*'s portrayal of 9/11, the war on terror, and environmental catastrophe provokes pleasure through sublime effects arising both from technological and from natural phenomena. Central to *Avatar*'s imagery is the notion of infinitude, of the scale of life and landscape on Pandora, and the capacity of military destructiveness, the film's cinematography and editing consistently enhancing these sublime aspects. Certainly, the generic attributes of fantasy cinema allow it to conflate the spectacular effects of film with the spectacular possibilities of warfare.

In this respect, *Avatar* highlights one obvious cause for its success—that of technical innovation. Together with the chance to escape from reality and simultaneously engage in a narrative trajectory that entails a paradigm of good overcoming evil, the film affords the viewer sensations of power and morality and enables a working through of new millennial anxieties through sublime spectacles that are presented as arresting images. These visuals initiate associations and memories of the events of 9/11, the aftermath of Ground

Zero, the controversy of the invasion of Iraq, and its tragedies and losses as well as environmental concerns. The highest grossing film of all time, *Avatar*'s success indicates that, like its fantasy contemporaries, its recurring iconography and themes resembling 9/11 chimed with contemporary audiences. In addition, coinciding with other fantasy films, *Avatar* offers consolation in its suggestions of an afterlife, exemplified in its closing scenes, which entail a close-up of Sully's opening eyes as he permanently assumes his avatar form.

CONCLUSION

In the introduction, I noted that Kathy Smith claimed that fantasy films such as *Harry Potter* and *The Lord of the Rings* provided relief to audiences traumatized by 9/11 (2005: 69–70). The box-office dominance of fantasy film since 2001 seems to support such a claim. However, this analysis of some of the most commercially successful fantasy films made since 2001 reveals that the genre has been a vehicle through which to reprise themes and images relating to 9/11 and the war on terror. Jack Zipes outlines an analogous scenario in relation to the success of *Star Wars* (Lucas, 1977) and its post-Vietnam and Watergate contexts, suggesting that "the film, with all its sequels obviously endeavors to serve as a palliative for the discord which divided Americans in the late 1960s and early 1970s. It suggests that the system is all right, but it can fall into evil hands at times, and this evil must then be subdued by the mystical force of democracy" (2002: 132). Further discernible is a progressive darkening of theme and visual style in franchises such as the *Harry Potter* and *Pirates of the Caribbean* series, which both span the first decade of the new millennium. Films made toward the end of the decade are also more inclined to address the political aspects of the war on terror (*Avatar* and *Iron Man* both openly criticize the war in Iraq). In a review essay of 9/11 film and media scholarship in *Cinema Journal*, David Slocum states:

> Notwithstanding the range of films included in filmographies and other accounts of the period, a thorough understanding of the topic also requires considering those films left out. Reviewing the box office leaders following 2001 leaves one wondering how immensely popular films—including multiple entries in the *Harry Potter*, *Shrek*, *Spiderman*, *Lord of the Rings*, and *Pirates of the Caribbean* franchises—can be reconciled with the defining aspects of films in the age of terrorism. Certainly, the place of films *other than* action and horror films, as cinematic responses to 9/11 and the war on terror, should likely be revisited in the future and their significance reconsidered relative to other kinds of productions [original emphasis]. (Slocum, 2011: 183)

This book has attempted to contribute to such reconciliation by considering ways in which fantasy films since 9/11 may appeal both to younger and to older viewers (since they are orientated toward lucrative family demographics). In proposing this reconciliation, Colin Campbell's contention for an Easternization of Western culture has proved useful in elucidating magic, mysticism, and spirituality as major factors in fantasy's appeal. Often manifesting in various forms of spectacle, these elements surface in each of the films examined here. For younger audiences, magic has obvious attractions, while for older viewers, fantasy's spiritualism and consistent conjuring of an afterlife afford reassurance and solace in times of threat. Indeed, in his more recent study of fantasy film, Zipes claims, "Fairytale films [...] are concerned with profound human struggles and seek to provide a glimpse of light and hope despite the darkness that surrounds their very creation and production" (2011: 350). Correspondingly, the films examined in this study appear to deliver such hope, constantly portraying death as a transient state from which one can return. For, even though they each espouse a subtext of death and regularly display loss of life, the accompanying imagery, either of resurrection or ghostly apparitions occupying proximate worlds affords a way to address mortality. This is significant to post-9/11 audiences not only because of the events of September 11 but also in respect of losses of military personnel in the war on terror. In some instances, the prompting of flashbulb memory directs the viewer to read fantasy's images of death in the context of the terrorist attacks. At other times, the allusion is more nebulous, mediated through Klinger's concept of the "arresting image" or merely summoning vague emotions of loss through poignant or pessimistic sequences (images of the Dead Marshes in *The Two Towers* and the dead Kraken and Elizabeth Swann's floating dress in *Pirates of the Caribbean* are typical examples here). Otherwise, films may access 9/11 and the war on terror through the concept of multidirectional memory whereby viewers interpret historical trauma through the lens of contemporary circumstance. These include the use of nuclear weapons at Hiroshima and Nagasaki (implied in *The Kingdom of the Crystal Skull*) and the large-scale fatalities of the World Wars (as in *The Lord of the Rings*). There are also subtle intertexualities between 9/11 and the Vietnam War in *Avatar,* which emerge through *Avatar*'s reference to films about Vietnam (*Full Metal Jacket* (Kubrick, 1987) and Coppola's 1979 film *Apocalypse Now*).

Further relevant to fantasy's ubiquity is its combined affinity for technology and nature (in line with Friedman's claim), with scenes of environmental damage pervading many of the narratives examined here. Tolkien's literary references to the industrializing landscape of the 1950s translates into imagery that is relevant to contemporary audiences experiencing the effects of climate change, and *Avatar, Kingdom of the Crystal Skull,* and *Iron Man 2* also

address ecological concerns. In relation to the environment, fantasy films of the new millennium implicate other disasters of the twenty-first century, namely, Hurricane Katrina and the Indonesian tsunami, through the deployment of digital effects. Additionally, technology has enabled the credible depiction of Tolkien's *The Lord of the Rings*, where previous animated versions have failed commercially, and technological innovation is central to *Avatar*'s success. The facilitation of digitally enhanced "timespaces" is also crucial to the *Potter* films' images of magical transformation and the creation of proximate realms.

Moreover, the proclivity for crossgenerational literary adaptation has been integral to fantasy's post-9/11 prominence, with the highest grossing films mostly deriving from their literary forebears (*Pirates of the Caribbean* being an exception), whereas high-profile stars have proved fundamental to the success of films such as *The Kingdom of the Crystal Skull* and *Pirates of the Caribbean*. Yet, not all films have depended on stars, with computer-generated or digitally enhanced characters sometimes taking precedence (e.g., Gollum in *The Lord of the Rings* and the Na'vi in *Avatar*). At other times, however, the adaptation of well-known novels may bring certain limitations: the film versions of *The Chronicles of Narnia* did not perform as well as other literary adaptations, in part because C. S. Lewis's original novels are modest in size, include a limited number of characters, and narratively, do not have a single overarching trajectory against evil.

A consistent feature of post-9/11 fantasy film, however, is its reference to 9/11 and the war on terror, reframed as pleasurable spectacle through diverse aesthetic forms, namely, those of abjection, the sublime, nostalgia, digital enhanced settings, or the "impact aesthetic." Fantasy has a peculiar proclivity in this respect since its dominant narrative paradigm of good overcoming evil in the face of adversity is amenable to such reframing. Moreover, its characterization of physically diverse beings enables the visualization of the terrorist other. The ways in which fantasy has sign-posted 9/11 and the war on terror in its subtext are varied. Sometimes, these coincide with the conventional vocabulary of the fantasy film—falling, flight, a collection of disfigured, fantastic, or monstrous others, and a quest that traverses diverse territories. Otherwise, a distinctive iconography associated with post-9/11 fantasy has emerged, including falling debris, burning edifices, billowing smoke, black clouds, precipitous heights, and shattering glass. In addition, there is a preoccupation with subterranean spaces and its associations with entombment. Flight or control over falling is especially prominent in new millennial fantasy, evident in the *Harry Potter* series, *Iron Man*, *The Dark Knight,* and *Spiderman*, whereas *Avatar*'s Jake Sully learns to fall "safely." Scenes of falling are especially resonant for audiences because of media and scholarly attention to photographs of "the Falling Man" (Richard Drew),

one of the victims of 9/11, who was forced to jump from the Towers. In general, there has been a reticence to discuss such disturbing imagery, and, arguably, its prevalence in the fantasy film allows ways in which to address this (see Lurie, 2006 and Smith, 2011). Post-9/11 fantasy narratives also revisit contentious moral issues associated with the war on terror, including the use of "waterboarding," torture, and other degrading interrogation techniques employed at US terrorist detention camps.

Perhaps fantasy film does merely offer escapism during difficult times, and certainly, some viewers may not consciously respond to the films' reflections of their new millennial climate. However, it is difficult to explain why this escapism is inevitably foregrounded by death, and why such films, especially those that directly reference 9/11 and the war on terror, should be so commercially successful. It is possible to interpret 9/11 in any filmic scenes of destruction, and certain visual and thematic parameters discussed here are nonspecific and open to interpretation. This book does not dispute this, and, indeed, as Baudrillard (2003) points out, cinematic images predating 9/11 seemed to anticipate the event. Rather, its aim is to suggest ways in which fantasy film of the twenty-first century may be resonant for audiences and the means by which their narratives may have offered resolution and perhaps some closure. One explanation lies in fantasy's capacity to explore traumatic issues in different, "safe," but yet discernibly familiar forms. In line with recent neurobiological developments in trauma understanding (Kirmayer *et al.*, 2007), the future development of the role of fantasy in trauma may therefore consider more empirically how concepts of spectacle and the arresting image emotionally and physiologically affect spectators.

This book opened with considering Winston Wheeler Dixon's question regarding the impact of 9/11 on genres. The films examined here suggest a profound darkening of fantasy film and a prevailing subtext of death. Conclusively, therefore, such films have enabled the spectator to reexperience terrorism, torture, death, and disaster in ameliorated forms. Seemingly reluctant to witness realistic imagery in Iraq-based combat films such as *Green Zone* and *The Hurt Locker*, audiences have instead turned to fantasy. Although many of the top-grossing fantasy films of the twenty-first century have explored various dimensions of 9/11, the most significant image must surely be the death of Voldemort in *The Deathly Hallows: Part 2*. Given the obvious and conscious congruencies between the later films of the *Potter* franchise and visual elements of 9/11, Voldemort's death is profoundly emotional for viewers, young and old alike, in signaling the destruction of evil and is exemplary in illustrating how fantasy may access diverse audiences through the language of spectacle.

NOTES

INTRODUCTION

1. Available at http://boxofficemojo.com/alltime/world/ [Accessed 09/08/12].
2. See Hewitt, 2003: 109.
3. Traumatic memory is used here in the way that E. Ann Kaplan extends trauma to include suffering terror (2005: 1).
4. For further discussion, see Prince (2009: 11).
5. For further reading, see E. Foa *et al.* (2009).

1 SETTINGS, SPECTACLE, AND THE OTHER: PICTURING DISGUST IN JACKSON'S *THE LORD OF THE RINGS* TRILOGY

1. Available at http://www.imdb.com/boxoffice/alltimegross?region=world-wide.[Accessed 11/08/12].
2. Available at http://www.imdb.com/title/tt0120737/awards [Accessed 13/08/12].
3. This notion may originate, fundamentally, in the idea of hell, the mythological space of Hades or as Lefebvre notes, in "Dante's depths" (1991: 242).
4. See François Debrix (2005).
5. *Cadere* is a Latin verb, meaning "to fall."

2 BEWITCHING, ABJECT, UNCANNY: MAGICAL SPECTACLE IN THE *HARRY POTTER* FILMS

1. See http://boxofficemojo.com/news/?id=3217&p=.htm [Accessed 25/12/11].

3 PIRATE POLITICS AND THE SPECTACLE OF THE OTHER: *PIRATES OF THE CARIBBEAN*

1. See http://www.boxofficemojo.com/alltime/world/ [Accessed 10/07/12].
2. See http://www.boxofficemojo.com/franchises/ [Accessed 29/07/12].
3. See http://www.imdb.com/title/tt0325980/ [Accessed 14/07/12].

4. Guantanamo's position on Cuba places it outside US legal jurisdiction, and George W. Bush declared its detainees exempt from the Geneva Convention (Wallechinsky, 2006).

4 RESURRECTION, ANTHROPOMORPHISM, AND COLD WAR ECHOES IN ADAMSON'S *THE CHRONICLES OF NARNIA; THE LION, THE WITCH AND THE WARDROBE*

1. Available at http://boxofficemojo.com/yearly/chart/?view2=worldwide&yr=2005&p=.htm [Accessed 30/08/12].
2. Available at http://boxofficemojo.com/alltime/world/?pagenum=1&p=.htm [Accessed 20/8/12].
3. Available at http://www.telegraph.co.uk/culture/books/books-life/7545438/The-20-greatest-childrens-books-ever.html [Accessed 02/08/12].

5 THE AESTHETICS OF TRAUMA: TEMPORALITY AND MULTIDIRECTIONAL MEMORY IN *PAN'S LABYRINTH*

1. See http://www.imdb.com/title/tt0457430/awards [Accessed 26/08/12].
2. See http://www.boxofficemojo.com/movies/?id=panslabyrinth.htm [Accessed 28/08/12].
3. See http://www.jjay.cuny.edu/churchstudy/main.asp [Accessed 28/08/12].

6 REFRAMING THE COLD WAR IN THE TWENTY-FIRST CENTURY: ACTION, NOSTALGIA, AND NUCLEAR HOLOCAUST IN *INDIANA JONES AND THE KINGDOM OF THE CRYSTAL SKULL*

1. See IMDB at http://www.imdb.com/title/tt0367882/ [Accessed 08/06/12].
2. See IMDB at http://www.imdb.com/title/tt0367882/ [Accessed 08/06/12].
3. See S. Spielberg (2008) *Indiana Jones and the Crystal Skull* Special features DVD: Previsualisation Sequences.

7 THE ECSTASY OF CHAOS: MEDIATIONS OF 9/11, TERRORISM, AND TRAUMATIC MEMORY IN *THE DARK KNIGHT*

1. See www.imdb.com/boxoffice/alltimegross?region=world-wide [Accessed 10/08/12].
2. For further reading see Leonard Smith (2007).

8 WOUNDING, MORALITY, AND TORTURE: REFLECTIONS OF THE WAR ON TERROR IN *IRON MAN* AND *IRON MAN 2*

1. See http://www.boxofficemojo.com/alltime/weekends/ [Accessed 28/07/12].
2. See http://boxofficemojo.com/alltime/world/ [Accessed 28/07/12].
3. See http://www.boxofficemojo.com/news/?id=2766&p=.html [Accessed 03/08/12].
4. Available at http://abcnews.go.com/Archives/video/feb-2003-colin-powell-wmd-12802420 [Accessed 04/08/12].
5. Available at http://www.guardian.co.uk/world/2003/feb/05/iraq.usa [Accessed 04/08/12].
6. See http://abcnews.go.com/Archives/video/feb-2003-colin-powell-wmd-12802420 [Accessed 04/08/12].

BIBLIOGRAPHY

Alford, Matthew (2010) *Reel Power: Hollywood Cinema and American Supremacy*, London: Pluto Press.

Alter, Ethan (2007) "Deconstructing *Pan's Labyrinth*, Guillermo Del Toro Puts Horror Back into Fairy Tales." *Film Journal International*, 110(1), pp. 14–16.

———— (2010) 'Avatar', *Film Journal International*, 111(1), pp. 27–28.

Altman, Rick (1999) *Film/Genre*, London: BFI Publishing.

Anatol, Giselle (ed.) (2003) *Reading Harry Potter: Critical Essays*, Westport and London: Praeger Publishers.

Arroyo, José (2006) "*Pan's Labyrinth*," *Sight and Sound*, 16(12), pp. 66–68.

Austin, Thomas and Wilma de Jong (eds.) (2008) *Rethinking Documentary: New Perspectives, New Practices*, Maidenhead and New York: Open University Press.

Baker, Steve (2001) *Picturing the Beast: Animals, Identity, and Representation*, Illinois: University of Illinois Press.

Barker, Martin (2008) "The Functions of Fantasy: A Comparison of Audiences for *The Lord of the Rings* in Twelve Countries," in Martin Barker and Ernest Mathijs (eds.) *Watching The Lord of the Rings: Tolkien's World Audiences*, New York: Peter Lang, pp. 149–180.

———— (2011) *A Toxic Genre: The Iraq War Films*, London: Pluto Press.

Baudrillard, Jean (1994) *Simulation and Simulacra* (Trans. S. Glaser), Michigan: The University of Michigan Press.

———— (2003) *The Spirit of Terrorism* (Trans. C. Turner), London and New York: Verso.

Bell, David (2007) *Cyberculture Theorists*, London and New York: Routledge.

Bellin, Joshua (2005) *Framing Monsters: Fantasy Film and Social Alienation*, Carbondale: Southern Illinois University Press.

Benshoff, Harry and Sean Griffin (2009) *America on Film: Representing Race, Class, Gender and Sexuality*, Malden and Oxford: Wiley-Blackwell.

Bettelheim, Bruno (1991) *The Uses of Enchantment: The Meaning and Importance of Fairy Tales*, London and New York: Penguin Books.

Binkley, Christina (2011) "The Maestro in the 'Batcave,'" *Wall Street Journal*, New York: US, February 25.

Birkenstein, Jeff, Anna Froula, and Karen Randell (eds.) (2010) *Reframing 9/11: Film, Popular Culture and the 'War on Terror'*, London and New York: Continuum.

Boggs, Carl and Tom Pollard (2007) *The Hollywood War Machine: U.S. Militarism and Popular Culture*, Boulder and London: Paradigm Publishers.

Bond, Richard (2010) "Piratical Americans: Representations of Piracy and Authority in Mid-Twentieth Century Swashbucklers," *The Journal of American Culture*, 33(4), pp. 309–321.

Bouton, Mark and Jaylyn Waddell (2007) "Some Biobehavioral Insights into Persistent Effects of Emotional Trauma," in Laurence Kirmayer, Robert Lemelson, and Mark Barad (eds.) *Understanding Trauma: Integrating Biological, Clinical, and Cultural Perspectives*. Cambridge and New York: Cambridge University Press, pp. 41–59.

Braudy, Leo and Marshall Cohen (eds.) (2009) *Film Theory and Criticism*, Oxford and New York: Oxford University Press.

Brown, Devin (2007) "The Ongoing Appeal of The Chronicles of Narnia: A Partial Explanation," *New Review of Children's Literature and Librarianship*, 9(1), pp. 99–112.

Bruzzi, Stella (2006) *New Documentary*, 2nd edition. London and New York: Routledge.

Buckland, Warren (2006) *Directed by Steven Spielberg: Poetics of the Contemporary Hollywood Blockbuster*, New York and London: Continuum.

Bukatman, Scott (2000) "The Artificial Infinite: On Special Effects and the Sublime," in John Orr and Olga Taxidou (eds.) *Post-War Cinema and Modernity*, Edinburgh: Edinburgh University Press, pp. 208–222.

Burke, Edmund (1998) *A Philosophical Enquiry into the Origin of our Ideas of the Sublime and Beautiful*, Oxford and New York: Oxford University Press.

Butler, David (2009) *Fantasy Cinema: Impossible Worlds on Screen*, London and New York: Wallflower Press.

Butler, Judith (2009) *Frames of War: When is Life Grievable?* London and New York: Verso.

Campbell, Colin (2010) "The Easternization of the West: Or, How the West Was Lost," *Asian Journal of Social Science*, 38, pp. 738–757.

Campbell, Lori (2010) *Portals of Power: Magical Agency and Transformation in Literary Fantasy*, Jefferson: McFarland Press.

Caruth, Cathy (ed.) (1995) *Trauma: Explorations in Memory*, Baltimore and London: The Johns Hopkins University Press.

——— (1996) *Unclaimed Experience: Trauma, Narrative, and History*. Baltimore and London: The Johns Hopkins University Press.

Catalan, Cristobal (2008) "'Heckuva Job, Tony!' Racism and Hegemony Rage in Iron Man," *Bright Lights Film Journal*, Available at http://www.brightlightsfilm.com/61/61ironmancatalan.php [Accessed 03/08/12].

Chambers, Todd (2004) "Virtual Disability," in Lester Friedman (ed.) *Cultural Sutures: Medicine and Media*, Durham and London: Duke University Press, pp. 386–398.

Chapman, James and Nicholas Cull (2009) *Projecting Empire: Imperialism and Popular Cinema*, London and New York: IB Tauris.

Chapman, Roger (2012) "The Lion, The Witch and the Cold War: Political Meanings in the Religious Writings of C.S. Lewis," *Journal of Religion and Popular Culture*, 24(1), pp. 1–14.

Chossudovsky, Michel (2005) *America's "War on Terrorism,"* Montreal: Global Research.

Church, David (2011) "Freakery, Cult Films and the Problem of Ambivalence," *Journal of Film and Video*, 63(1), pp. 3–17.

Clark, Roger and Keith McDonald (2010) "'A Constant Transit of Finding': Fantasy as Realisation in *Pan's Labyrinth," Children's Literature in Education*, 41(1), pp. 52–63.

Corrigan, Timothy (ed.) (2012) *American Cinema of the 2000s: Themes and Variations*, New Brunswick and London: Rutgers University Press.

Costello, Matthew (2011) "Spandex Agonistes: Superhero Comics Confront the War on Terror," in Veronique Bragard, Christophe Dony, and Warren Rosenberg (eds.) *Portraying 9/11: Essays on Representations in Comics, Literature, Film and Theatre*, Jefferson and London: McFarland Press, pp. 30–43.

Creed, Barbara (1993) *The Monstrous-Feminine: Film, Feminism, Psychoanalysis*, London and New York: Routledge.

Cubitt, Sean (2005) *Eco Media*, Amsterdam and New York: Rodopi.

——— (2006) "The Fading of the Elves: Eco-Catastrophe, Technopoly, and Bio-Security," in Ernest Mathijs and Murray Pomerance (eds.) *From Hobbits to Hollywood: Essays on Peter Jackson's Lord of the Rings*, Amsterdam and New York: Rodopi, pp. 65–80.

Damour, Lisa (2003) "Harry Potter and the Magical Looking Glass," in Giselle Anatol (ed.) *Reading Harry Potter: Critical Essays*, Westport and London: Praeger Publishers, pp. 15–24.

Danner, Mark (2004) *Torture and Truth: America, Abu Ghraib and the War on Terror*, New York: New York Review Books.

Dargis, Manohla (2008) "Showdown in Gotham Town," *The New York Times*, New York: USA, July 18.

Debrix, Francois (2005) "Discourses of War, Geographies of Abjection: Reading Contemporary American Ideologies of Terror," *Third World Quarterly*, 26(7), pp. 1157–1172.

Del Toro, Guillermo (2006) "Director Commentary—*Pan's Labyrinth," Pan's Labyrinth* DVD, UK: Optimum Home Entertainment.

Denby, David (2008) "Unsafe—Review of *Iron Man," The New Yorker*, May 5. Available at http://www.newyorker.com/arts/critics/cinema/2008/05/05/080505 crci_cinema_denby [Accessed 20/07/12].

Denison, Rayna (2004) "Review of 'Pirates of the Caribbean: The Curse of the Black Pearl'," *Scope: An Online Journal of Film Studies*. Available at http://www.scope.nottingham.ac.uk [Accessed 17/07/12].

DeRosa, Aaron (2011) "September 11 and Cold War Nostalgia," in Veronique Bragard, Christophe Dony, and Warren Rosenberg (eds.) *Portraying 9/11: Essays on Representations in Comics, Literature, Film and Theatre*, Jefferson and London: McFarland Press, pp. 58–72.

Deschowitz, Jessica (2010) "Johnny Depp: Disney Hated My Jack Sparrow," November 30. Available at http://www.cbsnews.com/ [Accessed 17/07/12].

DiPaulo, Marc (2011) *War, Politics and Superheroes: Ethics and Propaganda in Comics and Film*, Jefferson: McFarland.

Dixon, Winston Wheeler (2003) *Visions of the Apocalypse: Spectacles of Destruction in American Cinema*. London and New York: Wallflower Press.

Dixon, Winston Wheeler (ed.) (2004) *Film and Television After 9/11*, Carbondale: Southern Illinois University Press.

Drew, Julie (2004) "Identity Crisis: Gender, Public Discourse, and 9/11," *Women and Language*, 27(2), pp. 71–82.

Eichner, Susanne, Mikos Lothar, and Michael Wedel (2006) *"Apocalypse Now* in Middle Earth: 'Genre' in the Critical Reception of *The Lord of the Rings* in Germany," in Ernest Mathijs (ed.) *The Lord of The Rings: Popular Culture in Global Context*, London and New York: Wallflower Press, pp. 143–159.

Elden, Stuart (2009) *Terror and Territory*, Minneapolis and London: University of Minnesota Press.

Ellwood, Robert (2009) *Tales of Darkness: The Mythology of Evil*, London and New York: Continuum.

Elsaesser. Thomas (2001) "Postmodernism as Mourning Work," *Screen*, 42(2), pp. 193–201.

Etherington, Dan (2003) "Pirates of the Caribbean: the Curse of the Black Pearl," *Sight and Sound*, 60(9), pp. 59–60.

Faludi, Susan (2007) *The Terror Dream: What 9/11 Revealed About America*, London: Atlantic Books.

Felman, Shoshana and Dori Laub (1992) *Testimony: Crises of Witnessing in Literature, Psychoanalysis and History*, London and New York: Routledge.

Felperin, Leslie (2006) "Pirates of the Caribbean: Dead Man's Chest," *Sight and Sound,* 16(9), pp. 65–66.

Foa, Edna, Terence Keane, Matthew Friedman, and Judith Cohen (eds.) (2009) *Effective Treatments for PTSD: Practice Guidelines from the International Society for Traumatic Stress Studies*, London and New York: Guilford Press.

Ford, Judy and Robin Reid (2011) "Into the West: Far Green Country or Shadow on the Waters?" in Janice Bogstad and Philip Kaveny (eds.) *Picturing Tolkien: Essays on Peter Jackson's The Lord of the Rings Film Trilogy*, Jefferson: McFarland Press, pp. 169–182.

Foster, Jonathan (2009) *Memory: A Very Short Introduction*, Oxford and New York: Oxford University Press.

Fowkes, Katherine (2010) *The Fantasy Film*, Malden and Oxford: Wiley-Blackwell.

Freud, Sigmund (1953) *A Case of Hysteria, Three Essays on Sexuality and Other Works, The Standard Edition of the Complete Psychological Works of Sigmund Freud*, Volume 7 (Trans. James Strachey), London: Vintage.

―――― (1955a) *Totem and Taboo and Other Works, The Standard Edition of the Complete Psychological Works of Sigmund Freud*, Volume 13 (Trans. James Strachey) London: Vintage.

―――― (1955b) *An Infantile Neurosis and Other Works, The Standard Edition of the Complete Psychological Works of Sigmund Freud*, Volume 17 (Trans. James Strachey) London: Vintage.

Friedman, Ted (2008) "The Politics of Magic: Fantasy Media, Technology, and Nature in the Twenty-First Century," *Scope—An On-line Journal of Film and*

Television Studies. Available at http://www.scope.nottingham.ac.uk [Accessed 17/06/10].

Fuller, Graham (2002) "Trimming Tolkien," *Sight and Sound*, 12(2), pp. 18–20.

Furby, Jacqueline and Claire Hines (2012) *Fantasy*, London and New York: Routledge.

Garland-Thomson, Rosemarie (1996) "From Wonder to Error—A Genealogy of Freak Discourse in Modernity," in Rosemarie Garland-Thomson (ed.) *Freakery: Cultural Spectacles of the Extraordinary Body*, New York and London: New York University Press, pp. 1–19.

Garland-Thomson, Rosemarie (1997) *Extraordinary Bodies: Figuring Physical Disability in American Culture and Literature*, New York and Chichester: Columbia Unversity Press.

Gelder, Ken (2006) "Epic Fantasy and Global Terrorism," in Ernest Mathijs and Murray Pomerance (eds.) *From Hobbits to Hollywood: Essays on Peter Jackson's Lord of the Rings*, Amsterdam and New York: Rodopi, pp. 101–118.

Goldberg, Ruth and Krin Gabbard (2006) "What Does the Eye Demand: Sexuality, Forbidden Vision and Embodiment in *The Lord of The Rings*," in Ernest Mathijs and Murray Pomerance (eds.) *From Hobbits to Hollywood: Essays on Peter Jackson's Lord of the Rings*, Amsterdam and New York: Rodopi, pp. 267–281.

Goldenberg, Suzanne (2006) "Marines May Face Trial over Iraq Massacre," *Guardian*: London, UK, May 27, 2006.

Gordon, Andrew (2008) *Empire of Dreams: The Science Fiction and Fantasy Films of Steven Spielberg*, New York and Plymouth: Rowman and Littlefield Publishers.

Gray, Mitchell and Elvin Wyly (2007) "The Terror City Hypothesis," in Derek Gregory and Allan Pred (eds.) *Violent Geographies: Fear, Terror, and Political Violence*, London and New York: Routledge, pp. 329–348.

Gray, Simon (2001) "Ring Bearers," *American Cinematographer*, 82(12), pp. 36–51.

Greenberg, Judith (ed.) (2003) *Trauma at Home After 9/11*, Lincoln and London: University of Nebraska Press.

Griesinger, Emily (2002) "Harry Potter and the 'Deeper Magic': Narrating Hope in Children's Literature," *Christianity and Literature*, 51(3), pp. 455–480.

Grodal, Torben (1997) *Moving Pictures: A New Theory of Film Genres, Feelings, and Cognition*, Oxford and New York: Oxford University Press.

Guillen, Michael (2006) *"Pan's Labyrinth—Interview with Guillermo del Toro,"* December 17. Available at http://twitchfilm.com/interviews/2006/12/pans-laby-rinthinterview-with-guillermo-del-toro.php [Accessed 30/08/12].

Gunning, Tom (2006) "Gollum and Golem: Special Effects and the Technology of Artificial Bodies," in Ernest Mathijs and Murray Pomerance (eds.) *From Hobbits to Hollywood: Essays on Peter Jackson's Lord of the Rings*, Amsterdam and New York: Rodopi, pp. 319–350.

Gupta, Suman (2009) *Re-Reading Harry Potter*, Basingstoke and New York: Palgrave Macmillan.

Hall, R. (2007) "Through a Dark Lens: Jackson's *Lord of the Rings* as Abject Horror," *Mythlore*, 25.3(4), p. 55.

Hammond, Philip (2007) *Media, War and Postmodernity*, London and New York: Routledge.

——— (ed.) (2011) *Screens of Terror: Representations of War and Terrorism in Film and Television Since 9/11*, Suffolk: Arima Publishing.

Hanich, Julian (2009) "Dis/liking Disgust: The Revulsion Experience at the Movies," *New Review of Film and Television*, 7(3), pp. 293–309.

Hanley, Jane (2007) "The Walls Fall Down: Fantasy and Power in El Laberinto del Fauno," *Studies in Hispanic Cinema*, 4(1), pp. 35–45.

Hantke Steffen (2010) "Bush's America and the Return of Cold War Science Fiction: Alien Invasion in *Invasion, Threshold*, and *Surface*," *Journal of Popular Film and Television*, 38(3), pp. 143–151.

Hartley, George (2003) *The Abyss of Representation: Marxism and the Postmodern Sublime*, Durham and London: Duke University Press.

Harvey, Alex (2010) "Superman *Is* the Faultline: Fissures in the Monomythic Man of Steel," in Jeff Birkenstein, Anna Froula, and Karen Randell (eds.) *Reframing 9/11: Film, Popular Culture and the 'War on Terror'*, London and New York: Continuum, pp. 117–126.

Heilman, Elizabeth (ed.) (2003) *Harry Potter's World: Multidisciplinary Critical Perspectives*, New York and London: RoutledgeFalmer.

——— (ed.) (2009) *Critical Perspectives on Harry Potter*, 2nd edition, New York and London: Routledge.

Hewitt, Christopher (2003) *Understanding Terrorism: From the Klan to Al-Qaeda*, London and New York: Routledge.

Hockenhull, Stella (2008) *Neo-Romantic Landscapes: An Aesthetic Approach to the Films of Powell and Pressburger*, Newcastle: Cambridge Scholars Publishing.

Holleran, Scott (no date) "Ted Elliott and Terry Rossio on *Pirates of the Caribbean*,"available at http://www.scottholleran.com/old/interviews/elliott-rossio-pirates-caribbean.htm [Accessed 21/07/12].

Holloway, David (2008) *9/11 and the War on Terror*, Edinburgh: Edinburgh University Press.

Hoyle, Ben (2009) "War on Terror Backdrop to James Cameron's Avatar." *The Australian*. Sydney (Australia), December 11, 2009 [Accessed 06/01/12]. Available at http://www.theaustralian.com.au/news/arts/war-on-terror-backdrop-to-james-camerons-avatar/story-e6frg8pf-1225809286903.

Hurst, Steven (2009) *The United States and Iraq Since 1979: Hegemony, Oil and War*, Edinburgh: Edinburgh University Press.

Jackson, Richard (2007) "The Politics of Fear," in Kassimeris, George (ed.) *Playing Politics with Terrorism: A User's Guide*, London: Hurst, pp. 176–202.

James, Caryn (2007) "In Foreign Oscar Entries, the Past Masks the Present," *New York Times*, February 16. Available at http://www.nytimes.com/2007/02/16/movies/awardsseason/16osca.html [Accessed 25/08/12].

Jameson, Fredric (1985) "Postmodernism and Consumer Society," in Hal Foster (ed.) *Postmodern Culture*, London: Pluto Press, pp. 111–125.

Jess-Cooke, Carolyn (2010) "Sequalizing Spectatorship and Building Up the The Kingdom: The Case of Pirates of the Caribbean, Or How a Theme-Park

Attraction Spawned a Multibillion-Dollar Film Franchise," in Carolyn, Jess-Cooke and Constantine Verevis (eds.) *Second Takes: Critical Approaches to the Film Sequel*, Albany: State of New York University Press, pp. 205–223.

John Jay College of Criminal Justice (2004) *The Nature and Scope of the Problems of Sexual Abuse by Catholic Priests and Deacons in the United States*, New York: US Conference of Catholic Bishops.

Kant, Immanuel (1987) *Critique of Judgement*, Indianapolis and Cambridge: Hackett Publishing Company.

———— (2003) *Observations on the Feeling of the Beautiful and the Sublime*. London, Los Angeles, and Berkeley: University of California Press.

Kaplan, E. Ann (2005) *Trauma Culture: The Politics of Terror and Loss in Media and Culture*, New Brunswick, New Jersey, and London: Rutgers University Press.

Kassimeris, George (ed.) (2006) *The Barbarisation of Warfare*, London: Hurst.

———— (ed.) (2007) *Playing Politics with Terrorism: A User's Guide*, London: Hurst.

Kaveney, Roz (2008) *Superheroes: Capes and Crusaders in Comics and Films,* London: IB Tauris.

Kellner, Douglas (2006) "The Lord of the Rings as Allegory: A Multiperspectivist Reading," in Ernest Mathijs and Murray Pomerance (eds.) *From Hobbits to Hollywood: Essays on Peter Jackson's Lord of the Rings*, Amsterdam and New York: Rodopi, pp. 17–40.

———— (2010) *Cinema Wars: Hollywood Film and Politics in the Bush-Cheney Era*, Malden and Oxford: Wiley-Blackwell.

Kendrick, James (2008) "Representing 9/11 in Film and Television," in Peter Rollins and John O'Connor (eds.) *Why We Fought: America's Wars in Film and History*, Lexington: University of Kentucky Press, pp. 511–528.

Kermode, Mark (2006) "Girl Interrupted," *Sight and Sound*, 16(12), pp. 20–24.

Khoddam, Salwa (2001) "'Where Sky and Water Meet': Christian Iconography in C. S. Lewis's *The Voyage of the Dawn Treader*," *Mythlore*, 23(2), pp. 36–52.

King, Geoff (2000) *Spectacular Narratives, Hollywood in the Age of the Blockbuster,* London and New York: I. B. Tauris.

———— (2003) 'Spectacle, Narrative and the Blockbuster,' in Julian Stringer (ed.) *Movie Blockbusters*, London and New York: Routledge, pp. 114–127.

———— (ed.) (2005) *The Spectacle of the Real: From Hollywood to Reality TV and Beyond*, Bristol and Portland: Intellect.

Kirmayer, Laurence, Robert Lemelson, and Mark Barad (eds.) (2007) *Understanding Trauma: Integrating Biological, Clinical, and Cultural Perspectives*, Cambridge and New York: Cambridge University Press.

Klavan, Andrew (2008) "What Bush and Batman Have in Common," *Wall Street Journal*, New York: US, July 25.

Klinger, Barbara (2006) "The Art Film, Affect and the Female Viewer: *The Piano* Revisited," *Screen*, 47(1), pp. 19–41.

———— (2008) "What do Female Fans Want? Blockbusters, *The Return of the King*, and US Audiences," in Martin Barker and Ernest Mathijs (eds.) *Watching The Lord of the Rings: Tolkien's World Audiences*, New York: Peter Lang, pp. 69–82.

Koh, Wilson (2009) "Everything Old Is Good Again: Myth and Nostalgia in *Spider-Man*," *Continuum Journal of Media and Cultural Studies*, 23(5), pp. 735–747.

Kornfeld, John and Prothro, Laurie (2009) "Comedy, Quest, and Community," in Elizabeth Heilman (ed.) *Critical Perspectives on Harry Potter*, 2nd edition, New York and London: Routledge, pp. 121–137.

Kramer, Peter (2006) "Disney and Family Entertainment," in Linda Ruth Williams and Michael Hammond (eds.) *Contemporary American Cinema*, New York: McGraw-Hill, pp. 265–279.

Kristeva, Julia (1982) *Powers of Horror* (L. Roudiez, trans.) New York: Columbia University Press.

——— (1984) *Revolution in Poetic Language* (M. Waller, trans.) New York: Columbia University Press.

——— (1991) *Strangers to Ourselves* (L. Roudiez, trans.) New York: Columbia University Press .

——— (1993) *Nations Without Nationalism*, (L. Roudiez, trans.) New York: Columbia University Press.

Kuipers, Giselinde and Jeroen De Kloet (2008) "Global Flows and Local Identifications? *The Lord of the Rings* and the Cross-National Reception of Characters and Genres," in Martin Barker and Ernest Mathijs (eds.) *Watching The Lord of the Rings: Tolkien's World Audiences*, New York: Peter Lang, pp. 131–148.

Lacan, Jacques (1993) "The Mirror Stage," in Antony Easthope (ed.) *Contemporary Film Theory*, London and New York: Longman, pp. 33–39.

LaCapra, Dominick (2001) *Writing History, Writing Trauma*, Baltimore and London: The Johns Hopkins University Press.

Landesman, Cosmo (2008) "The Dark Knight—The Sunday Times Review," *The Sunday Times*, London, UK, July 27.

Lane, Richard (2009) *Jean Baudrillard*, London and New York: Routledge.

Lang, Derrik (2008) " 'Indiana Jones' and the Computer-Generated Jungle," *Seattle Times*, May 22, 2008 [Accessed 08/06/12].

Lefebvre, Martin "Between Setting and Landscape in the Cinema," in Martin Lefebvre (ed.) *Landscape and Film*, London and New York: Routledge, 2006, pp. 19–59.

Lenoir, Timothy (2004) "The Shape of Things to Come: Surgery in the Age of Medialization," in Lester Friedman (ed.) *Cultural Sutures: Medicine and Media,* Durham and London: Duke University Press, pp. 351–372.

Leotta, Alfio (2011) *Touring the Screen: Tourism and New Zealand Film Geographies*, Bristol and Chicago: Intellect.

Levine, Deborah (2008) "Pan's Labyrinth," *International Journal of Psychoanalytic Self Psychology*, 3(1), pp. 118–124.

Lewis, Aidan (2010) "Looking Behind the Catholic Sex Abuse Sandal," *BBC News*, London: May 4. Available at http://news.bbc.co.uk/1/hi/8654789.stm [Accessed 27/08/12].

Lewis, Clive Staples (2001) *The Chronicles of Narnia: The Lion, the Witch and the Wardrobe* [first published 1950], London: HarperCollins.

Leys, Ruth (2000) *Trauma: A Genealogy*, Chicago and London: The University of Chicago Press.

Leyshon, Michael and Catherine Brace (2007) "Deviant Sexualities and Dark Ruralities in *The War Zone*," in Robert Fish (ed.) *Cinematic Countrysides*, Manchester and New York: Manchester University Press, pp. 195–210.

Liberzon, Israel, Anthony King, Jennifer Britton, K. Luan Phan, James Abelson, and Stephan Taylor (2007) "Paralimbic and Medial Prefrontal Cortical Involvement in Neuroendocrine Responses to Traumatic Stimuli," *American Journal of Psychiatry*, 164, pp. 1250–1258.

Lockwood, Dean (2005) "Teratology of the Spectacle," in Geoff King (ed.) *The Spectacle of the Real: From Hollywood to Reality TV and Beyond*, Bristol and Portland: Intellect, pp. 71–81.

Lombroso, Cesare (2006) *Criminal Man* (Trans. Mary Gibson and Nicole Hahn Rafter), Durham and London: Duke University Press.

Lovell, Alan and Gianluca, Sergi (2009) *Cinema Entertainment: Essays on Audiences, Films and Film Makers*, Berkshire and New York: Open University Press.

Luckhurst, Roger (2008) *The Trauma Question*, London and New York: Routledge.

—— (2010) "Beyond Trauma: Torturous Times," *European Journal of English Studies*, 14(1), pp. 11–21.

Lurie, Susan (2006) "Falling Persons and National Embodiment: The Reconstruction of Safe Spectatorship in the Photographic Record of 9/11," in Daniel Sherman and Terry Nardin (eds.) *Terror, Culture, Politics: Rethinking 9/11*, Bloomington and Indianapolis: Indiana University Press, pp. 44–68.

Lury, Karen (2010) *The Child in Film: Tears, Fears and Fairytales*, London and New York: I.B. Tauris.

Lyotard, Jean-François (1992) *The Postmodern Explained: Correspondence 1982–1985*, Minneapolis: University of Minnesota Press.

—— (1994) *Lessons on the Analytic of the Sublime*, Stanford: Stanford University Press.

—— (2000) "Can Thought Go On Without a Body?" in Neil Badmington (ed.) *Posthumanism,* Basingstoke and New York: Palgrave Macmillan, pp. 129–140.

MacAskill, Ewen (2009) "US Defence Secretary Announces Large Cuts to Help Curb Spending," *Guardian*, London: UK, April 6. Available at http://www.guardian.co.uk/world/2009/apr/06/robert-gates-defence-budget-cuts [Accessed 25/08/12].

Mackie, Erin (2005) "Welcome the Outlaw: Pirates, Maroons, and Caribbean Countercultures," *Cultural Critique*, 59, pp. 24–62.

Malpas, Simon (2003) *Jean François Lyotard*, London and New York: Routledge.

Manners, Paula (2006) "Frodo's Journey," *The Psychologist*, 19(2), pp. 98–99.

Markovitz, Jonathan (2004) "Reel Terror Post-9/11," in Winston Wheeler Dixon (ed.) *Film and Television after 9/11*, Carbondale: Southern Illinois University Press, pp. 201–225.

Mauss, Marcel (2001) *A General Theory of Magic*, London and New York: Routledge.

Mayer, Jane (2009) *The Dark Side*, New York: Anchor Books.

McAlister, Melani (2006) "A Cultural History of War Without End," in David Slocum (ed.) *Hollywood and War: The Film Reader*, London and New York: Routledge, pp. 325–337.

McBride, Joseph (2009) "A Reputation: Steven Spielberg and the Eyes of the World," *New Review of Film and Television Studies*, 7(1), pp. 1–12.

McLarty, Lianne (2006) "Masculinity, Whiteness and Social Class," in Ernest Mathijs and Murray Pomerance (eds.) *From Hobbits to Hollywood: Essays on Peter Jackson's Lord of the Rings*, Amsterdam and New York: Rodopi, pp. 173–188.

McNally, Richard (2003) *Remembering Trauma*, Cambridge and London: Harvard University Press.

Melton, Brian (2011) "The Great War and Narnia: C.S. Lewis as Soldier and Creator," *Mythlore*, 30(10), pp. 123–142.

Mikos, Lothar, Susanne Eicher, Elizabeth Prommer, and Michael Wedel (2008) "Involvement in *The Lord of the Rings*: Audience Strategies," in Martin Barker and Ernest Mathijs (eds.) *Watching The Lord of the Rings: Tolkien's World Audiences*, New York: Peter Lang, pp. 111–130.

Miles, Robert (2011) "Reclaiming Revelation: *Pan's Labyrinth* and *The Spirit of the Beehive*," *Quarterly Review of Film and Video*, 28(3), pp. 195–203.

Miller, Kristine (2009) "Ghosts, Gremlins, and 'the War on Terror' in Children's Blitz Fiction," *Children's Literature Association*, 34(3), pp. 272–284.

Mills, Alice (2006) "Harry Potter and the Terrors of the Toilet," *Children's Literature in Education*, 37(1), pp. 1–13.

——— (2008) "The Chronicles of Narnia: Prince Caspian," *Scope: An Online Journal of Film Studies*, University of Nottingham. Available at http://www.scope.nottingham.ac.uk [Accessed 28/07/12].

Morgan, Gwendolyn (2007) "I Don't Think We're in Kansas Anymore: Peter Jackson's Film interpretations of Tolkien's *Lord of the Rings,*" in Leslie Stratyner and James Kellner (eds.) *Fantasy Fiction into Film*, Jefferson and London: McFarland Press, pp. 21–34.

Nacos, Brigitte (2007) *Mass-Mediated Terrorism: The Central Role of the Media in Terrorism and Counterterrorism*, New York and Plymouth: Rowman and Littlefield Publishers.

Nagy, George (2006) "The 'Lost' Subject of Middle-Earth: The Constitution of the Subject in the Figure of Gollum in *The Lord of the Rings*," *Tolkien Studies*, 3, pp. 57–79.

Napier, Susan (2005) *Anime from Akira to Howl's Moving Castle: Experiencing Contemporary Japanese Animation*, Basingstoke and New York: Palgrave Macmillan.

Natali, Maurizio (2006) "The Course of the Empire: Sublime Landscapes in the American Cinema," in Martin Lefebvre (ed.) *Landscape and Film*, London and New York: Routledge, pp. 91–123.

Neale, Steve (2000) *Genre and Hollywood*, London and New York: Routledge.

Neville, Jennifer (2005) "Women," in Robert Eaglestone (ed.) *Reading the Lord of The Rings: New Writings on Tolkien's Classic*, London and New York: Continuum, pp. 101–110.

Newman, Kim (2006) *The Chronicles of Narnia: the Lion, the Witch and the Wardrobe, Sight and Sound*, 16(2), pp. 47–48.

Niemic, Ryan and Stefan Schulenberg (2011) "Understanding Death Attitudes: The Integration of Movies, Positive Psychology and Meaning Management," *Death Studies*, 35(5), pp. 387–407.

Nininger, James (2001) "A Monument to the Towers of Pain and Might; We Will Recover," *The New York Times*. New York: USA, September 30.

Osborn, Jody and Stuart Derbyshire (2009) "Pain Sensation Evoked by Observing Injury in Others," *Pain*, 148(2), pp. 268–274.

Pawlett, William (2007) *Jean Baudrillard*, London and New York: Routledge.

Phillips, Martin (2007) "The Lord of the Rings and Transformations in Socio-Spatial Identity in Aotearoa/New Zealand," in Robert Fish (ed.) *Cinematic Countrysides*, Manchester and New York: Manchester University Press, pp. 147–176.

Phythian, Mark (1997) *Arming Iraq: How the US and British Secretly Built Saddam's War Machine*, Boston: Northeastern University Press.

Piippo, Taija (2009) "Is Desire Beneficial or Harmful," in Elizabeth Heilman (ed.) *Critical Perspectives on Harry Potter*, 2nd edition, New York and London: Routledge, pp. 65–82.

Plantinga, Carl (2009) *Moving Viewers: American Film and the Spectator's Experience*, Los Angeles and London: University of California Press.

Pollard, Tom (2011) *Hollywood 9/11: Superheroes, Supervillains, and Super Disasters*, Boulder and London: Paradigm.

Powers, Tim (1987) *On Stranger Tides*, London: Ace Publishing.

Prince, Stephen (2006) "Hollywood in the Age of Reagan," in Linda Ruth Williams and Michael Hammond (eds.) *Contemporary American Cinema*, New York: McGraw-Hill, pp. 229–246.

———(2009) *Firestorm: American Film in the Age of Terrorism*, New York: Columbia University Press.

Rateliff, John (2011) "Two Kinds of Absence: Elision and Exclusion in Peter Jackson's *The Lord of the Rings*," in Janice Bogstad and Philip Kaveney (eds.) *Picturing Tolkien: Essays on Peter Jackson's The Lord of the Rings Film Trilogy*, Jefferson: McFarland, pp. 54–69.

Rancière, Jacques (2009) *Aesthetics and Its Discontents*, Cambridge and Malden: Polity Press.

Rayner, Jonathan (2010) "Battlefields of Vision: New Zealand Filmscapes," in Jonathan Rayner and Graeme Harper (eds.) *Cinema and Landscape*, Bristol and Chicago: Intellect, pp. 257–267.

Rehak, Bob (2012) "Movies, 'Shock and Awe', and the Blockbuster," in Timothy Corrigan (ed.) *American Cinema of the 2000s*, New Brunswick and London: Rutgers University Press.

Rich, F. (2001) "The Day Before Yesterday," *The New York Times*, New York: USA, September 15, 2001.

Richards, Barry (2007) *Emotional Governance: Politics, Media and Terror*, London and New York: Palgrave Macmillan.

Roberts, Adam (2005) "The One Ring," in Robert Eaglestone (ed.) *Reading the Lord of the Rings: New Writings on Tolkien's Classic*, London and New York: Continuum, pp. 59–70.

Rogers, Paul (2006) "The Global War on Terror and its Impact on the Conduct of War," in George Kassimeris (ed.) *The Barbarisation of Warfare*, London: Hurst, pp. 186–206.

Rothberg, Michael (2006) "Auschwitz and Algeria: Multidirectional Memory and the Counterpublic Witness," *Critical Inquiry*, 3(1), pp. 158–184.

Rowling, J. K. (1998) *Harry Potter and the Philosopher's Stone*, London: Bloomsbury.

———— (1999) *Harry Potter and the Chamber of Secrets*, London: Bloomsbury.

———— (2000) *Harry Potter and the Goblet of Fire*, London: Bloomsbury.

———— (2000) *Harry Potter and the Prisoner of Azkaban*, London: Bloomsbury.

———— (2003) *Harry Potter and the Order of the Phoenix*, London: Bloomsbury.

———— (2005) *Harry Potter and the Half-Blood Prince*, London: Bloomsbury.

———— (2007) *Harry Potter and the Deathly Hallows,* London: Bloomsbury.

Russell, James (2009) "Narnia as a Site of National Struggle: Marketing, Christianity, and National Purpose in *The Chronicles of Narnia: The Lion, The Witch and The Wardrobe*," *Cinema Journal*, 48(4), pp. 59–76.

Ruud, Jay (2001) "Aslan's Sacrifice and the Doctrine of Atonement in *The Lion, The Witch and the Wardrobe*," *Mythlore*, 23(2), pp. 15–23.

Ryan, Michael and Douglas Kellner (1988) *Camera Politica: The Politics and Ideology of Contemporary Hollywood Film*, Bloomington and Indianapolis: Indiana University Press.

Said, Edward (2003) *Orientalism*, London and New York: Penguin.

Sanchez-Escalonilla, Antonio (2010) "Hollywood and the Rhetoric of Panic: The Popular Genres of Action and Fantasy in the Wake of the 9/11 Attacks," *Journal of Popular Film and Television*, 38(1), pp. 10–20.

Sandifer, Philip (2008) "Amazing Fantasies: Trauma, Affect and Superheroes," *English Language*, 46(2), pp. 175–192.

Schatz, Thomas (2012) "Movies and a Hollywood too Big to Fail," in Timothy Corrigan (ed.) *American Cinema of the 2000s: Themes and Variations*, New Brunswick and London: Rutgers University Press, pp. 194–215.

Schulenberg, Stefan (2003) "Psychotherapy and Movies: On Using Films in Clinical Practice," *Journal of Contemporary Psychotherapy*, 33(1), pp. 35–48.

Seegert, Alf (2010) "Till We Have [Inter]Faces: The Cybercultural Ecologies of *Avatar,*" *Western Humanities Review*, 64(2), pp. 112–131.

Segal, Timothy (2009) "*Pan's Labyrinth*: A Subjective View on Childhood Fantasies and the Nature of Evil," *International Review of Psychiatry*, 21(3), pp. 269–270.

Shaheen, Jack (2008) *Guilty: Hollywood's Verdict on Arabs After 9/11*, Northampton: Interlink Press.

Shalev, Arieh (2007) "PTSD: A Disorder of Recovery?" in Kirmayer, Laurence, Robert Lemelson, and Mark Barad (eds.) *Understanding Trauma: Integrating Biological, Clinical, and Cultural Perspectives*, Cambridge and New York: Cambridge University Press, pp. 207–223.

Shapiro, Francine (1995) *Eye Movement Desensitization and Reprocessing: Basic Principles, Protocols and Procedures*, New York: Guilford Press.

Shaw, Philip (2006) *The Sublime*, London and New York: Routledge.

Sherman, Daniel and Terry Nardin (eds.) (2006) *Terror, Culture, Politics: Rethinking 9/11*, Bloomington and Indianapolis: Indiana University Press.

Sibley, David (1995) *Geographies of Exclusion*, London and New York: Routledge.

——— (1999) "Outsiders in Society and Space," in Kay Anderson and Fay Gale (eds.) *Cultural Geographies*, Australia: Longman, pp. 135–151.

Silverman, Hugh (ed.) (2002) *Lyotard: Philosophy, Politics and the Sublime*, London and New York: Routledge.

Simpson, David (2006a) "The Texts of Torture," in George Kassimeris (ed.) *The Barbarisation of Warfare*, London: Hurst, pp. 207–219.

——— (2006b) *9/11: The Culture of Commemoration*, Chicago and London: The University of Chicago Press.

Singer, P. W. (2009) *Wired for War: The Robotics Revolution and Conflict in the Twenty-First Century*, London and New York: Penguin.

Slocum, David (2011) "9/11 Film and Media Scholarship: A Review Chapter," *Cinema Journal*, 51(1), pp. 181–193.

Smith, David (2011) "9/11: The Fallen," *Sunday Times Magazine*, September 4, London, pp. 40–49.

Smith, Kathy (2005) "Reframing Fantasy: September 11 and the Global Audience," in King, Geoff (ed.) *The Spectacle of the Real*, Bristol and Portland: Intellect Publishing, pp. 59–70.

Smith, Leonard (2007) *Chaos: A Very Short Introduction*, Oxford and New York: Oxford University Press.

Smith, Paul (2007) *"Pan's Labyrinth," Film Quarterly*, 60(4), pp. 4–9.

Sontag, Susan (2004) *Regarding the Pain of Others*, London: Penguin Books.

Spanakos, Anthony (2011) "Exceptional Recognition: The US Global Dilemma in *The Incredible Hulk, Iron Man*, and *Avatar*," in Richard Gray and Betty Kaklamanidou (eds.) *The Twenty-First Century Superhero: Essays on Gender, Genre and Globalization in Film*, Jefferson: McFarland Press, pp. 15–28.

Spicer, Andrew (2002) *Film Noir*, Harlow: Pearson Education Limited.

Stargardt, Nicholas (2006) *Witnesses of War: Children's Lives under the Nazis*, London, New South Wales, and Auckland: Pimlico Press.

Sterritt, David (2009) "Spielberg, Iconophobia, and the Mimetic Uncanny," *New Review of Film and Television Studies*, 7(1), pp. 51–66.

Stoner, Megan (2007) "The Lion, the Witch, and the War Scenes: How Narnia Went from Allegory to Action Flick," in Leslie Stratyner and James Keller (eds.) *Fantasy Fiction into Film*, Jefferson: McFarland, pp. 73–79.

Stratyner, Leslie and James R. Keller (eds.) (2007) *Fantasy Fiction into Film: Essays*, Jefferson, NC: McFarland Press.

Stringer, Julian (ed.) (2003) *Movie Blockbusters*, London and New York: Routledge.

Tankard, Paul (2007) "The Lion, the Witch and the Multiplex," in Leslie Stratyner and James Keller (eds.) *Fantasy Fiction into Film*, Jefferson: McFarland Press, pp. 80–92.

Thompson, Kristin (2007) *The Frodo Franchise: The Lord of the Rings and Modern Hollywood*, Berkeley and London: University of California Press.

Thompson, Moana (2006) "Scale, Spectacle and Movement," in Ernest Mathijs and Murray Pomerance (eds.) *From Hobbits to Hollywood: Essays on Peter Jackson's Lord of the Rings*, Amsterdam and New York: Rodopi, pp. 283–300.

Todorov, Tzvetan (1975) *The Fantastic: A Structural Approach to a Literary Genre*, New York: Cornell University Press.

Tognetti, Gary (2008) "The Dark Knight," *Film International*, 73, pp. 81–83.

Tolkien, John (1991) *The Lord of the Rings* [first published 1954], London: HarperCollins.

Tran, Mark (2008) "CIA Admit 'Waterboarding' Al-Qaida Suspects," *Guardian*: London, February 5.

Tsuei, Kam Hei (2010) "The Antifascist Aesthetics of *Pan's Labyrinth*," *Socialism and Democracy*, 22(2), pp. 225–244.

Turim, Maureen (2001) "The Trauma of History: Flashbacks upon Flashbacks," *Screen*, 42(2), pp. 205–210.

Turnbull, Sue (2008) "Beyond Words? *The Return of the King* and the Pleasures of the Text," in Martin Barker and Ernest Mathijs (eds.) *Watching The Lord of the Rings: Tolkien's World Audiences*, New York: Peter Lang, pp. 181–190.

Valantin, Jean-Paul (2005) *Hollywood, The Pentagon and Washington: The Movies and National Security From World War II to the Present Day*, London: Anthem Press.

Virilio, Paul (2002) *Ground Zero*, London and New York: Verso.

Walker, Jeanne Murray (1985) "The Lion, The Witch, and The Wardrobe as Rite of Passage," *Children's Literature in Education*, 16(3), pp. 177–188.

Wallechinsky, David (2006) "Is George Bush Guilty of War Crimes... and Who Cares," *Huffington Post*, August 7. Available at http://www.huffingtonpost.com/david-wallechinsky/is-george-bush-guilty-of-_b_26669.html [Accessed 20/06/12].

Walters, James (2011) *Fantasy Film: A Critical Introduction*, Oxford and New York: Berg Publishing.

Warner, Marina (1995) *From the Beast to the Blonde: On Fairy Tales and Their Tellers*, London: Vintage.

Wasko, Janet (2008) "*The Lord of the Rings*: Selling the Franchise," in Martin Barker and Ernest Mathijs (eds.) *Watching The Lord of the Rings: Tolkien's World Audiences*, New York: Peter Lang, pp. 21–36.

Weber, Cynthia (2006) *Imagining America at War: Morality, Politics, and Film*, London and New York: Routledge.

Weinberg, Leonard and William Eubank (2007) "A Nested Game: Playing Politics With Terrorism in the United States," in George Kassimeris (ed.) *Playing Politics with Terrorism: A User's Guide*, London: Hurst, pp. 157–174.

Westfahl, Gary (2005) "The Lord of the Rings: Fellowship of the Ring," in Westfahl, Gary (ed.) *The Greenwood Encyclopaedia of Science Fiction and Fantasy: Themes, Works and Wonders*, Connecticut and London: The Greenwood Press.

Whittaker, David (ed.) (2001) *The Terrorism Reader*, London and New York: Routledge.

——— (2004) *Terrorists and Terrorism in the Contemporary World*, London and New York: Routledge.

Williams, Linda Ruth and Michael Hammond (eds.) (2006) *Contemporary American Cinema*, London and New York: McGraw-Hill.

Wisnewski, Jeremy and R. D. Emerick (2009) *The Ethics of Torture*, London and New York: Continuum.

Wood, Aylish (2002) "Timespaces in Spectacular Cinema: Crossing the Great Divide of Spectacle versus Narrative," *Screen*, 43(4), pp. 370–386.

Woodward, Rachel and Patricia Winter (2007) "Militarised Countrysides: Representations of War and Rurality in British and American Film," in Robert Fish (ed.) *Cinematic Countrysides*, Manchester and New York: Manchester University Press, pp. 91–108.

Zipes, Jack (2002) *Breaking the Magic Spell: Radical Theories of Folk and Fairy Tales*, Lexington: University of Kentucky Press.

——— (2011) *The Enchanted Screen: The Unknown History of Fairy-Tale Films*, London and New York: Routledge.

Žižek, Slavoj (2002) *Welcome to the Desert of the Real*, London and New York: Verso.

——— (2005) *Iraq: The Borrowed Kettle*, London and New York: Verso.

Zlosnik, Sue (2005) "Gothic Echoes," in Robert Eaglestone (ed.) *Reading the Lord of the Rings: New Writings on Tolkien's Classic*, London and New York: Continuum, pp. 47–58.

FILMOGRAPHY

Apocalypse Now (1979) Francis Ford Coppola. USA.

Armageddon (1998) Michael Bay. USA.

Avatar (2009) James Cameron. USA/UK.

Bend it Like Beckham (2002) Gurinda Chadha. UK/Germany/USA.

Collateral Damage (2002) Andrew Davis. USA.

The Chronicles of Narnia: Prince Caspian (2008) Andrew Adamson. USA/UK.

The Chronicles of Narnia: The Lion, the Witch and the Wardrobe (2005) Andrew Adamson. USA/UK.

The Chronicles of Narnia: The Voyage of the Dawn Treader (2010) Michael Apted. USA.

The Dark Knight (2008) Christopher Nolan. USA/UK.

Die Hard (1988) John McTiernan. USA.

Fahrenheit 9/11 (2004) Michael Moore. USA.

Full Metal Jacket (1987) Stanley Kubrick. USA.

Green Zone (2010) Paul Greengrass. France/Spain/USA/UK.

Harry Potter and the Chamber of Secrets (2002) Chris Columbus. USA/UK/Germany.

Harry Potter and the Deathly Hallows: Part 1 (2010) David Yates. USA/UK.

Harry Potter and the Deathly Hallows: Part 2 (2011) David Yates. USA/UK.

Harry Potter and the Goblet of Fire (2005) Mike Newell. USA/UK.

Harry Potter and the Half-Blood Prince (2009) David Yates. USA/UK.

Harry Potter and the Order of the Phoenix (2007) David Yates. USA/UK.

Harry Potter and the Philosopher's Stone (2001) Chris Columbus. USA/UK.

Harry Potter and the Prisoner of Azkaban (2004) Alfonso Cuarón. USA/UK.

The Hurt Locker (2008) Kathryn Bigelow. USA.

Inception (2010) Christopher Nolan. USA.

Independence Day (1996) Roland Emmerich. USA.

Indiana Jones and the Kingdom of the Crystal Skull (2008) Steven Spielberg. USA.

Iron Man (2008) Jon Favreau. USA.

Iron Man 2 (2010) Jon Favreau. USA.

The Lord of the Rings (1978) Ralph Bakshi. USA.

The Lord of the Rings: The Fellowship of the Ring (2001) Peter Jackson. USA/New Zealand.

The Lord of the Rings: The Return of the King (2003) Peter Jackson. USA/New Zealand.

The Lord of the Rings: The Two Towers (2002) Peter Jackson. USA/New Zealand.

Marvel's The Avengers (2012) Joss Whedon. USA.

Pan's Labyrinth (2006) Guillermo del Toro. Spain/Mexico.

The Piano (1993) Jane Campion. Australia/New Zealand/France.

Pirates of the Caribbean: At Worlds End (2007) Gore Verbinski. USA.

Pirates of the Caribbean: Dead Man's Chest (2006) Gore Verbinski. USA.

Pirates of the Caribbean: On Stranger Tides (2011) Rob Marshall. USA.

Pirates of the Caribbean: The Curse of the Black Pearl (2003) Gore Verbinski. USA.

Shrek (2001) Andrew Adamson, Vicky Jenson. USA.

Shrek 2 (2004) Andrew Adamson, Kelly Asbury, Conrad Vernon. USA.

Shrek Forever After (2010) Mike Mitchell. USA.

Shrek the Third (2007) Chris Miller, Raman Hui. USA.

Shutter Island (2009) Martin Scorsese. USA.

Spider-Man (2002) Sam Raimi. USA.

Spider-Man 2 (2004) Sam Raimi. USA.

Spider-Man 3 (2007) Sam Raimi. USA.

Star Wars (1977) Steven Spielberg. USA.

Taxi to the Dark Side (2007) Alex Gibney, USA.

The Sum of All Fears (2002) Phil Alden Robinson. USA/Germany.

Toy Story 3 (2010) Lee Unkrich. USA.

United 93 (2006) Paul Greengrass. France/USA/UK.

Wall-E (2008) Andrew Stanton. USA.

War of the Worlds (2005) Steven Spielberg. USA.

World Trade Center (2006) Oliver Stone. USA.

INDEX

Printed in the United States of America